Drawing the Line

V

Drawing the Line

Art and Cultural Identity
in Contemporary Latin America

ORIANA BADDELEY

AND

VALERIE FRASER

VERSO

London · New York

Published in association with
the Latin America Bureau

First published by Verso 1989

Verso
UK: 6 Meard Street, London W1V 3HR
USA: 29 West 35th Street, New York, NY 10001–2291

Verso is the imprint of New Left Books

British Library Cataloguing in Publication Data

Baddeley, Oriana
 Drawing the line: art and cultural identity in
 contemporary Latin America. – (Critical studies in
 Latin American culture).
 1. Latin America. Visual arts. Cultural aspects
 I. Title II. Fraser, Valerie III. Series
 709′.8

ISBN 0–86091–239–6
ISBN 0–86091–953–6 pbk

US Library of Congress Cataloging in Publication Data

Baddeley, Oriana, 1954–
 Drawing the line: art and cultural identity in contemporary Latin
America / Oriana Baddeley and Valerie Fraser.
 p. cm. — (Critical studies in Latin American culture)
 Bibliography: p.
 Includes index.
 ISBN 0–86091–239–6 : $49.50 (U.S.). — ISBN 0–86091–953–6 (pbk.) :
$17.95 (U.S.)
 1. Art, Latin American. 2. Art, Modern—20th century—Latin
America. 3. Art and society—Latin America. I. Fraser, Valerie.
II. Title. III. Series.
N6502.5.B3 1989
700′.1′03098—dc19

Text designed by 2D Design
Disc conversion by Columns Typesetters of Reading
Printed in Great Britain by Bookcraft (Bath) Ltd

CONTENTS

CRITICAL STUDIES IN
LATIN AMERICAN CULTURE

SERIES EDITORS:

James Dunkerley
Jean Franco
John King

This major series – the first of its kind to appear in English – is designed to map the field of contemporary Latin American culture, which has enjoyed increasing popularity in Britain and the United States in recent years.

Six titles will offer a critical introduction to twentieth-century developments in painting, poetry, music, fiction, cinema and 'popular culture'. Further volumes will explore more specialized areas of interest within the field.

The series aims to broaden the scope of criticism of Latin American culture, which tends still to extol the virtues of a few established 'master' works and to examine cultural production within the context of twentieth-century history. These clear, accessible studies are aimed at all those who wish to know more about some of the most important and influential cultural works and movements of our time.

Other Titles in the Series

JOURNEYS THROUGH THE LABYRINTH: LATIN AMERICAN FICTION IN THE TWENTIETH CENTURY by Gerald Martin

PLOTTING WOMEN: GENDER AND REPRESENTATION IN MEXICO by Jean Franco

MAGICAL REELS: CINEMA IN LATIN AMERICA by John King

PREFACE AND ACKNOWLEDGEMENTS

There is very little literature, even specialist literature, on the subject of contemporary Latin American art. Outside Latin America over the last few years there have been exhibitions of the work of some better-known artists (most of them now dead) such as Orozco, Rivera, Kahlo, Matta, Torres García and Botero. These have resulted in well-illustrated and informative catalogues, and there have also been a few monographs on individual artists or on the art of particular countries. A few scholars have studied particular periods or movements in depth,[1] some have tackled the theoretical issues,[2] but Damian Bayón is almost alone in attempting to list and categorize twentieth-century Latin American artists.[3] Of the more general books Jean Franco's *The Modern Culture of Latin America* remains unique in its scope and intellectual value. The size of our bibliography reflects the lack of literature on the subject and – just as important – of accessible illustrations. However, one of our sources must be singled out for special mention: the catalogue of the exhibition held at the Indianapolis Museum of Art in 1987, *Art of the Fantastic: Latin America, 1920–1987*, edited by Holliday T. Day and Hollister Sturges. Although at the time of the exhibition we had already planned the outline of the present book, Day and Sturges's selection introduced us to several younger artists and presented new and exciting examples of work by artists with whom we were already familiar.

Our approach here has in some ways been similar to that of an exhibition organizer: to focus on certain artists whose work we feel exemplifies important aspects of contemporary Latin American art. It is futile to apologize for what a book does not contain: innumerable excellent artists have been left out or have been given short shrift – some arbitrarily, some inadvertently. It cannot be said that there are no opportunities for further research. A word about authorship. Although Valerie Fraser has been responsible for the first half of the book and Oriana Baddeley for the last three chapters, this has been a thoroughly collaborative venture. Over several years our shared interests in Latin American and pre-Columbian art make it impossible, not to say inappropriate, to lay individual claim to many of the ideas and arguments in the following pages. It has been a pleasure to work together.

Many, many people have helped to make this book possible. It has been a particular pleasure to have been able to work with Jean Franco. Her formative influence in the Latin American area programme at the University of Essex is something of which, as graduates of that university, we are very aware. Both directly and indirectly we owe her a great deal. James Dunkerley and John King have been unfailingly helpful and generous with their time. It is above all thanks to them, as well as to the enthusiasm and hard work of all the staff at Verso, that a disjointed manuscript has emerged as a book within a very tight time schedule. It is we, however, and not they who must take responsibility for the shortcomings of the final product. Our thanks, too, to Irma Arestizabal, Mark Axworthy, Maria Baddeley, Jorge Bernuy, Tim Butler, Ramsay Cameron, Nicola Coleby, Lucy Compton, Tania Costa Tribe, Jonathan Curling, Liliana Domínguez de Carvajal, Jan Fairley, José Gamarra, Dorothy Latsis, Patricia Ortiz Monasterio, Maureen Reid, Desmond Rochfort, Keith Robinson, Elisa Vargas Lugo, Vivian Schelling, Barry Woodcock, Carlos Zavaleta, and to everyone who so generously provided illustrations free of charge. By far our greatest debt is to Dawn Ades, colleague, friend and inspiration. Thank you.

On the day we finished the manuscript the Chilean people gave President Pinochet a resounding vote of no confidence. During the days preceding the referendum the artists had once again played their part, taking their art out on to the streets in support of the Vote No campaign. In the circumstances it seems only fitting to dedicate this book to the people of Chile.

INTRODUCTION

The term *Latin America* refers to the eighteen Spanish-speaking republics of the western hemisphere, together with Portuguese-speaking Brazil and French-speaking Haiti.[1] It was first used in France in the mid nineteenth century, at a time when to the north the United States were claiming the name *America* (its historical origins notwithstanding) for themselves. *Latin America* stuck and, short of reclaiming *America*, it is difficult to suggest a concise alternative. All we can do is remind ourselves that the origins of the term lie in the historical reality of southern European hegemony in Latin America, and that the most glaring exclusions of the term are, of course, the African and the indigenous American elements.

So, given the ambiguities of the term, what is Latin American art? Is it not arbitrary to group these countries together, dictatorships and democracies, rich and poor, regardless of racial or cultural mix? Can we, as Europeans who write from the outside, hope to say anything about Latin American art which is not at best an oversimplification and at worst a travesty? This is for others to judge, but it should be stressed our aim has been to explore the art from the point of view of areas of unequivocal common ground: the shared history of colonial oppression, its twentieth-century legacy of continuing

external interference and exploitation, and, in the face of all this, the persistent concern of Latin American creative artists to give authentic expression to their own voices, to locate their own cultural identity.

In his speech accepting the Nobel Prize for Literature in 1982 Gabriel García Márquez called on the Swedish Academy of Letters to recognize that his art is inseparable from what he called 'the monstrous reality' of Latin America.[2] He pointed to the way in which Europeans and North Americans are happy to credit Latin American writers with brilliance and originality while at the same time presuming that in the field of politics Latin Americans are incapable of devising forms of government appropriate to their own situations. This is where he locates the isolation, the solitude of Latin America. Our aim, perhaps ambitiously, has been to take up this challenge in relation to the visual arts: we would argue that the way to understand contemporary Latin American art must be to see it in the context of reality, the 'monstrous reality' of world politics. Yet this is only part of the problem. The international acclaim for Latin American literature to which García Márquez alludes is exceptional, even extraordinary. By far the greater part of contemporary Latin American art remains virtually unknown outside not only the continent but often its particular country of origin; and where it is discussed it continues to be considered as at best a fascinating excrescence on to the main body of Europe and North America, a benign growth (unlike politics) with some peculiar attributes all of its own, but with no real autonomy and certainly no possibilities of impact beyond its own boundaries. Typically, in his otherwise very useful *The Story of Modern Art*,[3] Norbert Lynton mentions only the three famous Mexicans – Rivera, Orozco and Siqueiros. Since it is his view that their propagandist intentions 'involved repudiating modernism', the reader is left with the sense that even the two paragraphs they are accorded are in the nature of a favour and that, strictly speaking, Lynton regards them as ineligible for inclusion. It is argued below that far from repudiating modernism the muralists, together with many other Latin American artists, have used modernism to their own ends, or have expropriated or subverted it to produce an alternative modernism better suited to a Latin American context. One of the recurring features of contemporary Latin American art is the way in which so many artists have experimented with the established categories and the subjects, forms and techniques of art not simply for the sake of novelty but as a part of a wider

challenge to the dominant cultural traditions of Europe and North America.

The themes which constitute the chapters of this book revolve around the history of Latin America and the 'monstrous reality' to which that history has given birth. These are the aspects of Latin America and Latin American art which interest us. The specifically *Latin American* features or qualities which can be identified in the work we discuss vary enormously. On the one hand, there are artists who work in a more or less representational mode, producing images with specifically Latin American themes, where the national or cultural signifiers are explicit. On the other, we include works of art which may have no more than a faint echo or evocation of, for example, the formal concerns of native American art or the texture of colonial paintings, but the recognition of these enhances our understanding and appreciation of the work concerned. And then again there are cases where perhaps it would be hard to identify any direct or indirect references to Latin America but where to view them as other than self-consciously Latin American would be to miss the point, as, for example, where the forms or techniques used are intended to be seen as in opposition to those of Europe or the United States. We have included within our definition of Latin American art the work of artists who have chosen to live abroad but for whom Latin America remains one of their central reference points, and others who are not Latin American by birth but who have made it their home. Because our interests are concentrated around the *Latin American* features of Latin American art, or the essentially Latin American issues which it raises, we have tended to exclude works which, for example, take the processes of composition and construction as their only subject matter. Since such purely reflexive abstract art deliberately avoids specificity it cannot be illuminated by being considered within a Latin American context. This is not to say that such art may not embody certain values, but these tend to be the values of the schools of New York or Paris, and of international capitalism. The most famous of the Venezuelan kineticists, Jesús Rafael Soto (born 1923), was recently commissioned by Air France to produce a work to illustrate its international advertising campaign, *The Fine Art of Flying*. The result, *Linear Movement*, consists of a number of blue, white and red lines (the colours of the French flag and of Air France) set diagonally against a background of black and white stripes so as to create optical vibrations and spatial illusions. The accompanying advertising copy said that

'his work, exploring matter, space and their relationship with time, is on permanent exhibition in many museums around the world'. This is not the art nor are these the values that interest us here.

The 'Drawing the Line' of our title is intended to suggest a range of different but converging meanings, ideas of mapping, defining and limiting as they relate to Latin America. Our overall aim is to introduce to a wider audience what we consider to be among the most interesting trends in contemporary Latin American art, to map out a territory virtually unknown outside Latin America. In so doing we have envisaged a metaphorical boundary line between Latin American art and that of elsewhere. It has seemed to us essential to avoid incorporating contemporary Latin American art into the art historical discourses of Europe and North America: to do so is inevitably to perpetuate a view of Latin American art as a sort of cul-de-sac, branching off from the main creative highway and leading nowhere.

The way in which developments in Latin American art have been repeatedly marginalized is the product of an attitude that is not restricted to art criticism; it is but an aspect of the self-satisfied superiority which could enable the US Secretary for Education William J. Bennet to say recently, 'The West is the culture in which we live. It has set the moral, political, economic and social standards for the rest of the world.'[4] The same attitude can be traced back through the history of the Western imperial powers, from the British Empire back to the Roman via – crucially for Latin America – the Spanish and Portuguese Empires. This patronizing stance is deeply embedded in the iconography of Latin America, and links in with the imagery of America as a New World. Latin America is here the wayward offspring, youthful and immature, in need, especially on questions of politics, of parental guidance and discipline. In the field of culture, Europe, the Old World, can readily assume the image of the mother to whom her children turn when in need of nourishment. If adult, Latin America's image is that of the receptive woman, its unexplored riches and potential simply waiting to be enjoyed, exploited or controlled. Latin America has been repeatedly discovered and rediscovered, interpreted, classified and expropriated by others. Within the history of art the prime example is André Breton who staked a claim to the discovery of Latin America as the Surrealist Continent, and proceeded to classify Latin American artists such as Kahlo, Matta, Gironella and the photographer Nacho López, as 'natural' surrealists, innocent and unself-

conscious. When, however, Matta laid claim to conscious, independent thought, Breton expelled him from the movement. When in 1983 Grenada was plunged into chaos by the assassination of Maurice Bishop, the United States took the opportunity to invade and take the island over. They are very different events but, ultimately, they are rooted in the same set of values and assumptions.

Educated Latin Americans, whether or not they are of European descent, have themselves inherited much of the culture and many of the values of what is now so oddly termed the West. The problem can perhaps be exemplified by the ambivalence surrounding this term, because Latin America can be included within some definitions of the West, although not, of course, in that of William J. Bennet. To deny this European heritage would be to falsify history. Yet to espouse it wholeheartedly is to accept, within its own terms, second-class citizenship. The works of art on which we concentrate in this study repeatedly demonstrate an awareness of these contradictions, of the way in which history permeates the present, of the need to confront and challenge and where appropriate to reuse alien values, and of the need to draw on other home-grown sources of inspiration. Our approach has been to explore a number of recurrent themes in contemporary Latin American art in the light of the work of comparatively few artists.

Chapter 1 discusses cultural identity and the sense of place and of roots. The landscape and the people, especially the jungles, the mountains and Indians, real or imagined, past or present, offer artists sources of inspiration that are unequivocably Latin American. The specificity of much Latin American painting in this field is not a manifestation of limited or provincial vision, but of an insistent reality. Any serious consideration of either the physical geography of Latin America or its ethnic and cultural diversity almost inevitably leads to a consideration of political, economic or social issues, as well as to the historical origins of the persistent tensions and conflicts within these areas. Chapter 2 focuses on another central aspect of the question of roots: the historical and art historical legacies of Europe. The colonial past cannot simply be wished away any more than can, for example, the power of Velázquez's paintings or the pervasive influence of the Catholic Church. These are all to be found in various forms, transmuted or subverted, as recurrent themes in Latin American art.

The Mexican muralists, Rivera, Orozco and Siqueiros, raised a number of questions about content, style, technique, authorship and audience, which have tended to set

the parameters for Latin American art ever since. They therefore form a useful bridge between the general issues of geography and history and more specific aspects of the relationship between contemporary Latin American art and that of Europe and the United States. Chapter 3 then continues with a discussion of more recent Latin American art and the way different artists have continued to seek solutions to these questions. The absence of information on contemporary Latin American art must to a large extent derive from the way in which these various solutions, in not conforming neatly to the established view of modern art, have in turn served to justify their continuing exclusion from serious consideration outside Latin America.

Chapter 4 considers the question of Surrealism. In its deliberate challenge to the established values of both art and society, Surrealism, more than any of the other -isms of the twentieth century, has provided many Latin American artists with an attractive framework within which to work. The question of the search for cultural identity, for roots and a sense of authenticity is again the central theme of the final chapter. The argument focuses on the relationship between Latin America's strong traditions of popular and non-European art and the high art of the galleries and the professional artists. There is a considerable cross-over between the two: the high art tradition has borrowed liberally from popular and indigenous or Afro-American artists, but the latter are often not untouched by or unaware of developments in avant-garde art.

Some subjects inevitably recur in several different contexts: the artistic and cultural traditions of pre-Columbian America, for example, are repeatedly invoked in the forms and techniques as well as in the content of much contemporary art. Myth as subject and substance, myths old and familiar, or newly created out of the contradictions of the 'monstrous reality' recur throughout the following pages. José Gamarra's work will be discussed in more detail below but his *St George and the Gorilla* (1979) will serve as an example. A serene St George on a Uccello-like white horse kills the gorilla/guerrilla in the foreground on the edge of an unseen forest. The dividing line between civilization and barbarism is in itself a theme that cuts across those of the different chapters, as are those of race and of religion. *St George and the Gorilla* also illustrates another persistent image of pre-Columbian, colonial and modern Latin America alike: danger, violence and the proximity of bloody death. Numerous examples of violence both explicit and implicit will be found amongst the works discussed in the

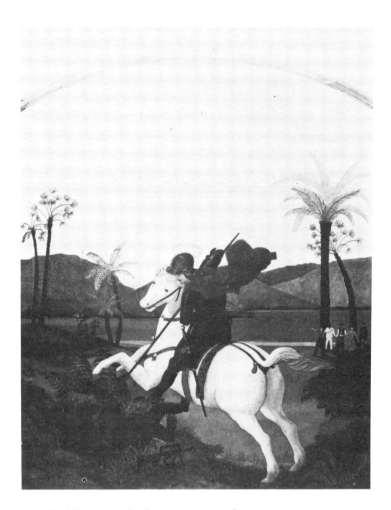

FIG. 1 **JOSÉ GAMARRA, *ST GEORGE AND THE GORILLA*,** 1979

pages below. In his painting *El duelo/The Duel*, 1984 [Plate 1], the Argentinian Luis Benedit (born 1937) exaggerates the sense of aggression by applying a series of three-dimensional knives around the edges of the panel all pointing inwards to the duelling protagonists. In his combination of paint and applied objects Benedit is representative of another recurrent theme in contemporary Latin American art – that of the popularity of collage and mixed media works, especially, although this is not the case with the Benedit, using refuse. In Latin America the left-overs of modern industrialized society, bottle tops, tin cans, rags, scrap metal, paper and cardboard, carry special

resonances when used by artists working within the traditions of high art because of the way these materials are so often re-used within mass culture. In Mexico old tin cans are fashioned into dainty ornaments, in Chile scraps of cloth are used to make patchwork pictures; car tyres can be turned into sandals, cardboard boxes into houses; many people survive by scaveng-ing on rubbish tips. In this context artists who incorporate such materials into their works cannot intend them to be value-free. There exists another trend which is so pervasive that it is tempting to see it as in deliberate opposition to the collages of rubbish. Here the traditional technique of oil on canvas can be seen to be being used very self-consciously, often deliberately parodying the idea of an Old Master by creating an impression of great age, of craquelure and layers of dirty varnishes, or of paint surfaces that have been abraded over time by misuse and over-cleaning. There is a nice irony in the idea of producing an Old Master in the New World, where the one is not old and the other not new.

If there are numerous other possible themes and ideas around which to structure a view of Latin American art, how much more true this is of the artists on whom we could have chosen to concentrate. To accord certain artists paradig-matic status in the way we have done in the following pages, and to use their works to exemplify aspects of the different themes, has inevitably involved some difficult decisions. The only possible alternative would have been to have referred in less detail to the work of many more artists, but this would inevitably have reduced the cogency of the individual chapters. This too is the reasoning behind our concentration on painting and collage, and to a lesser extent on sculpture and mixed-media installations, at the expense of graphics, photography, 'happenings' and the like, and of course of architecture. We therefore make no claims to comprehensiveness: our intention has been to provide a framework for further research, a series of pointers to what we believe are the more important concerns of contemporary art in Latin America.

CHAPTER 1
MAPPING LANDSCAPES

O ne would have thought that the landscape of the South American subcontinent offered enough scope to have inspired any number of great schools of landscape painting. Vast savannahs, gigantic snow-covered peaks and mountain ranges, volcanoes, waterfalls, jungle, desert, mangrove swamps, plenty of variety of coastline, islands, vegetation, colours and lighting effects; what more could an aspiring artist ask for? And yet there have been very few for whom the landscape itself, rather than a land that is populated and eventful, has been the central concern. Particularly surprising, perhaps, given that the need to forge some sort of distinctive national or continental identity was felt so strongly at the end of the nineteenth century when the Impressionist movement of Europe was at its height, there was no equivalent school anywhere in Latin America, nor has there been subsequently. Artists seem not, on the whole, to have been bewitched by the desire to capture in paint the transient effects of light and shadow on this stunningly beautiful and varied continent. The reasons for this are not of course that Latin American artists are insensitive to their landscape but that, as in other areas of contemporary Latin American art, the *l'art pour l'art* ethos of the Impressionists and subsequent European movements is inappropriate, often un-imaginable within the Latin American context. To think of the

landscape of Latin America purely in terms of the visual effects of light, shade and colour is to ignore the greater part of it: any consideration of the land is charged above all with questions of occupation, ownership and use, of appropriation, expropriation, exploitation and control.

The history of European ideas about content and subject matter is important for an understanding of the ways in which contemporary Latin American art has tended to be seen as marginal to the mainstream of modern art. Within the European hierarchy of genres established by the art theorists of Italy in the fifteenth and sixteenth centuries, landscape painting, portraiture or still life were of less significance than history painting. A history painting was understood to mean a painting of a group of people whose actions and interactions told a story which ideally should be morally uplifting to the beholder. 'History' was originally taken to mean subjects from the distant past, from the Bible or from classical history and mythology, but in the eighteenth century, especially under the impetus of politically motivated artists such as Hogarth, Goya and David, the genre came to include contemporary people and events. The relative inferiority of landscape painting was, theoretically at least, because of the lack of people, or at least of people actively engaged in doing anything that would interest or improve the spectator. In practice, of course, the tidy boundaries between the different genres were never very strictly respected, but the important point about any such theoretical framework is that it exists in the minds of an intellectual elite and can be taken up and revitalized at any moment. Within the traditional theories landscape and still life were considered categories of paintings without content, in other words without moral or intellectual content.

When the hegemony of such a view was challenged by artists and theorists in the later nineteenth century it was not replaced with arguments in favour of meaningful landscapes; on the contrary, it was their very meaninglessness which was prized. Here was a truer, purer, exclusively visual art form, where the skill of the artist and the true beauties of the formal values could be appreciated unhindered. This search for an exclusive and absolute art has preoccupied successive generations of artists in Europe and North America. In Latin America, however, the pursuit of a self-referential, inward-looking art has never had the same attraction. Indeed the majority of artists seem to survive very successfully without worrying about whether there could or should be such a thing. Life and art are too closely bound up, the experience of reality too urgent and omnipresent to be ignored or avoided or wished away. For the most part paintings have subjects, mean-

ingful subjects. As the contemporary Nicaraguan artist Efrén Medina puts it, pure abstraction has no soul.[1] Landscapes, whether or not they are populated, are about land and land use, space, frontiers, boundaries, territories. This is a fact, not an intellectual problem. In this sense, contemporary landscape painting in Latin America is closer to that of eighteenth-century English artists such as Gainsborough, Wilson or Constable than to most European and North American landscape artists of the last hundred or so years. To paint the English countryside at the time of the Enclosures Act and the so-called Agricultural Revolution was an arena of acute political sensibilities. Meaning, in such a context, is unavoidable. Even the absence of signs of enclosure, of fields, fences or gates, as in many of Gainsborough's views of Suffolk, is a statement about the landscape because it no longer represented the reality of the land nor of the dispossessed peasants who drift through it.[2] These are landscape paintings, but they tell a story; the traditional genres of landscape and history are, to all intents and purposes, blurred. The situation in Latin America today is similar: it is impossible to divorce the art from the reality, the landscape from its history.

It is the history of the place which constitutes the essential ingredient in the lived and perceived reality of Latin America, and this is what, in different ways, makes contemporary landscape painting in Latin America so interesting. How, indeed, would it be possible to paint pictures of the land without at some level being aware that many of the major political upheavals in Latin America in the last thirty years have been about land, and about the claims of different groups to its use? How could one be unaware that at the top of the agenda for so many incoming governments is still the problem of land reform? How could one be unaware of debates about mineral rights and access to the subsoil of agricultural land, or of the shanty towns which continue to proliferate around so many Latin American cities; shanty towns created by peoples who, having been forced (by human intervention as often as natural causes) to leave their rural lands, then lay claim to a patch of mud or dust in the shadow of urban wealth? Whether it be between the Aztec and Inca and their tributaries, the Spanish lords and the conquered Indians, Nestlé and the farming co-operative, or transnational firms and the peoples of the Amazonian rain forests, the landscape of Latin America has been and continues to be the scene of bitter tensions, conflicting interests and terrible loss of life.

Latin America – the place, the culture, the people – provides artists with endless subjects for pictures which are not only *of* Latin America but also *about* Latin America. Another

crucial factor, however, is the existence of a powerful imagery of America within European art, an imagery in which America is represented as essentially other.[3] Latin America has been re-peatedly discovered and rediscovered by Europeans and, more recently, by North Americans. Different generations discover different facets, but generally speaking new discoveries do not simply replace the old; they are added to the ever-growing pile of data, facts, impressions and fantasies, which go to make up the outsider's view of Latin America. Whether they like it or not, these five centuries of accretions to the image of the Latin American continent are a part of the inescapable legacy of conquest and colonization with which Latin American artists have to come to terms. While the Spanish conquerors discovered gold and pagans, European artists discovered (almost always from hearsay rather than from personal travel and experience) savages, both noble and living in a classical Golden Age, and ignoble, living like beasts and eating human flesh, all equally naked save for a few feathers. These early stereotypes persisted alongside successive new categories of American visual imagery. The newly discovered continent was soon to provide European artists with material for new sections in the books of costume and of flora and fauna so popular in the later sixteenth and seventeenth centuries where some sort of documentary accuracy was expected, but at the same time it offered a source for ever more exotic painted ceilings or allegorical portraits, or for designs for masques, operas and plays. The Dutch artist Albert Eckhout, for example, working in Brazil in the 1640s, painted the fruits, plants and vegetables and the inhabitants with an unusual degree of attention to botanical and ethnographic detail, while in the same period in England Inigo Jones was using the idea of America and the American Indians as an excuse for pure fantasy, producing weird and wonderful costumes and sets for masques by William Davenant and Ben Jonson. These constitute perhaps the two main threads of the America of the European imagination: the one that is real or at least taken to be real, and one that is the springboard for fantasy, with the native inhabitants slotted into either the reality or the myth alongside the animals and plants. The attraction of it all is the exotic difference from things European.

In the eighteenth century the marvels of America were rediscovered by the scientists Humboldt and Bonpland. 'What a fabulous and extravagant country we're in!' wrote Humboldt to his brother in 1799, 'Fantastic plants, electric eels, armadillos, monkeys, parrots: and many, many real, half-savage Indians.'[4] Humboldt himself was not an accomplished

artist and regretted it, being well aware of the potential America offered for both science and the arts, but the illustrations to his books were produced from his own sketches and under his careful supervision. The intention of most earlier artists, even conscientious artists like Eckhout, had been principally to entertain their patrons, or, as in the case of the engravings by De Bry depicting the cruelty of the Spaniards towards the Indians, to grind an anti-Catholic axe. A few artists had represented particular aspects of the natural world that might be of benefit to colonists, the plants, fish and so on, as the Englishman John White had done for Virginia at the end of the sixteenth century. However, Humboldt's intention was much more ambitious and far-reaching. He set out to record and categorize on a hitherto unknown scale with the view that enterprising Europeans might benefit from a greater knowledge of the enormous natural resources of South America. It was in the many volumes on the flora, fauna, geology and peoples of South America which Humboldt published as a result of his travels and investigations that what may be called the first views of the American landscape were to appear – coastlines, rivers, forests and volcanoes; all, to his European audiences, fascinatingly new and different and full of potential.

Suddenly European rulers seemed willing, even anxious, to fund artists to travel to Latin America, and from the beginning of the nineteenth century numerous artists crossed the Atlantic in search of exciting new landscapes, many with the encouragement or patronage of Humboldt himself. Perhaps the greatest of these, the German J.M. Rugendas, first went to Brazil in 1821 at the age of nineteen on an expedition with the Russian Consul-General; he was to spend most of the rest of his life travelling throughout Mexico, Central and South America, in a frenzy of excitement, discovering new subjects, new types of landscape and new peoples with colourful costumes and colourful customs. His countryman Bellerman painted a Venezuela where the natural landscape is untameable and overpowering, while the French Debret and the Austrian Thomas Ender worked in Brazil in the early nineteenth century producing views of peaceful rivers and orderly estates.

Another wave of discoveries followed in the middle of the century with the archaeological expeditions of men like Catherwood, Stephens and Maudslay in the Yucatan. Catherwood's lithographs and aquatints of the Mayan ruins and fallen stelae evoke a lost civilization, dignified and mysterious, overwhelmed by time and the forces of nature. He often included some of the local inhabitants of the region in his

illustrations of the pre-Columbian remains, but, in much the same way as Piranesi had included shepherds amongst his etchings of the ruins of ancient Rome in the previous century, these modern Maya are depicted as simple peasants, uncomprehending of and unconnected with the grand architecture in the shadow of which they relax. In Maudslay's photographs of the ruins of Tikal, Quirigua, Palenque and Copán the Indians are not even accorded this cheerful sociability; they frequently sit in a corner, hunched and alone, while the European archaeologist stands proud and in full sunlight. It is he, not the Indian, who can recognize and understand the full significance of the ruins; it is he who has discovered them. Meanwhile, the wonders of Latin America, natural, ethnological and archaeological, were displayed in the international exhibitions of Paris and London, providing less adventurous artists with material for pictures of a more or less exotic nature. Latin America was becoming a refreshing substitute for the well-worn imagery of that other other, the Orient. The search for new sources of artistic inspiration amongst European artists is exemplified by Gauguin who, encouraged by memories of his childhood in Peru, travelled to Martinique in 1887 but soon moved on to Tahiti in pursuit of his ideal of a pure and simple savagery. The culmination of the European myth of the tropical utopia of America lies with Henri 'Le Douanier' Rousseau who fabricated a ten-year residence in Mexico in order to lend an aura of authenticity to his glorious visions of succulent plants, exotic animals and feathered Indians. More recently the image of the jungle has exercised a particular fascination for Western film directors, offering as it does opportunities for showing young girls, naked but natural, rushing through luscious undergrowth and between gigantic phallic trees.[5] All this wealth of imagery, both the more or less scientific and the more or less mythical, which has been accumulated by and for Europeans over the centuries, all this constitutes the context in which Latin American artists have had to try and construct an art of their own.

In the search for roots the land and what it contains is an obvious starting point, but if all the distinctly Latin American features – the mountains, the jungle, the Indians – had already been appropriated by Europeans and incorporated into their own artistic traditions, then how could they be repossessed? It was above all the Indians who posed the most acute problems. The Spanish conquest (the case in Brazil was rather different) involved the formation of a society in which the Spaniards and creoles lived in the towns and cities,

the Indians in the countryside. The conquerors had appropriated existing urban centres and superimposed their own grid-plan towns on to the foundations of pre-Columbian temples and palaces, gradually forcing the native inhabitants out.[6] Within the traditional European perspective, to be civilized is predicated upon living in towns, so that one of the direct results of colonization was effectively to de-civilize the Indians. How, therefore, could artists of European or mestizo blood, born and educated in cities, avoid treating the American landscape and the indigenous inhabitants as other, as something exotic and different in just the same way as European artists did? The starting point for Latin American artists in the nineteenth century was very different from that of their European contemporaries. They lived in the landscape and alongside the Indians, lumped together into the general categories of foreign and exotic; yet they themselves had inherited the urban= creole=civilized versus rural=Indian=primitive dichotomy. Thus, even to consider Indians as a suitable subject for a painting was an advance on the traditional creole racism, whereby all Indians were beneath contempt. It was precisely because the Indians, however alien they often seemed, could not be categorized simply as 'other' in the same way as for Europeans that the appreciation of them, of their history and their culture by their own countrymen was both so difficult and so important. The voyages of discovery of urban Latin Americans into the rural areas of their own countries have been crucial in establishing a sense of place and of national pride. In many countries, outside the main cities, the past greatness and continuing existence of Indian culture cannot be ignored, especially in Peru where it is currently challenging the hegemony of the urban ruling classes. In Argentina, however, where the Indian presence is now minimal, it is significant that many Argentinians are quick to say that there never were many Indians and that those there were were very primitive, even though recent archaeological evidence demonstrates neither of these to have been the case: it is easier to deny that there ever was an alternative culture.

The first great painter of the Latin American landscape was the Mexican José María Velasco (1840–1912).[7] Despite his broad vistas Velasco's paintings have an intimate quality that is born of familiarity and love. His paintings of the Valley of Mexico – the snow-capped volcanic peaks of Popocatépetl and Ixtaccíhuatl on the horizon, the ahuehuete trees, maguey and prickly pears in the foreground, with the city, the lake or the dusty plains between – proudly affirm that

Mexico is beautiful and grand, not wild and exotic. A few small figures can sometimes be seen walking along a track or gathered in front of a church, but they are not the subject of his pictures; their racial origins can often only be guessed at. What matters is that they are Mexicans in a Mexican landscape. The muralists and their generation, however, tended not to be painters of landscape so much as of the fruits of the land, the people of the land, allegories of the land.[8] Olga Costa's *Vendedora de frutas/The Fruit Seller*, 1951 [Plate 2], displays basket upon basket of carefully arranged fruits, nuts and squashes, many of them cut open to reveal their soft, colourful flesh, a powerful evocation of the fecundity of the Mexican earth. Rivera's central subject matter was Mexico, past, present and future, and its people: Indians, mestizos and creoles, peasants, soldiers, industrial workers, bourgeoisie, clerics, drunks and whores. Antonio Ruiz (1897–1964) explored the complexity of Mexico's history in a complex allegorical landscape called *El sueño de la Malinche/Malinche's Dream*, 1932.

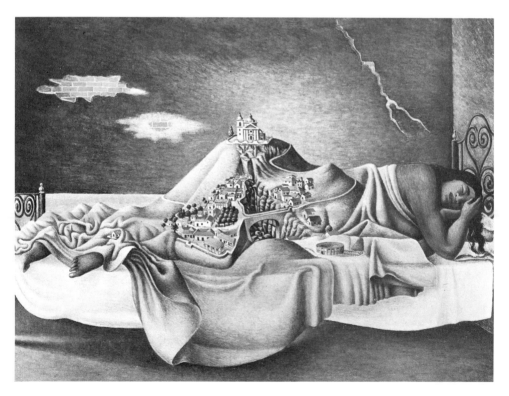

FIG. 2 **ANTONIO RUIZ, *EL SUEÑO DE LA MALINCHE/MALINCHE'S DREAM*, 1932**

The Indian woman Malinche, mistress of Cortéz, acted as an interpreter and ambassador for the invading Spanish; she betrayed her people but in so doing she gave birth to modern Mexico. She lies on her side, her body transformed into a hilly landscape. On the highest hill, formed by her exaggerated hip, is the church, and below it is a colonial town. A dry rocky chasm divides the larger, walled part of the town (where in the colonial period the ruling creoles would have lived) from the smaller, less orderly part which traditionally would have been an Indian settlement, but they are linked together by a stone bridge. The source of the chasm is in effect the church which dominates everything, while the bull ring, which lies outside and below the divided town, is common ground: here the two cultures can come together without the need of carefully constructed bridges. Frida Kahlo maps a different Mexican landscape again; hers is a very personal, biological sense of place and of the life-giving power of the soil. She repeatedly painted herself rooted into the earth, nurtured by the soil of Mexico, or, across racial and temporal boundaries, by the life-giving milk of the ancient Mexican past. This idea of shared telluric influences has provided many Latin Americans with an acceptable solution to the problem of cultural and national identity. In many different countries artists have found comfort and inspiration from the idea that, whatever the differences of blood or culture or education, the one thing which the members of a particular nation all inescapably have in common is the land beneath their feet, the air they breathe, the atmosphere they inhabit.

It is but a short step from this to a new appreciation of indigenous culture as representative of the natural, the original efflorescence of the land. In Peru several artists born at the beginning of this century have chosen Indians and Indian culture as their central subject matter. Their forerunner was the remarkable and isolated figure of Francisco Laso (1823–69) for whom painting and politics were closely linked. His *El Indio Alfarero/The Indian Potter*, c.1855 (Museo Nacional de Arte, Lima), has a powerful dignity: the young man holds a piece of anthropomorphic pottery from the Moche culture of about AD 500, and in his own head there are echoes of the Moche ceramic portrait heads. But the figure depicted on the pot has a rope around his neck; he is a slave or a prisoner of war.[9] Laso's reunification of contemporary Indians with their ancient past was exceptionally enlightened. The subsequent *indigenista* school of painting in Peru concentrated on the living traditions of the Andean peoples: there are few references even

to the relatively recent Inca past. Apurimak (1900–1984), Jorge Vinatea Reinoso (1900–1931), Camilo Blas (1903–84) and Enrique Camino Brent (1909–60) followed José Sabogal (1888–1956) in painting densely populated highland landscapes.[10] It is significant that most of these artists were born outside Lima which, as the capital, is by far the most Europeanized of the country's cities. One of the most interesting, Apurimak, was born Alejandro González Trujillo in Abancay but chose to proclaim his pure Indian blood by changing his name to that of the famous river, the scene of bitter fighting between the conquistadors and the Incas in the sixteenth century. In Quechua *apurimaq* means 'the great leader who speaks' and Apurimak spoke through his paintings for the Indians of the

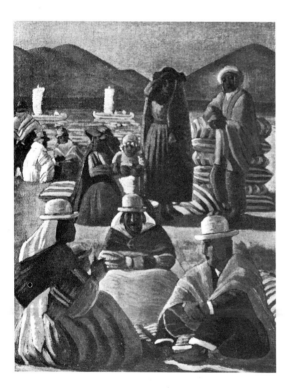

sierra. He uses rich, dark colours that evoke rather than imitate the vividness which colours have in the thin clear atmosphere of the high Andes, and his compositions are rigorous and formal. Seated on the ground, the women with their full skirts spread around them and the men draped in their ponchos seem part of the landscape itself like the ubiquitous mountains behind. These strong, solid figures have nothing of the prettily picturesque or quaint about them; although compositionally they are reminiscent of Gauguin, they have none of his dreamy idealism.

FIG. 3 **APURIMAK, *PUNO*, 1934**

In Brazil, where the questions of national and cultural identity revolve around the place not just of the Indian but also of the African within national culture, the early work of Tarsila do Amaral (1886–1973) is of central importance. It was while in Paris in the early 1920s that she and her long-term companion the poet Oswald de Andrade awoke to the possibilities of the so-called primitive art of their own country as a source of inspiration.[11] They returned to Brazil in 1923 and set out to discover and rediscover their own land and its

culture: the landscape and the vegetation, the architecture of the colonial past, popular Catholicism with its colourful festivals, Afro-Brazilian rituals and traditions, in fact all those aspects of popular culture, the loud colours and crude energy, which educated Brazilians (including Amaral herself) were brought up to despise as in poor taste. She began to paint landscapes, classically organized in successive plains across the surface of the canvas, but with bold, simple objects from contemporary Brazilian reality – fruits and vegetables, streets, houses, churches and factories – in the bright colours of popular art. She also created strange mythologies with eggs, snakes and exotic plants suggesting the fertility of the Brazilian earth and began to use titles from the Tupi-Guarani language to evoke indigenous Indian traditions.

Her most important painting of this period is *Abaporu* of 1928. On a small hillock, beside a cactus and beneath a blazing sun, sits a monumental figure with a diminutive head like a little sprout leaning towards the sun and with one gigantic foot: a strong, physical being, rooted into the Brazilian soil. This is an imaginative descendant of the sciapods, one of the monstrous races of classical and medieval legend.[12] The sciapod, who is said to use its single foot to shelter from the sun and the rain, is found in Pliny's *Natural*

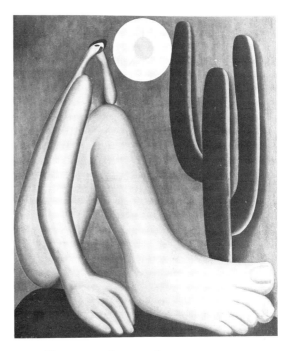

FIG. 4 **TARSILA DO AMARAL**, *ABAPORU*, 1928

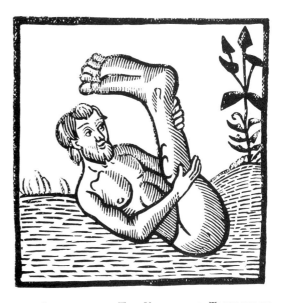

FIG. 5 **SCIAPOD FROM** *THE VOIAGE AND TRAVAILE OF SIR JOHN MAUNDEVILLE*, LONDON 1725

History and Sir John Mandeville's *Travels* alongside the people with ears so large they used them like cloaks to keep out the cold, the people with eyes in their chests, and the anthropophagi, the man-eaters, who were morally rather than physically deformed. These monstrous races had traditionally peopled the unknown world beyond the Mediterranean, and in the years following Columbus's first voyages to America travellers repeat stories of similar monstrous races who are to be found further on, in the next valley, or over the next range of mountains but whom (of course) the writer never actually sees. They always inhabit the world immediately beyond reality. Amaral's imagination was evidently moving around such sources because shortly afterwards she produced a painting entitled *Antropofagia/Cannibalism* (private collection, São Paolo, 1929) where two similarly monumental-monstrous figures sit in front of a backdrop of gigantic cacti and banana leaves. Cannibals were supposedly discovered by Europeans in several different parts of America, but the imagery of cannibalism is especially strong in relation to the native inhabitants of Brazil. From the very beginning of the sixteenth century numerous popular prints had circulated in Europe showing the Indians of the Brazilian coast gnawing on large arms, or turning fleshy legs on a spit over a fire. This is the imagery, along with that of the bold woodcuts of the sciapods from Mandeville's *Travels*, which informs Tarsila do Amaral's extraordinary paintings.

In European terms cannibalism represented the absolute antithesis of morality and civility. In a great imaginative leap Amaral, Oswald de Andrade and their circle appropriated this Eurocentric concept and turned it on its head to mean something positive and unequivocally Brazilian. It was Andrade who gave Amaral's painting the title *Abaporu*, a Tupi-Guaraní word meaning 'the one who eats', and shortly afterwards he launched the *Antropofagia* movement with a 'Cannibalist Manifesto' proclaiming that the way forward to a new genuinely national culture was not by ignoring or turning one's back on the European past but by deliberately, aggressively, consuming it like food, digesting it and producing out of it something fresh and independent. This, after all, was no more than the Europeans had done with America for centuries.

The solution of Teresa D'Amico (1914–65) to the problem of creating original *Brazilian* art was very different.[13] Her meticulous little maps and bird's-eye views are collages using beans, seeds, bones and shells; she creates representations

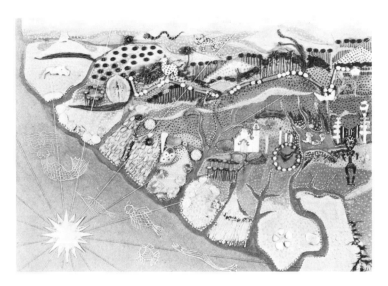

FIG 6 **TERESA D'AMICO, *PAISAGEM ENCANTADA/ENCHANTED
LANDSCAPE,*** 1963

of the land out of its very produce. *Paisagem encantada/Enchanted
Landscape*, 1963, is a view of a coastline which echoes the
mixture of fact and fancy of the European map-makers at the
time of the conquest and colonization of Brazil, except that
here the figures that frolic in the water are not the sea gods and
mermaids of classical antiquity but the deities of Afro-Brazilian
popular culture, including the two water goddesses, Oxun,
goddess of life, of lakes and springs, and Iemanja, goddess of
the sea and of death. On land is Xangu, also of Nigerian
origins, while beside him, representing Christianity, is the
whitewashed façade of a little rococo church. The fruitfulness
of the earth and the fruitfulness of the combinations of different
cultures are all interlinked, part of the same world.

Another important but very different figure in the
recent painting of Brazil is that of Candido Portinari (1903–62).[14]
Portinari painted the poor and the dispossessed, haggard and
weak, with the staring eyes and distended stomachs of the
malnourished. This is not the America of myth and allegory, of
fruitfulness and plenty, but a barren land of earth and rocks and
hunger. In his *Série dos retirantes/The Refugees Series*, 1944, three
paintings showing the effects of drought on the peoples of the
north-eastern region of Brazil, the figures stand against a hard
blue sky and fragments of arid empty landscape. They are

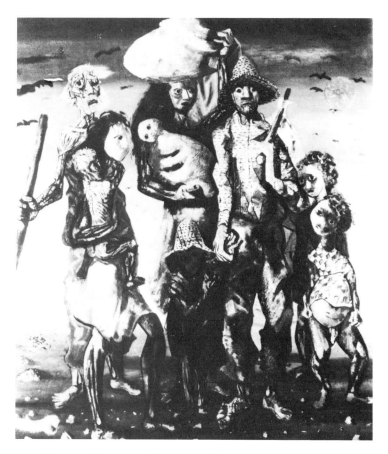

FIG. 7 CANDIDO PORTINARI, *RETIRANTES/REFUGEES*, 1944

almost colourless compared with the landscape behind, their
limbs black and white, like skeletons, their garments of pale
greyish blues and pinks, and sometimes flecked with black so
that their bodies suggest newsprint: bones and scraps of
newspaper blowing about in the dust. It is impossible not to
see the religious echoes of these paintings. The painting of the
series title, *Retirantes*, shows a whole family fleeing from the
drought, recalling the Flight into Egypt, although the landscape
itself is more like that of Calvary. *Criança morta/Dead Child*
shows a pathetically skinny child draped across its mother's
knees with other members of the family standing weeping on
either side, an unmistakable reference to the Lamentation over
the Dead Christ, and in *Entêrro na rêde/Burial in a Net*, where
two men carry a dead body slung in a cloth on a pole between
them, the woman kneeling in the centre foreground, her arms

outstretched and her head flung back, is in the characteristic pose of the Magdalen at the foot of the cross. Portinari was a socialist for whom the formalist concerns of modernism in Europe and the United States were irrelevant. Yet in common with other Latin American artists who have painted the unacceptable social realities of their times – the Ecuadorian Oswaldo Guayasamín (born 1919), for example – his work has sometimes been skirted over or excused, as if the content were a sort of aberration in an otherwise talented artist.[15] In Brazil today Portinari's imagery is still sharply real and meaningful. The Grande Carajás programme has already dispossessed some 40,000 people to make way for the Tucuruí reservoir, and the aluminium plant, railway terminal and port on the island of São Luís.[16]

This is the reverse of the tropical paradise, but the reality is that the destruction of the paradise of the Amazonian rain forests creates precisely the barren waste lands of Portinari's paintings. As the Amazonian jungle attracts the rich and the powerful it disappears, but so, too, its fascination increases. The last of the great wildernesses not only of Latin America but of the world, it grips both artistic and entrepreneurial imaginations and within the last few years the destruction of the Amazonian rain forest has become a matter of urgent global concern.

Maria Thereza Negreiros was born in Brazil in 1930 in the town of Maués on a tributary of the Amazon and now lives in Colombia. 'I am an Amazonian,' she says, 'and I paint this region because I am sure it is going to disappear.'[17] Working in oil on canvas, she paints the forest on fire and creates the most dramatic, vivid combinations of green, red, black and purple. In *The Fires* of 1982, for example, it is as if the sky is a wall of dark red flames, a latter-day version of Dante's hell. The self-educated Brazilian José Antonio da Silva (born 1909), has repeatedly painted pictures of a land that has only just ceased to be jungle: acres of cotton or corn, reservoirs, huge herds of cattle, and everywhere there are the black stumps of burned trees. The changing face of the Brazilian landscape is also the subject of installations that combine photography with free-standing sculpture by the Polish-born Frans Krajcberg (born 1921). His stark black and white photographs depict the forest, burnt and empty, a smoking ruin, where charred trees stand like black skeletons. This close focus on the devastation of the natural environment is teamed with structures which evoke the culture of the peoples of the Amazon: strange combinations of wood and

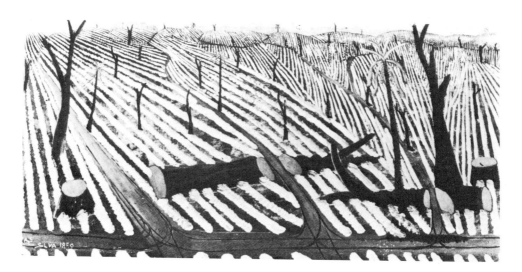

FIG. 8 JOSÉ ANTONIO DA SILVA, *ALGODOAL/COTTON FIELDS*, 1950

coloured yarns suggesting complex rituals designed to maintain
the balance betwen human beings and the forces of nature
[see Fig. 56]. Krajcberg juxtaposes human creativity with
human destruction but the format of the installations, where
the photographs are ranged around the walls of a room or
enclosed space and the sculptures are placed in the middle,
gives the overall impression that the forces of destruction are
closing in.

José Gamarra is an artist who combines an ideal
image of the tropical Latin American landscape with an acute
awareness of the irony of the parallel history of conquest,
colonization and exploitation.[18] Born in Uruguay in 1934, he
has lived and worked in Paris since 1963, and it is perhaps this
absence which makes his vision so sharp. From this perspective
the issues are clear and his representation of them meaningful
to outsiders and insiders alike. Gamarra epitomizes the way in
which landscape painting in Latin America has to be history
painting. The genres are inseparable, but for Gamarra this is
not to deny the European traditions of painting; in many ways
he could be regarded as a startlingly traditional painter. He
works predominantly in oil on canvas using a painstakingly
intricate technique. Gamarra's preferred subject is not the
grassy plains of his native Uruguay but a vision of the tropical
utopia which explorer-writers like Christopher Columbus, Jean
de Léry and Sir Walter Raleigh established in European
consciousness in the sixteenth century. His is a jungle of the

imagination, fantastic and mysterious, with gigantic trees and exotic birds, but within this jungle are tiny figures; often he includes a tiny incident which is always disturbingly real and sometimes discordantly violent in the otherwise mythical world. The scale of his paintings – usually 150 cm × 150 cm or 200 cm × 200 cm – is large given the amount of detail, but the square format sets them firmly apart from the more traditional rectangular landscape views. This square canvas shape emphasizes the size of the trees, lianas and stranglers which limit or even eliminate the horizon. The 'landscape' is, as it were, dominated by the vegetation; the effect is not of peaceful, airy spaciousness as in a Claude or a Monet, but more often of contained, even oppressive tension. The artist closest to Gamarra is the Nicaraguan Armando Morales (born 1927) whose jungle scenes are similarly overcrowded with trees, trees with wonderful textured bark like some strange sort of skin and with vaguely anthropomorphic forms, limbs and torsos, which grow out of the entwined trunks, as, for example, in *Tropical Forest II* of 1984 [Plate 3], but, unlike Gamarra, the narrative of his pictures is, as it were, contained within the trees themselves.

In Gamarra's *Landscape* of 1982–3, there is no horizon; it is closed off by the trees and ferns. More tall dark trees in the foreground frame a patch of still, green water. In the centre of the composition a gigantic pink and grey striped snake hangs dead or dying, suspended by a rope around its neck, its pathetically small forked tongue lolling out of the side of its red-lipped, grimacing mouth, its long body falling back into the pool to create a few sparkling ripples. In the right foreground the small figure of St George leans against a tree, his armour glinting dully in the green light and the white ring of his halo floating above his bare head. He stares up in apparent astonishment at the snake hoisted above him, the dragon he has killed. In his hand he holds a weapon similar to the one lodged in the monster's skull, a red and black striped spear in contrast to the pink and grey of the monster whose life-blood is draining away. At St George's feet lies a sleek jaguar and behind him is a twentieth-century man, perhaps a guerrilla or a forest ranger, the lower half of his face masked by a bandanna. He half sits, half stands as if in readiness, a US automatic rifle loosely resting on his thighs, his eyes, like those of the jaguar, watching us, not the drama behind. In the left foreground is an Amazonian Indian, as straight and dark as the tree trunks. He looks, open-mouthed, across the picture plane at the saint, while beside him, tied around a tree, as if it were

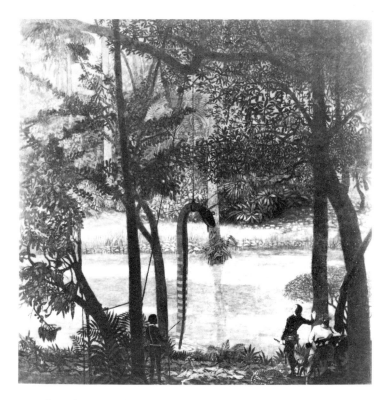

FIG. 9 **JOSÉ GAMARRA,** *LANDSCAPE,* 1982–3

somehow his responsibility, is the other end of the rope which supports the snake. All around, leafy undergrowth seems to be full of watching eyes. Is this really St George's dragon, Eve's serpent, the Christian devil? Although dead, it is positioned close to the other native inhabitant of the Amazonian paradise; the Indian and the serpent belong amongst the greenery. What are the other two figures doing here? St George who, although from some mythical age of Christian chivalry, also evokes, by his armour, the archetypal Spanish conquistador of the sixteenth century; he promises salvation from the devil, but this is more an inversion of the biblical story and a challenge to Christianity than any simple allegory of triumph over the devil. And what does the contemporary soldier promise? Liberation or simply another form of cultural and economic domination? Where do we as Europeans stand in relation to these events? Where do North and Latin Americans stand? In appearance the saint and the soldier may simply be manifestations

of the same thing, both equally alien to the situation in which Gamarra has depicted them.

In *Incitement to Anthropology*, 1984, the backdrop of trees is a little lower, allowing some patches of bright sky to glow above and between them and the green water stretches right down to the bottom edge of the picture, with no framing foreground trees, so that it feels a little less enclosed and humid. Here the intrusive element is not human but mechanical. In the bottom left-hand corner a wooden raft is moored in the middle of the river, carrying a Toyota Landcruiser with bundles strapped to its roof. The light reflecting from the water through its windows shows it to be empty, while in the upper right-hand corner, perched on a precarious fragment of ruined masonry and clearly visible against the pale sky, is the sculptured head of a mythical creature, its great beak-like mouth open to show a formidable set of teeth. Is it laughing at the absent (lost?) anthropologists, or at us, the spectators? Or perhaps it is we who by implication are the owners of the vehicle. Indeed, who is inciting whom to anthropological investigation? In this case it is quite clearly the Toyota which represents otherness, and as such could be seen to constitute a suitable subject for study by the inhabitants of the jungle.

The taste for titles which can be read in a number of different ways is a recurrent device in Latin American art, recalling the puns, proverbs and cryptic phrases that Goya included in his series of etchings. Gamarra's titles are often richly ambiguous in this way, as in *Cinco siglos de tormenta/Five Centuries of Storm*, 1983 [Plate 4], where the *tormenta* in question is represented by a huge black cloud and a streak of lightning, but where the combination of a Spanish caravel and a jet fighter both approaching the coastline suggest the metaphorical storms past, present and future for America. Inevitably, too, there is the sense of the masculine form, *tormento*, meaning torment or agony. In the foreground on a small rocky promontory in the sea, stands the upright figure of an Indian, two proud feathers in his hair and a tiny monkey at his feet; behind him, just visible in the blue water below the rock is the figure of a man floating face down, fishing for pearls, perhaps, in the manner of the sixteenth-century engravings of American pearl fishers by De Bry, but there is a premonitory sense that he may be drowned.

Another title, apt for much of Gamarra's work, is *Crónicas de una historia/Chronicles of a History*, 1984, where the tautology suggests a repetitive, circular history. The scene is of

a coastline with palm trees and a turquoise sea; in the foreground St Christopher – patron saint of travellers and in this context especially of Christopher Columbus – wades ashore; in the background the ships of the Spanish conquerors sail into the bay while other men, already disembarked, set off on their white horses as if on a crusade. The white horse is traditionally associated with St Michael in his fight against the rebel angels, and with Santiago in his fight against the Moors. In the iconography of colonial Latin America the two often become conflated, Moors and devils all being replaced by Indians. The emblem on the conquistadors' banners is that of a skull, and the Christ child on the saint's shoulders carries a skull with one hand while pointing to the forked lightning descending from the clouds with the other. Even the leaves and tendrils in the foreground have the appearance of skull-like heads and eyes. The omens for this chronicle of history are not good.

Gamarra repeatedly telescopes history, conflating early Christianity (St George and St Christopher) with the Spanish conquest, and with modern day scientific, ideological and cultural invasions. Latin American writers like Neruda and García Márquez regularly subvert the conventions of sequential history, or, as Julio Cortázar put it, Latin America has the obligation to be outside European historical time.[19] The sense of the persistent presence of the past, of the unresolved issues of the events of five hundred years ago, is integral to Latin American cultural identity. The figures of Columbus, Cortes or Pizarro are deeply rooted in consciousness at all levels, as is the iconography of conquest: the cross and the sword, the horse, the armour and the caravel. The role of the Church in this living history is particularly important because, unlike many of the other trappings of conquest, the visual imagery of the Church has remained largely unchanged and so is undatable. In Gamarra's painting *De la serie de tropelías ocultas/From the Series of Masked Aggressions*, 1983, gas-masked soldiers bloodily behead a nun in a jungle clearing, while a helicopter hovers in the middle distance beneath a pink evening sky. This picture was inspired by accounts of the massacre of US nuns by government forces in El Salvador in 1980, but it does not represent any one moment or event; the nun's black and white habit makes it impossible to tell whether she belongs to the sixteenth or to the twentieth century.

Although the native inhabitants and the vegetation in Gamarra's pictures imply the Amazonian rain forest, the location is deliberately generalized as a tropical paradise. In different pictures he presents the various overlapping versions

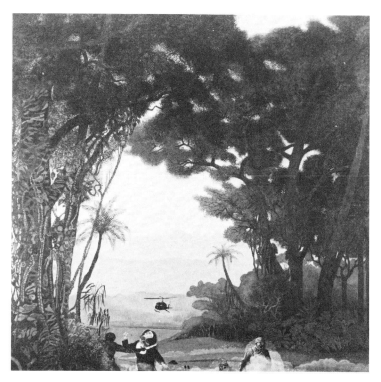

FIG. 10 **JOSÉ GAMARRA, *DE LA SERIE DE TROPELÍAS OCULTAS*/FROM THE SERIES OF MASKED AGGRESSIONS,** 1983

of the American Eden as it has been constructed within the European imagination since the first explorers crossed the Atlantic: the coastline and islands, the blue hills of the unexplored interior, streams and waterfalls, large, slow rivers, the extraordinarily fruitful ecology of the jungle, strange birds with brilliant plumage. The legend of El Dorado is evoked in the golden light, golden stream and golden path of *Cinco siglos después/Five Centuries Later*, 1986, perhaps situated somewhere up the Orinoco river where Sir Walter Raleigh was to search for the fabled gilded king. Elsewhere the fragments of monumental masonry suggest the Yucatán peninsular, home of the Maya. These however, together with the quetzal bird, the jaguar and the more fanciful brightly coloured serpents that recur in the paintings, are intended not as references to specific cultures but to the pre-Columbian past in general, and so, too, to its continuing presence within contemporary Latin America. And just as the geographical area is non-specific, so too are the

various invaders and intruders. They come from the past and the present, from Europe, from North America, from Japan, motivated by greed or religion or under the guise of scientific inquiry or social conscience.

It is the last five centuries which have brought successive generations of uncomprehending intruders to America. But what of Gamarra's Indians? Are these the Indians of whom film-makers dream – pure, unacculturated primitives, unchanged in their patterns of belief and behaviour over centuries, and at one with their universe? Are they the only legitimate inhabitants of a continent which is now known by a term which excludes them from it? In *Vínculos/Links*, 1983 [Plate 5], Gamarra makes it clear that he does not see the Indians as an isolated anachronism. (How, in any case, can there be anachronisms in a non-linear view of time?) An Indian, well camouflaged with body paint, aims his bow and arrow at a bright bird which flutters on the opposite side of the canvas. A shaft of sunlight pierces the tangle of branches overhead and within this, as if being beamed to earth, is a glowing figure like a hologram made up of the colours of the rainbow. The hat, boots and bandolier, and indeed the stance, unmistakably identify this as Sandino. The Nicaraguan revolutionary leader is, the title implies, linked to the tribal Amerindian. They are united in their struggle against the alien, oppressive forces of brutal dictators and economic systems which expropriate their labour, their land and its resources. Gamarra's paintings are not simply a nostalgic yearning for a paradise lost; they are a challenge to the present to recognize the contradictions of the historical legacy and to work towards not an imaginary paradise, but a more just reality.

Alongside the images of natural fecundity – real or ideal, threatened or inviolate – the other dominant image of Latin America is that of mountains. The skyline of most of Mexico and Central America and the whole of the western half of South America is dominated by mountains, snow-capped cordilleras or dry rocky escarpments, volcanoes in splendid isolation or grouped together in families. Perhaps nowhere else in the world are towns, countries, peoples, so closely associated with individual mountains, or with mountain ranges. (In Europe and North America towns, where they are thought of geographically at all, are generally associated with rivers or the coastline.) To think of Mexico City is to think of Popocatépetl and Ixtaccíhuatl (even though they are now almost permanently obscured by pollution), La Paz lies at the foot of Illimani, Quito has Pichincha and a ring of other volcanoes further

away, Rio de Janeiro has the Pão de Açúcar and the Corcovado, Potosí in Bolivia owes its existence to the mountain of silver above the town. Many of the capitals – Guatemala City, Tegucigalpa, Bogotá, Caracas – all have steep mountains in close proximity; Lima and Santiago, and indeed all the towns and cities of the Pacific coast of America south of Guayaquil are unimaginable without the constant backdrop of the jagged, craggy teeth of the Andes.

Journeying almost anywhere in Latin America involves traversing mountain ranges; rough roads of endless hairpin bends that for hours may seem to lead nowhere before suddenly opening on to a new valley and a new range beyond. In his series entitled *Huacayñan* painted in the 1940s the Ecuadorian Oswaldo Guayasamín (born 1919) used the imagery of a wild and mountainous Andean landscape to explore in allegorical form a Latin American's journey through life. *Huacayñan* means 'the road of tears' in Quechua. The Argentinian Alejandro Xul Solar (1887–1963), a close friend of Jorge Luis Borges, used impossibly steep mountains to not dissimilar ends: to symbolize the questings of the human soul. Sometimes ladders or steep paths lead upwards to shrines or monuments on the peaks, sometimes a ladder leads nowhere, projecting over an abyss or out into the emptiness, while in other paintings mountains are represented as animate beings, silent and watchful.[20]

Mountains attract myth and tradition. In indigenous culture they are regularly associated with the gods because they offer access to the heavenly sphere. They are accorded personalities, as in the twin volcanoes above Mexico City which are traditionally viewed as a husband and wife team; or they are seen as the result of the metamorphosis of a living being, human or animal, into a part of the landscape. In pre-Columbian Mesoamerica place-names frequently relate to local geographical features, especially to hills, which are then represented in glyphic form in the screenfolds and codices. In the pottery produced on the northern coast of Peru from about 200 BC up until the time of the Spanish conquest, vases were often modelled in the form of particular mountains, sometimes with a deity seated upon or in front of them. In Bolivia the silver-rich mountain of Potosí was traditionally associated with the Andean earth-mother figure Pachamama; after the conquest this image became fused with that of the Virgin and in colonial paintings the Virgin of Potosí is depicted as a mountain with head and hands protruding from it.[21] In the illustrations to the unique early colonial manuscript of the Peruvian Indian

TRAVAXOS

PAPAALLAIMITAPA

Guamán Poma de Ayala mountains are the constant place-marker.[22] Rocky peaks form the background to specific towns or to conceptual world views; they locate and anchor the whole book. The centrality of the Andes within the consciousness of the people who live in proximity to them is evidenced today in the line of pointed hills which, just as in Guamán Poma, so frequently forms the background to the Chilean patch-work pictures or *arpilleras* [Plate 6], or to the scenic tapestries and embroideries produced for the tourist market in Peru and Bolivia.

The work of the Peruvian artist Tilsa Tsuchiya (1932–84) focuses on the mythic and symbolic resonances of the Andes.[23] As with Tarsila do Amaral earlier in the century, it took a spell in Paris in the 1960s before Tsuchiya found that her own artistic inspiration was to lie not in the shifting and often doubt-ridden artistic fashions of contemporary Europe but in the landscape and atmosphere of her own country. These are not real views, recognizable corners of Peru; they encapsulate the idea of a mountainous Andean landscape, of thin atmosphere and cold winds, of places of great spiritual import. In this Tsuchiya's solution is comparable to that of Gamarra, whose tropical jungle is the ideal jungle of the imagination. Yet whereas Gamarra includes in his landscapes figures from history, Tsuchiya peoples her magical mountains with strange semi- or super-human creatures who stand in tense readiness on the mountain tops or float amongst the clouds. These are the objects of myth created within Tsuchiya's imagination. The mountains are all manner of improbable shapes, the colours strange and dream-like, and the sense is always of being very high up, above the world, looking down

on misty landscapes below. The indigenist tradition had been especially strong in Peru during the late nineteenth and earlier twentieth centuries, but artists tended to concentrate on the living Andean traditions rather than on representing the pre-Columbian past in the way that, for example, Rivera chose to do in Mexico. Tsuchiya does not try to represent or recreate the Inca past, but to capture its continuing psychological importance for the present, to make it spiritually relevant for contemporary Peru.

The story of the famous archaeological site of Machu Picchu is another example of the discovery of a world that already existed: all that had been lacking was the ability to see it.[24] Hiram Bingham found it in 1911, and as a result many Peruvians began to reassess the monuments and the landscapes which the Inca and their predecessors had shaped for the purposes of agriculture and ritual. This was a past that they could legitimately claim for themselves, a unique history worthy of the admiration of the world. Machu Picchu is the stuff of myth, spectacularly situated on a high saddle between two mountain peaks, with the sacred river Urubamba curling round below, and it immediately became the focus of tremendous national pride. Although it has long since been proved that it was not the legendary lost city of the Incas as Bingham believed, it has retained all the associated mystery and excitement, and despite the commercialization of recent years it remains an extraordinarily magical place. It is this, not an archaeological reconstruction of the Inca citadel, that Tsuchiya has sought to capture in her painting *Machu Picchu*, 1974 [see Fig. 50]. In fact, there are also references to the style of carving of the very much earlier Chavín culture (900–200 BC), so suggesting the historical lineage of the Incas, their strength based on the achievements of their predecessors (see pp. 112–15 below for a more detailed analysis of this painting). Tsuchiya's knowledge of Chavín is evident in *El Encuentro/The Encounter*, 1970 (Coll. E. Goldenberg, Lima) where she uses similar reptilian forms, this time recognizably derived from the Tello obelisk, one of the most famous pieces of Chavín monumental sculpture which is in the form of a cayman. This is not a new world where cultures such as the Aztec and the Inca suddenly appeared out of nowhere, just in time to be discovered by Europeans; it is an ancient world with a rich cultural history of its own. Tsuchiya's technique lends her own work an ancient quality, and her mountains and her mythical beings seem to float through time and space.

In a canvas simply named *Painting* of 1971 (private

collection, Lima) an improbably shaped pink and mauve island
floats in a swirl of bright red water. Up the side of this rocky
outcrop a naked, armless female figure half leans, half hovers
on faint feathery wings, its square head dominated by a single
piercing black eye, like the eye of a bird of prey, watching us.
Above the sea and against the steep slope of the island floats a
strange creature, a sort of grey sea slug, with a tree sprouting
from between its eyes. A possible source for the painting is the
story of the beautiful young woman Cavillaca who, in order to
escape the unwanted attentions of the bird-man Cuniraya,
threw herself into the sea just south of Lima where she was
turned into an island.[25] However, in this, as in Tsuchiya's other
work, the point lies not in identifying a particular story which
will explain the meaning, but in recognizing the truths which
are encapsulated in all myths, and in evoking the strength and
richness of indigenous culture. The oral traditions of the
Quechua people abound with stories of metamorphosis, of
birds turning into men, of snakes turning into rocks, of women
turning into islands. Deities and spirits are believed to inhabit
rivers, trees, caves, mountains, lakes and especially strange-
shaped rocks and stones. The stories told about them refer to
cosmic and earthly events, the creation of heaven and earth and
the forces of nature, successive ages of the world, the fertility
of the land, the history of particular groups. Frequently they
record battles between rivals, between the lords of the air, the
earth and the underworld. These may be represented by the
condor or the falcon in the air, by the puma and, since the
Spanish conquest, the bull on land, and serpents or reptiles in
the water and the underworld. These stories form a part of
children's general knowledge of their country and culture, and
they form the starting point for Tsuchiya's work. Into these
she roots a new but at the same time familiar mythology. In
Painting, as in many of her works, there are references to the
three worlds: the water, and the fish and reptilian forms of the
underworld, the rocky forms and the torso and legs of the
figure refer to the terrestrial sphere; the bird attributes of the
figure and the glowing light of the upper part of the picture
belong to the celestial. It is inventive and traditional at the same
time.

A powerful female image recurs regularly in her
work, a figure with small firm breasts, flowing hair that often
extends down round the jaw line, and exaggerated calves and
thighs, as for example in *Mito de los sueños/Myth of the Dreams*,
1976 [Plate 7]. This is not a motif derived from the
iconography of the Peruvian pre-Columbian past, but because

there are echoes of the fertility symbols of other places and eras – the Venus of Lespugue of European pre-history and the pottery figurines of the Tlatilco culture of ancient Mexico – there is a strong sense of a type of earth mother goddess, of fertility, growth and regeneration. This is explicitly the case in *La gran madre/The Great Mother*, *c.*1970 (private collection, Lima): a large dark-red figure with the usual mask-like head sits astride a steep-sided mountain and fish- or slug-like creatures are attached to her three full breasts. A fish-filled river snakes away towards the horizon between a series of similarly phallic peaks, taking our eye back to a greenish heavenly body set within an ellipse of clouds. In pre-Columbian Peruvian cultures the colour red is often closely associated with life and fertility; the mummies preserved in the sands of the coastal deserts were often coloured red as were ritual offerings.[26] *The Great Mother* and Tsuchiya's other mythical women are

spiritual beings, not solid and earth-bound. Their realm is on the tops of mountains, in the branches of a tree, or in the sky with the birds or amongst the clouds. They have their male counterpart in *Mito del guerrero/ Myth of the Warrior*, a fiery red figure, armless like all the others, poised on a mountain in the immediate foreground, with numerous phallic mountain tops emerging from a sea of mist behind him.

Other artists have used the ancient Andean heritage as a source of inspiration in a number of different ways, but the effect is always to locate the work geographically and temporally. Alberto Quintanilla, born in 1934 in the Inca capital of Cuzco, borrows his strange masked figures with combinations of bird, fish, feline and reptilian attributes from the extraordinary textiles of the Paracas culture of the southern Peruvian coast, dating back to

FIG. 12 **TILSA TSUCHIYA, *MITO DEL GUERRERO/MYTH OF THE WARRIOR*,** N.D.

35

800 BC. The Chilean Mario Murúa (born 1952) also uses the imagery of the ancient cultures of the Pacific coast (which, of course, did not respect the modern political boundaries) as in *Jinete de Atacama/Rider in the Atacama Desert*, 1984. Here, amongst the fish, rainbow, sea-shell and egg-like motifs he includes a weird masked horseman which, despite the relatively un-horselike appearance of his mount, suggests not only the culture of the pre-conquest coastal fishermen but also the colonial past of the conquistadors. Bolivia's pre-Columbian heritage includes plenty of Inca remains as well as ruins from the earlier but equally expert builders, the people of Tiahuanaco. Gonzalo Ribero (born 1943) was trained as an architect, an interest which is reflected in his painting. *Refugio de los dioses/Refuge of the Gods*, 1975, evokes the masonry as well as the spirit of the indigenous past with a wall of tightly interlocking stone blocks in a roughly textured pinkish-brown with the junctures emphasized in blue; above hovers a white celestial body – the sun, perhaps, from whom the Inca claimed descent. The recess in the stonework below this shimmering ball suggests the home, the refuge, from which the sun rises and to which it returns in safety each night. In his more recent work the concentration is on sculptural rather than architectonic forms, as for example, in *Sol y luna/Sun and Moon* of 1988, which represents two great stone monuments like altars raised against a fiery red sky.

Fernando de Szyszlo (born 1925), perhaps the best known of the older generation of Peruvian painters, seems at first glance and would perhaps choose to call himself an Abstract Expressionist. For the titles of his paintings, however, he frequently uses Quechua words or phrases which removes from them any claim to universality, and implies a relationship between the paintings and the Quechua world, past and present. *Puka wamani* (1966), for example, consists of a green rectangle decorated with a regular pattern of small raised rings, and a red circle with two green splashes above it, both set against a red background. The textured areas suggest native forms, but it is not until we understand that *puka wamani* means *red mountain lord* that we can be sure that the correct reading of the conjunction of rectangle and circle is as an anthropomorphic figure, stiff and upright like the stylized monolithic statues of the Tiahuanaco culture. Once the connection has been made it is easy to see the dense textures and vivid colours as reminiscent of pre-Columbian textiles, and the particular forms as derived from indigenous iconography. The dagger-like shape in *Waman wasi/Home of the Falcon* (1975), for

FIG. 13 **GONZALO RIBERO, *SOL Y LUNA/SUN AND MOON,*** 1988

instance, resolves itself into a sharp beak or claw. *K'encco,* 1980, is named after the Inca shrine on the hills above Cuzco. This shrine includes a rock in the form of a puma, caves and a rocky outcrop carved with channels and crevices probably associated with divination and with the veneration of the dead.[27] In Szyszlo's painting there is a strong sense of powerful spirits and hallucinatory effects; interlocking pink and blue shapes with appurtenances suggestive of the teeth and claws of a puma float above a flight of steps and some dark entrances in the rock. *Inkarrí* of 1966 [Plate 8] refers to the post-conquest myth of the hero, Inkarrí, who was decapitated by Españarrí, but whose head and body are believed to be growing together under the ground. One day he will become whole and will rise up to release the people from foreign bondage.[28] In Szyszlo's painting the head is growing, expanding, separated from the body by a narrow band; shapes suggestive of hands appear to be pressed to the chest creating a tightly contained torso in the manner of a mummy bundle from an early coastal burial. In Peru today, where the Sendero Luminoso guerrilla movement is trying to bring the story of Inkarrí to its predicted conclusion, this painting would have much greater political resonance than it did in 1966. Szyszlo himself would never agree with such a reading of the Inkarrí story; he was using it as a general

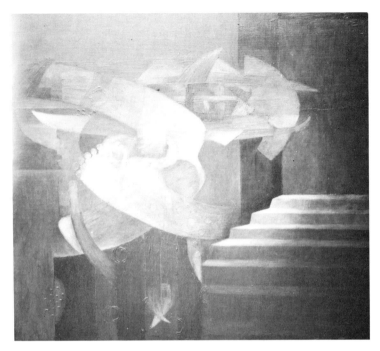

FIG. 14 **FERNANDO DE SZYSZLO, *K'ENCCO*,** 1980

metaphor of *peruanidad* – as an affirmation of indigenous culture, and as a call to bring together the various traditions within Peru to resist economic or cultural domination by external forces.

In the nineteenth century many European artists were inspired by the combination of a magnificent and varied landscape with a wealth of non-European cultural traditions. In the present century Latin American artists have reclaimed these for themselves, using them to establish their own sense of place. This process has not always been easy but the results are impressive in their diversity and imaginative force. The problems involved are perhaps exemplified by the work of Arnaldo Roche Rabell, who was born in Puerto Rico in 1955, moved to Chicago in 1980, and now divides his time between the two. His work includes uneasy landscapes of his island home overlaid with complex signs and symbols, images evoking rituals of African origin, full of wild and barbaric excitement. It also contains so-called self-portraits which explore the mestizo reality of Puerto Rico, combining the racial clichés of black skin and blue eyes, and gigantic pink and white nudes, male as well as female. He often uses a technique which

FIG. 15 **ARNALDO ROCHE RABELL,** *DÉJAME ENTRAR/LET ME IN,* 1988

FIG. 16 **ARNALDO ROCHE RABELL,** *LA MUJER PERFECTA/THE PERFECT WOMAN,* 1987

he calls 'rubbing' which usually involves laying the canvas over the model and applying the paint by hand.[29] Given the range of subject matter and the urgency of his execution, there is a sense that Roche Rabell has developed this technique as a way of pinning down his subject matter in order to locate or anchor both himself and it in time and space. Despite, or perhaps because of, his close but inescapably ambivalent relationship with the United States, his artistic reference points are not North American culture but Puerto Rican, together with the art of the European past. In this last he is not alone.

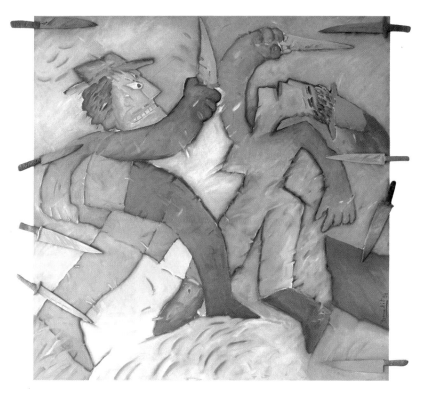

PLATE 1 **LUIS BENEDIT,** *EL DUELO/THE DUEL,* 1984

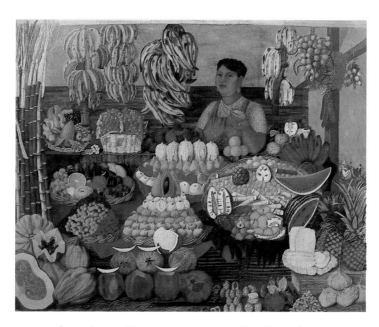

PLATE 2 **OLGA COSTA,** *VENDEDORA DE FRUTAS/THE FRUIT SELLER,* 1951

PLATE 3 ARMANDO MORALES, *TROPICAL FOREST II*, 1984

PLATE 4 JOSÉ GAMARRA, *CINCO SIGLOS DE TORMENTA/*
FIVE CENTURIES OF STORM, 1983

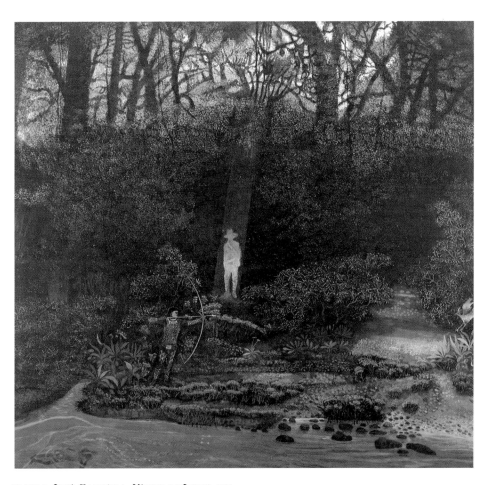

PLATE 5 JOSÉ GAMARRA, *VÍNCULOS/LINKS*, 1983

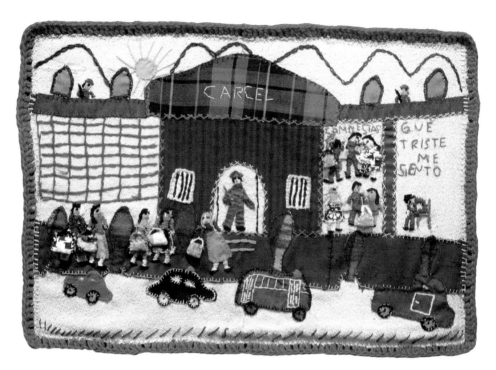

PLATE 6 *ARPILLERA,* CHILE, C. 1975

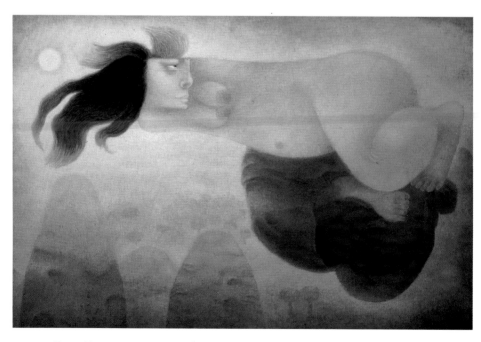

PLATE 7 **TILSA TSUCHIYA,** *MITO DE LOS SUEÑOS/MYTH OF THE DREAMS,* 1976

PLATE 8 FERNANDO DE SZYSZLO, *INKARRÍ*, 1966

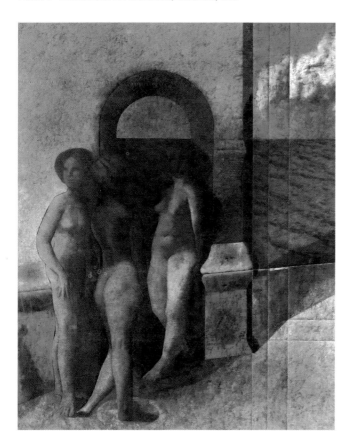

PLATE 9 ARMANDO MORALES, *THREE BATHERS*, 1986

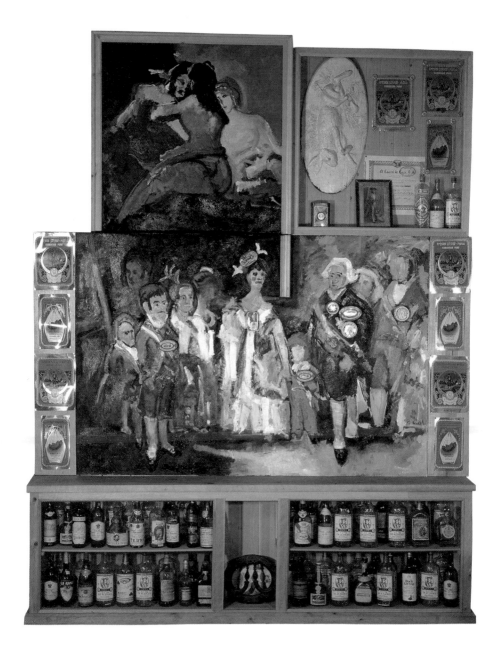

PLATE 10 **ALBERTO GIRONELLA,** *LOT Y SUS HIJAS/LOT AND HIS DAUGHTERS,* 1984–7

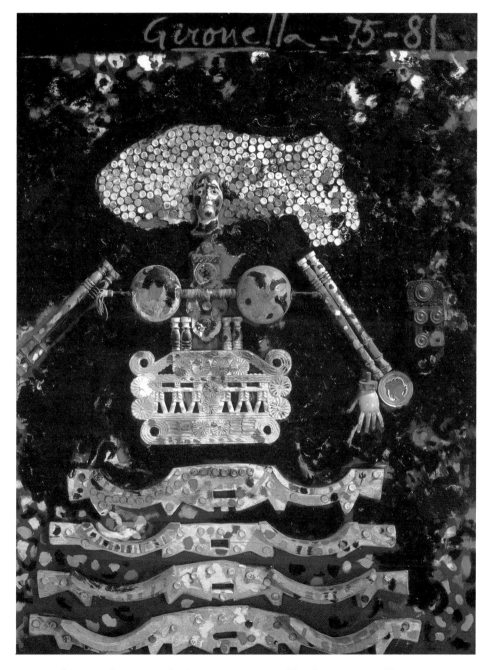

PLATE 11 ALBERTO GIRONELLA, *LA REINA DE LOS YUGOS/THE QUEEN OF THE YOKES*, 1975–81

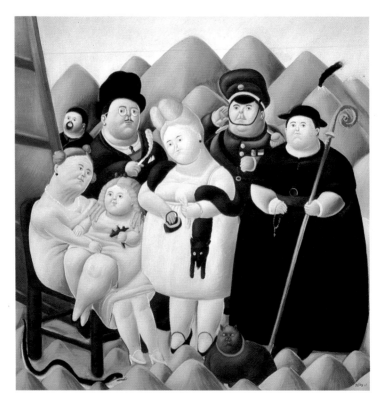

PLATE 12 **FERNANDO BOTERO,** *THE PRESIDENTIAL FAMILY,* 1967

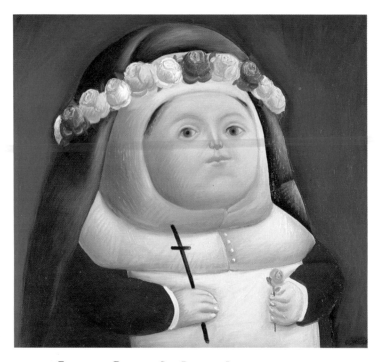

PLATE 13 **FERNANDO BOTERO,** *STA ROSA DE LIMA,* 1966

CHAPTER 2

CONFRONTING A COLONIAL PAST

For Latin American artists the art of the European past remains both important and deeply problematic. How can one develop a distinctive identity in the face of the looming presence of the internationally acknowledged Great Masters of Italy, Spain, France and the Netherlands? How can Latin American artists borrow and learn and yet retain some autonomy and originality? This in turn is part of the broader problem of the inescapable legacy of conquest and colonization which is one of the recurring concerns of this study. For some artists the solution has been to try and avoid European art and to turn elsewhere for inspiration; some have successfully borrowed certain elements, incorporating them more or less discreetly into their works; others have confronted the problem directly and produced works that are explicitly based on paintings by Velázquez or Rubens or Delacroix. Sometimes the intention is to recognize a debt and to pay homage; sometimes it seems to be to lay the ghosts, to exorcize the past; occasionally, and perhaps most interestingly, it is ambivalent and we are left with a sense of the tensions inherent within any attraction to these Old Masters.

In the period immediately following independence Europe remained the cultural model for all the newly formed Latin American nations. In fact, political independence was

often accompanied by a more rigid cultural dependency than that which had obtained during the colonial period.[1] Academies along European lines were set up in several Latin American capitals at a time when many European artists were turning away from traditional academic training. These new Latin American academies were often run by Europeans who were anxious to uphold the norms into which they themselves had been schooled, and their influence is evident in both the styles and the subject matter of much nineteenth-century Latin American art. After the First World War disillusion with the values of the Old World encouraged artists to turn to their own continent for inspiration; Latin Americans looked to the United States, while a number of North Americans turned to Mexico. During the last thirty years, with increasing US intervention in so many spheres of Latin American life,[2] and with greater historical and emotional distance between Latin America and Europe, many artists have felt it possible to claim back some of the best of the artistic heritage of Europe without compromising their own cultural identities. In addition to the numerous political and artistic reasons for turning away from the United States, the liberalization of Spain following the death of General Franco in 1975 provided a further incentive to look back to the Iberian peninsula. More recently, the impending quincentennial of Columbus's first voyage has given a new urgency to the reassessment of the European past.

The legacy of the European academicism of the nineteenth century may not, in the long term, have been entirely pernicious, nor is it irrelevant to an understanding of the art of Latin America today. The traditional academic emphasis on the nude as a subject for painting, and so on figure drawing, has persisted in many art schools throughout the continent, especially, perhaps, because drawing from the nude was not permitted in some countries – Venezuela, for example – until the early years of this century. This novelty must have contributed to the fascination with the female nude of the Venezuelan Armando Reveron (1889–1954), who was to return to it constantly throughout his life. A number of younger artists have chosen to concentrate on the nude. The numerous drawings of a Christ-like male figure, usually wounded or dead, by the Colombian Luis Caballero (born 1943), the acquiescent females in smooth bronze of his compatriot, Dario Morales (born 1944), and the monumental nudes of the Nicaraguan Armando Morales (born 1927) [see Plate 9], as well as the strange mythical females of Tilsa Tsuchiya and the energetically modelled nudes of Roche Rabell: all these testify

to the persistence of an academic tradition that reaches back, via the Renaissance, to classical antiquity. More generally, the unselfconsciousness with which so many Latin American artists have continued to work in vigorous, original figurative modes regardless of the abstractions of Europe and the United States can perhaps be attributed to the academic emphasis on content as an integral part of figure drawing and composition that dates back to Alberti's treatise on painting, *De Pictura*, of 1435.

Another feature of the traditional academic training with far-reaching consequences for Latin American art is that of copying from the Old Masters. It is axiomatic that art cannot be reproduced in the same way as can music or literature, so for aspiring young artists in countries where the public collections contain little or nothing apart from that from their own colonial and nineteenth-century past the impact of a trip to Europe can be immeasurable, and the art of copying while on such a visit of especial value. The result of this practice is evident in those works produced by artists during the last fifty years which are deliberate reworkings of paintings by European artists. Copying may well also help to account for the many other works which are more loosely based on or derived from European models.

Nevertheless, copying as a form of confrontation with the legacy of the past is not always easy, the results not always understood. Those artists who demonstrate most openly their debts to European art have tended to be marginalized both by Latin Americans, who see them as belonging to Europe, and by Europeans and North Americans, who see them as neither sufficiently Latin American nor sufficiently in touch with the modernist developments to be of particular interest. Even Botero, one of the best-known living Latin American artists and an enormously prolific painter, is extremely poorly represented in public museums and galleries although he is very popular amongst private collectors, especially in North America. This suggests that those in charge of the buying policy of institutional art collections do not find it easy to categorize his *faux-naïf* reworkings of European Old Masters (which they presumably see as too derivative) nor his satires on the pretensions of the Latin American haute bourgeoisie. For private collectors his attraction may lie precisely in the copyist aspect: to own a Botero variant of a Leonardo is in some ways to own a Leonardo that is unique in a way that no full-colour reproduction of the original could be.

Generally speaking, appeals to Latin Americans to value their Iberian roots as well as their Indian or African

cultural traditions still seem to have a slightly apologetic ring to them. In 1964 Rufino Tamayo wrote of the art of Alberto Gironella that its roots are unquestionably Mexican 'only in a different way, given that it is not nourished by the Indian sources from which so many of us have drunk and which fill us with such pride, but he feeds himself on the Spanish, which is the other perfectly valid half of our national identity'.[3] Even the phrasing suggests this to be a somewhat novel suggestion, and Tamayo goes on to add a reference to the baroque cathedrals of Mexico as proof of the validity of a sense of pride inspired by things of Spanish origin.[4] This is a revealing conjunction and one to which we shall return again.

In looking back to the European past, Latin Americans have been especially drawn to the Spanish Golden Age, the epoch of Cervantes and Calderón, of El Greco and above all of Velázquez. This was the age of the Habsburg kings, when mainland Central and South America were conquered and colonized by the Spaniards – the point at which *Latin* American history begins. It is a period which evokes images of both greatness and corruption, of glorious architectural and theatrical extravagances and of economic collapse, of pure spirituality and of the grossest forms of servitude and exploitation, of unquestionably magnificent paintings depicting physically degenerate monarchs and their attendant sycophants and dwarfs. It both attracts and repels, but its legacy, more than that of any other period of European history, is inescapable. Another reason for its attraction beyond the directly historical is perhaps that it is the period conventionally classified as the baroque era, and Latin Americans are often very ready, even if with self-conscious irony, to accept the term *baroque* as descriptive in some way of themselves and their culture as a whole; it suggests a style, an idea, a way of life that is rich and strange, riddled with impossible paradox and incredible realities, grand, flamboyant and macabre. The artists to whom Latin Americans repeatedly return, El Greco, Pereda, Valdés Leal and Velázquez, both define and epitomize an idea of the baroque, as in some looser way does their obvious successor in the subsequent century, Goya.

The visionary paintings of El Greco with their unearthly lighting effects, elongated figures, dramatic compositions and intense spirituality can be traced behind the works of a number of twentieth-century Latin American artists. The view of Mexico City, *Ciudad de México*, 1942, by Juan O'Gorman (1905–82) refers directly to El Greco's celebration of his adopted home in his *View and Plan of Toledo* of c.1609

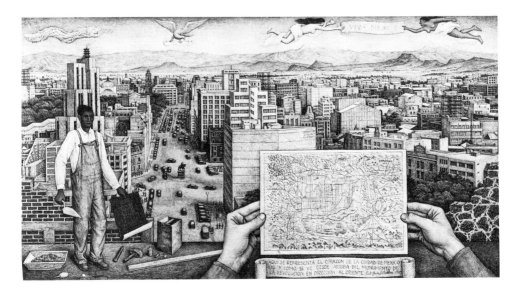

FIG. 17 JUAN O'GORMAN, *CIUDAD DE MÉXICO/CITY OF MEXICO*, 1942

(Museo del Greco, Toledo).[5] It uses the same high foreground with a plan of the city displayed in the foreground, and the buildings spread out behind. El Greco's allegory, with the Virgin and angels floating above the city depicted in a disturbingly acidic palette, was not designed to document the Toledo of mundane reality, but a spiritual ideal, a new Jerusalem. O'Gorman's city is painted in a clear cool daylight, but it too is an allegory, clean and modern and full of hope for the future. In the sky O'Gorman's allegorical figures include two semi-nude women, representing the European and Indian races, supporting a scroll with the colours of the Mexican flag and inscribed VIVA MEXICO, and Quetzalcoatl, the feathered serpent. In this case the apparent inappropriateness of the borrowing gives O'Gorman's painting a special edge. In referring back to the ancient capital of New Castile with its rich mixture of Christian, Moorish and Jewish cultures, he is drawing attention to the parallels between this and the antiquity and similarly fertile conjunction of traditions represented within post-revolutionary Mexico.

El Greco's famous *Burial of Count Orgaz* of 1586 (Sto Tomé, Toledo),[6] a huge canvas with a semicircular head which takes up the whole end wall of a small chapel in Toledo, has been a recurrent source of inspiration both for its painterly qualities and for the way in which it combines three historical moments, a device repeatedly exploited by Latin American

artists and writers. The count in question died in 1312 and at his burial two long-dead early Christian saints, Stephen and Augustine, were said to have appeared to assist with the ceremony. El Greco paints this scene as if it were taking place in the sixteenth century, with the contemporary Toledan gentry standing round about and the count dressed in elaborate armour identical to that in which the conquistadors of America are usually represented. Above, amongst the swirling clouds of the heavenly realm, the Virgin receives the Count's soul while John the Baptist intercedes with Christ on his behalf. Gironella's *El entierro de Zapata/The Burial of Zapata*, 1972, uses the same canvas shape, sense of upper and lower spheres and visionary atmosphere as the El Greco, and is an exploration of a similarly mythic history. Even before his death in 1919 Zapata had begun to acquire the status of a hero-saint in popular iconography. By the 1970s he had come to represent for many, Gironella and Octavio Paz included, the pure spirit of the Mexican revolution; he stood for a form of Mexican nationalism based on the traditional values of collectivity and respect for the land of the Mexican *campesino*.[7] The presence of Christ, the Virgin and various saints elevate El Greco's Count Orgaz to semi-divine status, but there is a further possible gloss in that the early Christian saints St Stephen and St Augustine evoke the lost purity and simplicity of the early Church. Gironella is recalling the idealism of the early years of the revolution, and in his references to El Greco plays on the theme of the sanctification of the political leader.

The Burial of Count Orgaz is also the source for a painting by another Mexican, Alejandro Colunga (born 1948). His huge *La pasión de los locos 1/The Passion of the Lunatics 1*, 1981, is loosely based on El Greco's composition, but here the heavenly sphere resembles more the gates of hell with a skeletal monster enthroned at the top, and the body is that of the dead Christ, who, unlike Orgaz or Zapata, is doomed to remain eternally unburied. The pale, cadaverous figure lies on red velvet, entombed in a glass sarcophagus in the manner of the life-size images of the dead Christ found in Catholic churches. The sword thrust shows as a livid red slash between his ribs, and his knees are broken and bleeding from where he fell under the weight of the cross on the road to Calvary. The lunatics who gather in worship around the tomb-altar are dressed in exaggerated versions of the *capirotes*, the conical hoods traditionally worn by religious brotherhoods and flagellants during the processions of Holy Week. The Passion of Christ has become the focus for weird and devilish practices, macabre

FIG. 18 ALBERTO GIRONELLA, *EL ENTIERRO DE ZAPATA*/THE BURIAL OF *ZAPATA*, 1972

47

FIG. 19 **ALEJANDRO COLUNGA, *LA PASIÓN DE LOS LOCOS 1/THE PASSION OF THE LUNATICS 1*,** 1981

devotional excess. From behind the mask, so ubiquitous an image in Latin America, people can act out the part of lunatics and devils. The world can be turned upside down and traditional values inside out. In art, as in the imagination, everything is possible.

Velázquez is central to any consideration of the impact of the European artistic heritage on that of Latin America.[8] Goya and Picasso, the other figures to dominate the subsequent history of Spanish art, were both profoundly influenced by Velázquez, and in particular by what is probably his most famous painting, *Las meninas/The Maids of Honour*, 1656. This depicts the tiny Princess Margarita and her retinue, with, to the left, a self-portrait of Velázquez, palette and brush in hand, standing in front of a huge canvas of which we can

only see the back. Goya made an etched copy of this painting and also paid homage to it in his own most famous royal group portrait, *Carlos IV and His Family*, 1800–1801. In 1957 Picasso, in many ways the direct heir of Velázquez and Goya, was to produce no less than forty-four variations on *Las meninas*. In Latin America versions or aspects of this painting, particularly the device of the inclusion of the artist and unseen canvas, appear in quite surprising places. In 1968 the Peruvian Herman Braun (born 1933) beat Picasso's record, producing fifty-three versions to create a series entitled (in echo of Duchamp) *Velázquez mis à nu accompagné des meninas/ Velázquez Stripped Bare Accompanied by the Ladies-in-Waiting*, 1968.

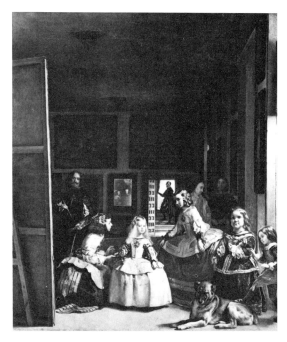

FIG. 20 **DIEGO DE VELÁZQUEZ, *LAS MENINAS*,** 1656

This series constitutes a dramatized version of the original in which different characters jump to the foreground and retreat away again, like a home video. The work of the Venezuelan artist Jacobo Borges (born 1931) includes several references to *Las meninas*. His *Nymphenburg* of 1974 (Coll. Mariana Otero, Caracas) is an unmistakable version, but the figure of the chamberlain José Nieto, silhouetted in the doorway in the background of the Velázquez,

FIG. 21 **HERMAN BRAUN, *VELÁZQUEZ APPROACHES HIS EASEL*,** 1968

FIG. 22 JACOBO BORGES, *EL NOVIO/THE GROOM*, 1975

has been replaced by a little scene in which a man is being
beaten up by security guards. The paintings on the walls are by
Borges himself. *El novio/The Groom*, 1975, evokes Velázquez in
the perspective construction of the high, long room, the
doorway with steps beyond and the suggestion of a mirror on
the wall, as well as the sense of stiff social conventions of the
group posing, in this case for a photograph. The Colombian
Fernando Botero playfully includes himself standing behind his
canvas in the corner of *The Presidential Family* of 1967 [Plate
12]. The Mexican artist Alberto Gironella repeatedly uses
elements from *Las meninas*; this and his other uses of paintings
by Velázquez require closer attention.[9]

Gironella's work is not easy to classify. André
Breton, the French poet and theorist of Surrealism, hailed him
as a Surrealist, a label Gironella seems to have shrugged off by
saying he was as much baroque as Surreal.[10] He is exceptional
(and so unclassifiable) in that the art of the European past is not
simply a source of inspiration: rather it is his very subject
matter. The paintings of Spain, and in particular those of the

Golden Age – the work of artists such as El Greco, Pereda, Valdés Leal and above all Velázquez – are the subjects of his paintings. It is specific paintings – not their style or atmosphere, nor their compositions, nor *their* subject matter – but the paintings themselves that make up Gironella's content.

The painting to which he has returned most frequently is not *Las meninas* but a relatively less well-known work, Velázquez's portrait of Queen Mariana of Austria of 1652. This is a full-length portrait in the conventional stiff posture. The queen wears a black velvet dress stitched with row upon row of silver braid and with a gigantic farthingale which spans the whole width of the canvas. The shape of this extraordinary skirt is echoed in her wig, a similarly fantastic creation, braided and beribboned and topped with a huge feather. Her right hand rests on a chair back, her left on her skirt with a large white silk scarf elegantly suspended from her fingers. A heavy red curtain, a standard prop in baroque portraits, cuts across the upper left-hand corner while the only other feature in the painting is an elaborate gold clock on a table in the background to the right.

Mariana was the second wife of Philip IV of Spain. She was also his niece and one of the last members of the declining Habsburg dynasty – their cretinous son Carlos II died without issue. She and her daughter Margarita, a rather healthier child than Carlos,

FIG. 23 **DIEGO DE VELÁZQUEZ, *QUEEN MARIANA,*** 1652

inspired some of Velázquez's most delicate paintings, even within the strict conventions of royal portraiture. These and his many contemporaneous portraits of the king himself are essentially dynastic portraits: their pose and composition is

entirely traditional, linking the mid-seventeenth-century mon-
archy with that of Philip II and with the empire of his father
Charles V in the sixteenth century. Such paintings were
intended to reinforce the sense of stability and longevity of the
lineage, and although with hindsight this seems deeply ironic,
it would certainly not have seemed so to Mariana, Philip or
Velázquez. Of course, the historical importance of these
paintings is not just as representations of a royal dynasty: they
are part of an artistic dynasty going back through previous
court painters, Pantoja de la Cruz and Sánchez Coello, to
Titian's prototypical portraits of the Emperor Charles V and his
wife Isabella of Portugal. Velázquez was well aware of his inheri-
tance, just as Gironella is of his. From a twentieth-century
viewpoint Velázquez's portraits are part of a tradition of Spanish
court portraiture that was to continue through the eighteenth
century to culminate in Goya's *Charles IV and His Family* (1800–
1801), another painting of which Gironella has done numerous
versions [Plate 10]. Goya's group portrait of the unmistakably
empty-headed Bourbons together with Velázquez's paintings of
the in-bred Habsburgs casts a strange light over history. They
make the whole Spanish colonial enterprise seem a fantastic,
incredible farce peopled with monstrous mannequins. Although
they never visited it, these creatures shaped and controlled an
entire continent. This is, no doubt, one of the reasons for the
fascination of Latin American artists with them today.

Since 1960 Gironella has produced dozens of
versions of Velázquez's portrait of Queen Mariana: paintings,
drawings and collages (many of which could be classified by
Rauschenberg's term *combine paintings*) as well as sculptures,
often on a huge scale.[11] He takes different aspects – her wig,
her fixed expression, her stiff pose, her huge skirt, her delicate
hand, the clock behind – and transforms them. Sometimes only
one identifying detail of the original remains – the hand, for
example. Sometimes, like Chinese whispers, nothing specific is
left at all, only an atmosphere of overblown baroque grandeur
and perhaps a suggestive title. In other examples Mariana is
transformed into a chair with an elaborately carved back but no
seat, a useless, decorative piece of furniture. Sometimes,
exaggerating the rigidity of her pose, Gironella makes her body
into a fluted classical column, her arms into turned wooden
table legs. On occasions she becomes a religious icon, her face
like a death-mask, or she is represented by a collage of cloth, a
few tattered, rotten remnants to suggest her wig or her bodice.
The variations may be on the head and shoulders alone, the
wig undergoing numerous slight alterations, so that it becomes

FIG. 24 **ALBERTO GIRONELLA,** *QUEEN MARIANA,* 1960

suggestive of a tree, a dissected brain, or the distinctive hat of a matador or the tin helmets of the *guardia civil* of Franco's Spain. Gironella's references are to past and present, to Spain and Mexico, to the queen as aggressor and the queen as victim, to the disintegration of the flesh and the preservation of the body through art and the imagination.

Gironella's attraction to this particular painting by Velázquez is perhaps because it embodies so many ironies and paradoxes. The flesh-and-blood woman would have been all but forgotten had it not been for Velázquez: she is preserved not in words and deeds, nor in embalmer's oils but as a painted image which Gironella exhumes and submits to innumerable autopsies. Mariana represents the Habsburgs and the Spanish

Empire yet as a woman her own real power was severely limited. In what sense, then, could she be held responsible for the excesses of the colonial regime in Mexico? Gironella alternately presents her as oppressor and as oppressed. Another irony is that from a twentieth-century viewpoint her costume, the epitome of baroque extravagance, makes her look like a ridiculous, helpless puppet although it was no doubt designed to represent her as both supremely grand and supremely fashionable. Her name is suggestively close to that of another woman whose image looms large in the colonial history of Mexico, that of Marina, the name with which Cortés's Indian mistress Malinche was baptized, the woman who was so instrumental in the success of the Spanish conquest of the Aztec capital of Tenochtitlán in 1521. This is the sort of verbal assonance which Gironella likes to encourage his audience to explore. His first love was literature. He studied Spanish literature at the Universidad Nacional Autónoma in Mexico City in the early 1950s and his most notable enterprise was the invention of a bad poet called Tiburcio Esquirla (the echoes of Borges are surely not accidental). This literary training is fundamental to his art, and punning references and wit based on verbal interpretations are often one of the most exciting ways his paintings work.

In one particularly brilliant version called *Objeto reina/Object Queen* (or alternatively *Reigning Object*), 1961 (Coll. Vicente Rojo, Mexico), Gironella replaces Mariana's head with *The Poultry Man* (1961) by the Mexican photographer Nacho López showing a man carrying a heap of plucked chickens on his head. The overall shape is very similar, and the effect of the substitution of the limp, distended necks and chickens' heads hanging around the man's face for Mariana's profusion of ringlets and bows is thoroughly macabre.[12] The painting suggests a witty pun in a way that is typical of Gironella's work: the photograph is of a poultry vendor, a *pollero*, which in the context of the queen can become feminized into the poultry woman, *pollera*, a word which also means a full and hooped skirt, like Mariana's own. There are further punning references to food: *Objeto reina* and others in Gironella's Mariana series include tins of sardines. Imported foods from Europe such as tinned sardines are often known in Latin America by the term *ultramarinos*, which as well as having echoes of Mariana's own name (and of Malinche/Marina's) suggests that she too is a transatlantic import, whose only purpose now is to be consumed by Mexicans.[13]

As well as claiming descent from the great court

portraits of the Spanish past, Gironella's numerous versions
establish their own internal lineages, and, appropriately, time is
one of the recurrent motifs linking many of them. For
Velázquez and Queen Mariana the clock in her portrait would
have been not so much a symbol of time as of status – a very
rare, expensive and exotic ornament. In the seventeenth
century time as a symbol of earthly vanity would have been
represented by an hour glass or by Father Time himself.
Gironella, however, takes the twentieth-century implications of
the clock as a symbol of the transience or futility of life as well
as of regularity and of the control of industrial labour. He often
takes the clock or elements of the clock from Velázquez's
painting and superimposes it on to Mariana's body suggesting
metaphorical relationships between the clock and the heart,
beating time, ticking heart: a mechanical woman who has to be
wound up, who ticks away monotonously. There is never one
neat explanation of Gironella's work. Its effectiveness depends
upon implications and suggestions, with the onus on the
spectators to explore the layers of possible meaning for
themselves. Some of Gironella's versions of Mariana incorporate
dismembered, broken clocks implying perhaps that time has
stopped, perhaps that she is dead. These images bring to mind
the Spanish phrase *reloj desconcertado*, which literally means a
broken clock but which as a figure of speech means an irregular
person, out of time, out of step, out of rhythm. The resonances
of this idea are rich: was Mariana out of touch with her own
times, or is the seventeenth-century queen out of step with
twentieth-century Mexico? In one particularly disturbing
version (*Reina Mariana*, n.d., Coll. Charles Zalber) Mariana's
painted head is cadaverous, sightless and yet screaming, and the
modelled, three-dimensional hand which in the Velázquez held
the scarf so daintily is tensed in agony. The torso of this figure
is represented by the vellum cover of an old book with the
word *luz* (light) just visible on the spine; the spine, as it were,
replaces her spine. The book cover is flattened and empty; it
has no contents, no story to tell, it can illuminate nothing. The
mechanism of a clock, the cog-wheels with a shiny brass bell
above, is screwed to the centre of the book's spine, marking
time.

Another recurrent theme is that of dogs, often
used to amplify the allusions to power and gender relations. In
Gironella's Mariana series there are two types of dog: a little lap
dog, associated with femininity and domesticity, and a huge
hunting dog. The latter is the sort Titian had included in his
portrait of the Emperor Charles V, that Velázquez included in

Las meninas, and in his portrait of Mariana's stepson Balthasar Carlos: it is associated with power and kingship and masculinity. One of Gironella's most horrific versions of Queen Mariana, *Perro devorando a la Reina Mariana/Dog Devouring Queen Mariana*, 1963 (no longer extant), consists of two parts. The lower section contains several boxes which frame three-dimensional objects: her hand, contorted but recognizable, a leg, severed just above the knee like an antique fragment, a frog, and an imaginary machine that is more like a barometer than a clock. Above this Cornell-like cabinet of curios or collection of holy relics is a painting of Mariana being torn apart by a huge snarling dog. Only her head and shoulders are visible, her skin pale, her eyes shut and her mouth slightly open in an expression of pride and suffering. Here her wig is in part transformed into a swirl of red drapery, like the curtain in the Velázquez, in part into rubbery entrails in the jaws of the fearsome hound. Two more dogs snap at the heels of the first and behind, on a table draped in red velvet, stands the clock, this time straight out of Velázquez, untransformed and immutable. The Spanish queen, meanwhile, is being eaten alive by her own history: as well as symbolizing kingly power and control this is also the sort of dog the Spanish conquistadors of the sixteenth century trained to attack and kill American Indians.[14] In this instance Mariana is presented as the ultimate victim who, like the Indians, is at the mercy of her husband and his dogs.

But, as elsewhere in Gironella's work, we are never allowed to hold on to one meaning or set of meanings for very long; at one moment we recognize in Mariana a metaphor for the powerlessness of the colonized but in other works she herself is actively culpable. In *Obrador de Francisco Lezcano/Workshop of Francisco Lezcano*, 1963, similarly snarling hunting dogs tear into chunks of meat, only in this case the dogs themselves are identified with Mariana: they wear parts of her costume including, ludicrously, her great plumed wig. She is the aggressor, in multiple canine form, and the orgy is being recorded by a dwarf from another of Velázquez's works, Francisco Lezcano, who stands in imitation of Velázquez's own self-portrait in *Las meninas*, palette in hand and in front of a large canvas, at the left-hand side of the picture. In *Festín en palacio/Feast in the Palace* of 1958, Mariana is completely marginalized, merely suggested in the bruised head and hand. In this case these objects are more like *ex votos* than religious relics: they are offerings to the image of a hunting dog which lies as if on an altar table above. Velazquez's self-portrait from

FIG. 25 **ALBERTO GIRONELLA, *OBRADOR DE FRANCISCO LEZCANO/***
WORKSHOP OF FRANCISCO LEZCANO, 1963

Las meninas is here again too, as is Francisco Lezcano; attendants on the sanctified dog in the centre.

The second type of dog which Gironella uses in his portraits of Queen Mariana is a lap dog reminiscent of those Velázquez includes in his portraits of girls, very young boys and young women although never in his portraits of Mariana. In the foreground of a drawing by Gironella of baroque curlicues and something faintly reminiscent of huge hooped skirts – *Reina Mariana,* 1961 (Coll. Albert Adams, New York) – there is an alert little dog with Mariana's wig and with the face of another of Velázquez's dwarfs, María Bárbola from *Las meninas.* The recurrent imagery in this series is of a degenerate royal family, and their attendant dogs and dwarfs. The constituents are constantly transposed and transmuted: who is really the more bestial, the more deformed? In another version this idea is quite explicit. A painting in oils, *Reina con cabeza de perro/Queen with the Head of a Dog,* 1961 (Coll. Charles Zalber, Paris), is quite close to Velázquez's original except that her face has metamorphosed into that of a little Pekinese-like dog, with floppy ears and a squashed, upturned nose. This last is a deformity deliberately encouraged by careful breeding and the parallels with the Habsburg dynasty are clear.

This is unusually obvious for Gironella who

FIG. 26 **ALBERTO GIRONELLA,** *FESTÍN EN PALACIO/FEAST IN THE*
PALACE, 1958

prefers to work by suggestion and implication, and he exploits
the possibilities of verbal as well as visual puns, of verbal
associations within a visual medium. A more recent version of
Velázquez's Queen Mariana, *La reina de los yugos/The Queen of*
the Yokes, 1975–81 [Plate 11], is a particularly good example of
this. It is a brightly coloured mixture of paint and collage. Her
skirt is composed of four roughly carved wooden ox yokes. The
central section of each of these yokes is suggestive of a mask

while the ends can certainly be read as serpents' heads in profile, a reference to pre-conquest iconography. Her wig is made up of bottle tops, the detritus of modern society and a travesty of the original. Her arms are of turned wood, like thin banister rails; her breasts of gourds linked together by a switch with the leather tassle, an attribute of a shaman or medicine man and so associated with Indian beliefs. Her torso evokes traditions of Mexican popular art: the style of the rosettes and the row of skeletons, the *calavera* figures of the popular celebrations for the Day of the Dead.

The earlier works in the Mariana series tended to have very plain titles: most commonly simply *Queen Mariana*, sometimes *Black Queen* or *Red Queen*, and sometimes explicit titles such as *Dog Devouring Queen Mariana*. But *The Queen of the Yokes* is much more suggestive. At the most obvious level the title refers, of course, to the inverted ox yokes which form her skirt, but the term *yugo* also reverberates in three broader contexts: marriage, colonial rule and the Church: *el yugo matrimonial*, *el yugo colonial* and *el yugo de la iglesia*, three great burdens. Gironella is evoking all three – Mariana yoked in marriage to her uncle Philip IV, colonial Mexico yoked to Spain and the Habsburgs, the populace yoked to the Church. The idea can be extended to include the cultural yoke that ties modern Mexico to the Spanish past, and so Gironella to Velázquez, and perhaps also the economic yoke which binds Mexico to the United States. Coca-Cola is the first image to be evoked by the bottle tops, for example, but Gironella has painted over them and hidden their origins. In fact, because he has painted them yellow – the colour of the tops of 'Superior', one of Mexico's most popular light beers – there is also perhaps a reference to Superior's notorious advertising slogan: *La rubia que todos quieren* (The blonde which everybody loves/wants): blonde beer/blonde queen. Again Gironella refuses us any one simple reading of his work.

Historically, the connotations of the yoke are especially rich and go back to Mariana's ancestors Ferdinand and Isabella and to the conquest of America. In the late fifteenth century Isabella of Castille had taken the yoke as her emblem (*Y* for *Ysabella*) when she married Ferdinand of Aragon, a marriage which yoked the two largest kingdoms of Spain together to form the basis of the modern state. Isabella's choice of personal emblem was, from the point of view of subsequent history, astonishingly apt. It was Isabella who gave Columbus the backing he needed to set off in search of America in 1492, and she was responsible for the introduction

of the Church into America as well as for the early colonial legislation about Indian labour and taxation. In other words, she herself was responsible for establishing the central features of the colonial yoke. Ferdinand's emblem was a bunch of arrows, *flechas*. These, usually in the form of a composite motif, are a dominant element in early-sixteenth-century Spanish iconography, appearing on the Catholic kings' numerous architectural and sculptural commissions. In twentieth-century Spain this combined yoke-and-arrows emblem was expropriated by the Falangists as a symbol of the Spanish nation in an attempt to establish historical legitimacy. Since Franco's death most of these have disappeared, but when Gironella travelled to Spain in 1960 it was to be found everywhere.

In his obsession with Mariana there is always a sense of the contradiction between the unquestionable greatness of the art historical past and the corruption and decadence of the era which it records. How to pay homage to Velázquez without being subjugated by him? How to cope with the extraordinary, macabre fascination exerted by the monarchy he immortalized? And how to come to terms with the inevitable, inescapable history and legacy of colonial rule? In *The Queen of the Yokes* Gironella alludes to all these confusions and contradictions. This painting is not an exorcism, nor an act of vandalism or iconoclasm; even less – in more conventional art historical terms – is it a painting which is simply influenced by or borrowing from the art of the European past. Gironella has appropriated Velázquez's Mariana, making her his own and Mexico's, and by doing so he challenges traditional assumptions about both history and the history of art. He combines references to high culture and to popular culture, to modern mestizo Mexico and to indigenous Mexico, even to Spain's own internal political history. The Mexican colonial past is here too, but, significantly, the yokes are upside down; the burden of the colonial yoke has been inverted, the colonized have become the aggressors. Mariana has been abducted across the Atlantic, dissected and reconstituted – pinned out, helpless, like a sort of cross between a strange character from a colourful carnival, a pre-Columbian sacrificial victim and a cult image of the Virgin, Maria, Queen of Heaven.

The work of the Colombian Fernando Botero (born 1932), while similarly dependent on the works of the Old Masters, makes very different use of them.[15] He is interested in all aspects of Europe's contribution to Latin America, both the art of the European past and those features of Latin American culture which, although naturalized, are European in origin. It

could be said that his art represents an interface between the two. Botero never paints Indians or Indian culture; there are no *ruanas* (the Colombian equivalent of ponchos) in his paintings, no rural poverty, no Amazonian rain forests. His men wear pin-striped suits or army uniforms, the women tight skirts and high-heeled shoes, and they are often disposed across the canvas in ways that echo the portraits of Velázquez or Rubens or Gainsborough. Yet we do not need the smoking volcano in the background or the odd piece of luscious tropical fruit to tell us that this is Latin America. The rich ladies, tin pot dictators, bishops and generals, all wrapped up in comfort and corruption, the whores and salesmen, are the characters that strut the streets of Latin American cities and the pages of García Márquez's novels. They may ape European mannerisms and snobberies but they remain a peculiarly indigenous breed.

Before his first trip to Europe in 1952, when he was twenty, the only original works of art Botero knew were the colonial paintings and sculptures – almost all of them religious – to be found in Bogotá and in his home town of Medellín. Europe was a revelation. His intention had been to study modern art but he was immediately drawn to the Old Masters. In Madrid he discovered Goya and Velázquez, who seemed to be painting a world that was not dissimilar from contemporary Colombia; their portraits of Spanish grandees resembled the Colombian ruling classes in their complacency, their extreme isolation from the rest of their own society and from the world at large. Botero spent months in the Prado Museum copying them, living on the profits from selling his copies. After a summer in Paris, he moved on to copy fourteenth- and fifteenth-century frescoes in Florence – Giotto, Uccello, Piero – and on his return to Bogotá in 1955 he exhibited the paintings he had completed in Florence. The critics said they were derivative and not one was sold. The history of European art includes innumerable examples of great artists who have reworked the artistic ideas of their predecessors without being dismissed as mere copyists, but for Latin American artists to do so is unacceptable.

None the less, Botero's loyalty to the Old Masters of Europe as his true source of inspiration remained unswerving and he held a more successful show in the United States in 1957. By this time he was gaining confidence and really beginning to develop his own style. In 1958 he painted the first version of his *Camera degli Sposi (Homage to Mantegna)*, based on the fifteenth-century frescoes of the Gonzaga court by Mantegna in the Ducal Palace in Mantua. Botero has taken

elements from two different scenes, cramming six figures and a dog (Botero makes it more like a cat, especially in the second version) into a canvas that seems too small for them. They are organized into an almost geometric pattern of flat, overlapping planes, but, although stiff and unmistakably courtly, they remain human, with Barbara of Brandenburg, Ludovico Gonzaga's wife, very much the matriarch at the centre of the composition. These figures already have what we would now recognize as the hallmarks of Botero's style: huge heads, short stocky bodies and a peculiarly fixed, unseeing gaze. In this case the gaze, although present in Mantegna's courtly family, is closer to that of earlier Florentine artists, Giotto and Masaccio, who use it to give their Madonnas, Christs and saints a sense of distance, moral superiority and monumentality. It is remarkable how, in a work specifically derived from and in homage to Mantegna, Botero also manages to convey a sense of the earlier history of Italian art. He sets up a visible artistic lineage of which he, of course, is as legitimate a descendant as any. He does this with a confidence that contemporary European artists would find difficult to match.

In the *Camera degli Sposi* Botero has painted the whole group with the proportions of dwarfs; indeed there is a dwarf amongst them, but the deformation of the other figures makes this less clear than it is in the Mantegna. It is perhaps not surprising, therefore, that he followed up this painting with a dozen or so versions of Velázquez's portrait of the dwarf Francisco Lezcano, *El Niño de Vallecas* (for example, that of 1959, Baltimore Museum of Art, gift of Geoffrey Gates), a figure to which Gironella too has been repeatedly drawn. The portrait of Francisco Lezcano is one of a series of paintings of dwarfs in which Velázquez explores the factors that go to make up physical deformity – the disproportionately large heads and awkward limbs – and in their thoughtful, wise or laughing faces he suggests a disjuncture between the ugly body and the character of the person enclosed within it. In many ways these Velázquez dwarfs provide a starting point for an understanding of Botero's own style. His subsequent work is characterized above all by his use of hugely inflated figures. He denies that they are fat, preferring to call them 'puffed up';[16] it is psychological rather than physical fatness that we are being asked to consider. He paints adults as children and children as adults; indeed sometimes the distinctions are quite unclear. He rejects conventional proportions not only between the head, limbs and body of a particular figure but also between the different figures and objects within the composition. This is a

device used in provincial colonial painting, where the figure of, say, the Virgin will often be enormous in comparison with the angels, saints or donors round about; Botero uses it to similar ends: to draw attention to the most important (or most self-important) people in the picture. 'My subject matter is sometimes satirical,' he has said, 'but these "puffed up" personalities are being "puffed" to give them sensuality. . . . In art as long as you have ideas and think, you are bound to deform nature. Art is deformation. There are no works of art that are truly "realistic".'[17]

Botero's inflated versions of the Old Masters serve, in effect, to deflate their originals while at the same time recognizing their iconic force. As Marta Traba has said, 'Europeans are too impressed by the force of their great traditions to dare to challenge them. . . . We Latin Americans are, in comparison with these responsible men, like acrobats in a puppet show. . . . But this has its advantages too. There is something in us that is dispersed, wandering, vagabond, that makes us lose gravity and that often leads us into tremendously harsh criticism. We walk illogically through the regions of culture without gravity, relieved of history.'[18] Botero certainly 'walks through the regions of culture without gravity'; he borrows from Leonardo, Caravaggio, Sánchez Cotán, Jan van Eyck, Rigaud, Rubens,

FIG. 27 **FERNANDO BOTERO, *LOS ARNOLFINI 3/THE ARNOLFINI 3*,** 1967

Joseph Wright of Derby, Bonnard – artists from different countries and of different periods but who, with the exception of the last, share a tendency to crisp delineation of form and rigorous compositional clarity. He reworks their compositions in his own style introducing changes which in turn can sharpen or even alter our perceptions of the original. In his *Los Arnolfini 3*, 1964, based on Jan van Eyck's *Arnolfini Marriage* of 1434 (National Gallery, London) he uses, in contrast to van Eyck's vertical panel, a horizontal canvas. This has the effect of exaggerating the dwarfishness of his squat plump couple, and, conversely, draws attention to the tall elegance of the originals.

There are other interesting changes, most obviously that of the relationship between the figures themselves. In the van Eyck, Arnolfini is undoubtedly the dominant partner: he holds up his right hand in oath, while his young wife stands demurely by, her hand, palm up, in his, her head tilted towards him with her eyes slightly lowered, and although she is in fact the same height she appears smaller. Botero has reversed this balance. She is considerably taller than Arnolfini, a matronly figure who looks not at her husband but out of the canvas. Instead of her hand lying in his it is she who seems to be patting his comfortingly, while his right hand, two fingers raised, two curled down, is pressed against his cheek in a gesture of thoughtfulness, almost doubt.

When Botero applies his style to subject matter from contemporary Colombia the effect is not dissimilar: it both deflates and draws attention to the strengths and distinctive features of the originals. He depicts a series of clichés from Colombian society that, as in the writings of his compatriot García Márquez, are also recognizable throughout Latin America: well-fed, self-satisfied bishops, dictators and their first ladies and undoubtedly obnoxious offspring. It would be a mistake, however, to see Botero's work as a simple diatribe against the ruling classes, and he himself says he does not paint with hate. He exposes them in all their ridiculous pomposity, but blending sympathy with cruelty he also suggests their fragility and petty anxieties. His paintings do not provide answers, only questions and challenges. Are these merely inflatable toys, full of air and emptiness, which can simply be knocked over or popped by a few well-placed pins of resistance or revolt? Or are they in fact as gigantic, immovable, permanent and insensate as the mountains and volcanoes behind them?

In *The Presidential Family* of 1967 [Plate 12] a bespectacled president and a general stand behind the first lady with her fox fur, gloves and elaborate hairdo. On either side of her are a priest and, to emphasize the continuity of the line, a daughter on her grandmother's knees. They all have the same unseeing gaze as the figures in the early Italian frescoes he had copied so avidly, but here it is entirely bland and untroubled, suggesting social not moral superiority. The references to Spanish traditions of court portraiture are unmistakable in this painting. As Botero put it himself, 'the pomposity of these presidential families that took over Latin American countries like they were their own farms: it was a perfect opportunity to work in the tradition of the court painters, Velázquez, Goya'.[19] In order to make this point clear Botero has painted to the

FIG. 28 **FERNANDO BOTERO, *WAR*,** 1973

extreme left of the frame both himself and the back of a gigantic canvas in imitation of Velázquez's self-portrait in *Las meninas*. Again, the artistic traditions of Europe are a motivating force, and here serve to undermine a reading of this painting as a mere caricature of an unsavoury ruling clique. Velázquez included himself in *Las meninas* out of pride, pride in his own achievement as painter to the king, and pride in his profession; Goya, in echo of Velázquez, had similarly included himself in the corner of his *Carlos IV and His Family*, although perhaps less unambiguously; Botero, with an uncertain degree of self-parody, is clearly demonstrating his artistic lineage.

　　　　Another particularly sharp-edged painting by this artist is *War*, 1973. This is like one of those satellite pictures of the earth – a great hemispherical dome against a black background, but instead of oceans and land masses covered with swirling cloud, the surface of this earth is made up of a tangle of bloated corpses. Most of them are naked, scratched and bruised, a heap of pink, yellow and greenish flesh entwined with spidery pieces of barbed wire. Dead fingers clutch at their earthly props: money, legal documents, weapons, patriotic

flags. A fat general, naked except for his hat, lies near the top of the pile ejaculating into the stratosphere, his right hand raised in eternal salute. The effect is disgusting, ludicrous and pathetic at the same time. This painting draws on the essentially religious iconography of seventeenth-century Spanish *memento mori* subjects such as Valdés Leal's *Finis gloriae mundi* of 1672 in the Hospital de la Caridad in Seville: death corrupts the flesh of everyone regardless of status or morality,[20] yet, however dubious the morality of the individuals concerned, the deaths in Botero's *War*, are premature and wasteful.

Although not a religious man himself, Botero recognizes religion as 'part of a tradition in art'.[21] More generally, he has often stressed the importance of the Church within Latin American culture and society. In his painting *Sta Rosa de Lima* (1966) [Plate 13] his reworking of a traditional theme is especially telling. Sta Rosa was the first American saint. Born in Lima of Spanish parents in 1586, she had a childhood of extreme sanctity and became a Dominican tertiary at the age of twenty. She died in 1617 after a life of self-immolation, penance and good works (and, of course, virginity) and was canonized in 1668 amidst enormous festivities in Spanish America, Seville and Rome. As with female saints in medieval Europe, in order to prove her saintliness to the world she had to deny all aspects of femininity, punishing her body for its beauty by starvation and self-inflicted torture.[22] In art, ironically, holiness in women is traditionally represented by physical beauty. Sta Rosa too, beneath the black and white robes of the Dominican habit, is always depicted in colonial paintings fresh faced and lovely, her femininity emphasized by a crown of pink and white roses around her wimple. In art, as in spirit, she epitomized European beauty and so, despite her dedication to the sick and the needy of the Indian population, she became the heroine of the creole classes. It is into this tangle of established imagery that Botero introduces his version of Sta Rosa, and the irony is immediately apparent. In practice she was a classic case of a holy anorexic; this was how she had been portrayed by the Peruvian Sérvulo Gutiérrez (1914–61) – a gaunt woman of indeterminate age, a Miss Haversham-like figure enclosed in a swirl of garish reds and pinks. Botero moves in the opposite direction to unmask the myth; in his painting, based on a version by the colonial Colombian artist Gregorio Vázquez (1638–1711), she is fat and healthy, moon-faced, with short arms which could not possibly meet across her broad chest, and tiny plump hands holding a cross and a rose. Even her

garments and the roses around her head are fat; she bulges towards the edges of the canvas, swelling almost visibly. She unmistakably belongs to the Botero family of the creole bourgeoisie; perhaps not quite smug, as so many of them are, but certainly contented in her faith.

The European legacy inherited by contemporary Latin American artists is not, of course, confined to the art and history of the European past. As Botero's work demonstrates, it includes the European class system, the associated political hierarchies and above all, the Church. When Tamayo argues that Velázquez is as legitimate a source of inspiration for Gironella as the baroque churches of Mexico can be for others, his parallel is not a close one. Velázquez's paintings remain, for the most part, firmly screwed to the walls of European museums, whereas the Church is fully present in Latin America. Sta Rosa exemplifies one of the ways in which the Christian Church in Latin America is both foreign and indigenous, one of the ways in which it has become embedded in Latin America. The impact of the Church on Latin America is immeasurable, but so too is the impact of Latin America on the Church. Some of its aspects remain almost unchanged, unmistakably European in origins, others have merged with elements of native American or African traditions in such a way that the component parts are still recognizable; some are transformed almost beyond recognition. The Church almost inevitably evokes political tensions. The buildings themselves – especially the magnificent baroque and rococo constructions that even in remote villages often have intricately carved façades and astonishingly rich gilded and polychromed interiors – inevitably embody the paradoxes of past and present, the power of the Church, the devotion of the poor. These churches were built during the colonial period; the taxes and labour tributes exacted to enable their construction played an important part in establishing social inequalities that have often persisted to the present day. On the other hand, the Church in Latin America remains very popular, especially amongst the poor and oppressed; it is frequently an important force behind movements for social change. The tension between the Church's traditional role as upholder of the status quo and the liberation theology of the radical priests has become increasingly important.

Since Latin America, and particularly Mexico, has experienced repeated waves of anti-clericalism Orozco's fresco of *The Friar and the Indian*, 1926 (National Preparatory School) must be read as deeply ambivalent. Is the friar in fact

comforting or suffocating the emaciated figure of the Indian? Is the friar's embrace simply a covert form of neo-colonial oppression? Although Orozco and his fellow muralists rarely exploited the fact, there is something subversive or potentially subversive in popular religion. A popular cult brings together large numbers of people, usually from the poorer classes, under one banner. The miraculous image of the Mexican Virgin of Guadalupe is a good example of the way an aspect of the Church has become so completely naturalized that it has acquired the status of something indigenous and in direct opposition to the traditions of Europe. The Virgin of Guadalupe, protectress of the Indians because she first revealed herself to an Indian, became the symbolic patroness of the nationalists during the struggle for independence and of the revolutionaries during the present century. Ironically, the image is an entirely orthodox representation of the Virgin of the Immaculate Conception – that peculiarly complex theological issue so hotly debated during the sixteenth century in Europe but of little concern to the Indian populations of Mexico.[23] More generally, but equally ironically, the religious fiesta, in origin among the most Iberian of customs, has become so closely associated with indigenous groups that it is now rarely seen as having any European affiliations. This is especially and tragically the case in Guatemala, where the traditional Catholic fiestas amongst the Mayan Indians are frequently banned because the authorities believe the food prepared on such occasions could be used to support the guerrillas.[24]

In all its various manifestations – political, social and spiritual as well as artistic – the Church offers artists in search of their own cultural identity an alternative to the imagery of the non-European cultural traditions of Latin America. However paradoxical it may seem, the Church in Latin America has come to represent a sort of fixed point within a constantly fluctuating reality. Several artists have explored the way the same images, paraphernalia, buildings, and pilgrimage routes have been used by successive generations and constitute important markers across time and space. Asked about his inclusion of parish priests within his *œuvre*, Botero has said, 'Priests were somehow contemporary, but they were out of the Middle Ages.'[25] A nun with a rosary, a bishop with a crucifix: the vestments as well as the attributes could refer to the present or to the sixteenth century. As has been seen, Gamarra uses such iconography to suggest that past and present are continuous, even coeval. Other artists have used churches, especially baroque churches, to similar ends.

This is especially true in Brazil. Unlike the often ambivalent attitude of Spanish America to Spain, Portugal tends to be regarded by Brazilians rather like a distant, elderly cousin, as something quaint and insignificant. Portugal was not the home of influential figures of art historical stature equivalent to Velázquez and Goya, and no Brazilian artist seems to have been obsessed with the art of the European past in the way that Botero or Gironella have been. As a result, the Church is probably the most important source of European artistic influence in Brazil. The white-washed rococo churches of the eighteenth century are a source of justifiable national pride, in the same way that baroque churches are for Mexico. As was seen in the previous chapter, Teresa d'Amico includes a rococo façade alongside Afro-Brazilian imagery in her *Paisagem Encantada* of 1963,

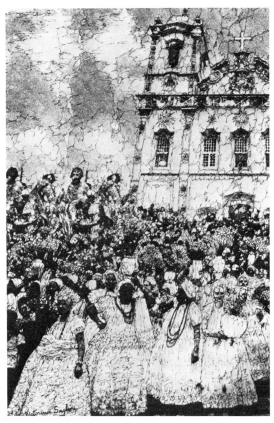

FIG. 29 **VICTORINA SAGBONI, *LAVAGEM DO BONFIM/THE WASHING OF BONFIM*, 1978**

demonstrating the range of cultural elements which go to make up her enchanted vision of Brazil. Other artists such as Fernando Lopes (born 1936) and Victorina Sagboni (born 1932) have repeatedly used colonial architecture to locate their works firmly in Brazil. In Sagboni's *Lavagem do Bonfim/The Washing of Bonfim*, 1978, which represents a popular religious festival in Bahia, the fine-line drawing technique exaggerates the florid qualities of the church façade, establishing a visual parallel with the white, lacy dresses of the women in the foreground. The church may evoke Europe and the colonial past, but here it is indissolubly linked with the Brazilian present, with the predominantly black and mulatto procession.[26]

Alberto de Veiga Guignard (1896–1962) has painted bird's-eye views of the mountainous landscape of the mining province of Minas Gerais with tiny baroque or rococo churches

perched on the lesser peaks and linked together by ribbons of road.[27] He vividly suggests a landscape which lives, and through which people move for reasons of commerce, pilgrimage or social intercourse; this is a landscape with a history. Many of the artist's scenes could be placed as easily in the seventeenth as in the twentieth century. Moreover, he uses techniques which lend his pictures the atmosphere of ancient maps of parchment or hide: a pale ground over which he works thin oily washes, or dabs of thicker paint which make the surface look old and worn. Sometimes, as in *Festa Junina/June Festival*, 1961, crowds of people like black ants are gathered in the atria of the churches for the fiesta and send huge, brightly coloured hot-air balloons into the sky. These roads and colonial churches have been used in identical ways for centuries, but in this case a tiny steam train emerges from a tunnel in the centre of the composition, locating it within the last hundred years. Veiga Guignard suggests a conflation of the colonial and the modern. Ironically, the hot-air balloons have been banned within the last few years because of the number of forest fires they cause, so these pictures now have an unintended nostalgic atmosphere. Other artists, such as the Mexican Valetta Swan (1904–73) and the Peruvian Jorge Vinatea Reinosa (1900–1931), have also used the church in the landscape to suggest the overlap of historical periods and to create a sense of a living landscape with traditions rooted far back in the past. Although the visible iconography of such subjects refers to the period since the conquest of America, an infinitely longer time period can also be inferred because during the conquest period churches were habitually positioned on sites of ancient ritual significance, serving as the spiritual, geographical and often astronomical markers for the local and wider populations.

The Christian Church is central in an entirely different way to the work of another Brazilian artist, Raimundo de Oliveira (1930–66). Oliveira is unusual amongst recent Latin American artists in that his subject matter is almost exclusively drawn from the Bible.[28] He could be said to represent a response to the European traditions of art that is in direct opposition to that of artists such as Gironella and Botero. Self-taught, he developed an individual style which to an extra-ordinary degree avoids reference to both the iconographic and the formal conventions – the concern with verisimilitude and recessional space – of mainstream European art since about 1400. This means that it is possible to see in his art similarities with that of several different countries and eras – Egyptian wall-paintings, Ethiopian manuscripts, early Christian mosaics,

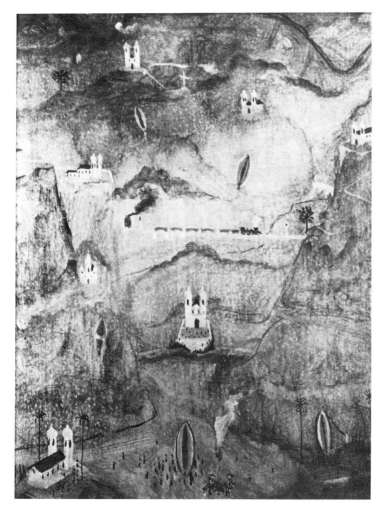

FIG. 30 **ALBERTO DE VEIGA GUIGNARD, *FESTA JUNINA/JUNE FESTIVAL,*** 1961

the stained-glass windows of medieval cathedrals, the picto-graphic screenfolds of Mesoamerica – that all share the same flat planes and preference for simple frontal or profile figures. What is also remarkable is the lack of influence from the enormous body of European-derived religious imagery. These are not naive versions of compositional and iconographic types established in, say, fifteenth-century Italy and reworked with endless minor variations in colonial churches throughout Latin America. They are entirely fresh visions of the familiar stories from both Old and New Testaments: Jacob's Dream, Joseph and His Brothers, Moses in the Bullrushes, the Nativity, the

FIG. 31 **Raimundo de Oliveira,** *Chegada à Belém/Arrival in Bethlehem,* N.D.

Flight into Egypt, the Road to Jerusalem. His *Chegada à Belém/Arrival in Bethlehem,* for example, depicts a row of seven almost identical tall yellow towers, each with six red windows or pairs of windows and a red door at the bottom. At the foot of the right-hand tower Joseph and Mary are being turned away by the inn-keeper, watched by six figures who lean out of the tower windows in a diagonal line from the figure in the window immediately above Mary's head to the figure in the top window of the tower on the left. Despite the almost cartoonish quality this is not a touching little real-life anecdote; the mathematical organization of gesticulating onlookers and their uniformity of colour (all the figures including the main protagonists are dressed in red and have green faces and hands) gives the picture a seriousness that is typical of Oliveira's work.

As well as the Christian Church, a number of other individual elements of European culture have become so entirely naturalized into Latin America that it would be perverse to think of them now as foreign imports. These include, for example, guitars, horses, bulls, cockerels and, although it is a slightly different case, the iconography of the conquistador himself. All have provided a rich fund of images for Latin American artists, as (with the exception of the last) they did for Picasso, who returned to them repeatedly from

his self-imposed exile. The Colombian Alejandro Obregón (born 1920) goes so far as to imply, by combining in his brilliantly coloured paintings references to guitars, bulls and the Andean condor, that these elements are equivalent; that this particular type of European import constitutes a parallel to the native American imagery of the Andes. In fact in popular Peruvian iconography the bull has changed sides, joining the upper ranks of the supreme pantheon of non-Christian Andean deities, along with the condor, the puma and the *amaru* or serpent. But more commonly these assimilated features are used to represent the mestizo aspects of Latin American culture. In Tina Modotti's photographs of the late 1920s which include combinations of a guitar, sickle, maize cob and bandolier, the guitar is as emblematic of *mexicanidad* as any of the other elements. At the same time the combination of images stands for a much more universal concept of a revolutionary peasantry.[29] To some extent, the way the guitar, for example, has become a standard element of a still life since the Cubist works of Picasso and Braque, means that such imagery can also be used to refer to a general tradition in Western art, a self-conscious device that draws attention to the work of art *as art*, without deliberate local or national connotations.

The iconography of the conquest and the conquistadors lacks such connotations internal to the history of art itself; it is unmistakably located in time and place. The conquerors were Spanish or Portuguese, but they are remembered for their part in the history of Latin America. Even glorified images of the conquistador in Spain, such as the bronze equestrian statue of Pizarro in the main square of his birthplace, Trujillo, draw their force from the imagery of Latin America, not vice versa. The traumatic upheavals of the conquest are commemorated in innumerable popular traditions and festivals throughout Latin America. In villages in highland Peru, schoolchildren ritually re-enact the murder of Atahualpa every year. In Bolivia the dress of the men of the Potosí region includes leather helmets based on those of the sixteenth-century Spanish soldiers. In Mexico, particularly in Oaxaca, Guerrero and Jalisco, festivals often include mock battles between the Christians and the Moors in commemoration of the Spanish successes in Spain in the fifteenth century as well as between the Spaniards and the Aztecs, the latter usually terminating with Moctezuma's capitulation to Cortés. The conquest is also, significantly, a common subject amongst naive or popular artists who have not received formal training and who work

FIG. 32 **ALEJANDRO COLUNGA, *NIÑOS JUGANDO A SAN JORGE/CHILDREN PLAYING AT ST GEORGE,*** 1981

more or less outside the gallery network of high art. It is common because it is still relevant and meaningful.

The image of the conquistador, with shining armour, deadly weapons and snorting horse, is a powerful one. As has been seen in the case of Gamarra, it tends to merge with images of famous Christian conquerors of pagans and/or devils and dragons: Santiago, St George, St Michael. In *Niños jugando a San Jorge/Children playing at St George*, 1981, Alejandro Colunga ironically conflates the two under an umbrella of childish fantasy: a small boy sitting astride a pantomime horse. Nevertheless the dominant image is less of toys and games than

of aggression real and assumed. The writhing dragon, worthy of a medieval illuminated manuscript, is fighting for its life, breathing fire into the face of the horse. The horse, however, breathes smoke back at it from the filtered cigarette it holds nonchalantly between its teeth. Apart from his shorts and stripy socks, the childish St George is not a benign figure: he is dressed up as a conquistador with a feathered helmet and a ruff at his neck and a ferocious expression on his face as he wields his stout sword. The lacy caparison of the horse evokes the elaborate finery of the colonial aristocracy, while the trousered legs which appear from beneath it suggest a Trojan treachery.

The Peruvian painter Armando Villegas (born 1928) also draws on the imagery of the conquest and colonization, the extravagant use of lace and jewels and beaten steel. The sense of translucent gauzes and laces laid over silk, velvet and brocade suggests an artistic lineage that goes back to the eighteenth-century paintings of elaborately dressed militant archangels to be found in Andean churches and, beyond them, to the art of the European Renaissance. Villegas is another of those Latin American artists who creates an effect of the passage of time, making his works look as if they have survived from an earlier era. In his many pictures of knights in armour the paint surface seems faded, worn and grimy. The faces that watch from within the canvas seem to be gazing down through the centuries and often have vacant or faintly puzzled expressions. *Caballero del cardo/Knight of the Thistle*, 1978 [Plate 14], with its fantastic silver helmet, could be a mythologized conquistador, a crusader knight or a militant saint, but because this is Latin America it also evokes a pre-conquest figure of the type of the eagle knight from Aztec Mexico and, more generally, the assumption of personae as a part of a shamanistic ritual. In his more recent *Noble en máscara/Masked Nobleman*, 1986, the dominant image of the knight in armour is again overlaid with echoes of the other cultures and historical periods which make up Latin America's present. Like Gironella's *Queen of the Yokes*, this is an image of European origins. In the form of the conquistador, the knight in armour is also essentially Latin American, a figure from the colonial past. In so far as the helmet is a completely fantastic extravaganza, this is something from popular culture, from a carnival in which, for purposes of both serious ritual significance and entertainment, people assume masks and identities other than their own.

Latin American artists have sought a personal or national or continental sense of cultural identity in numerous

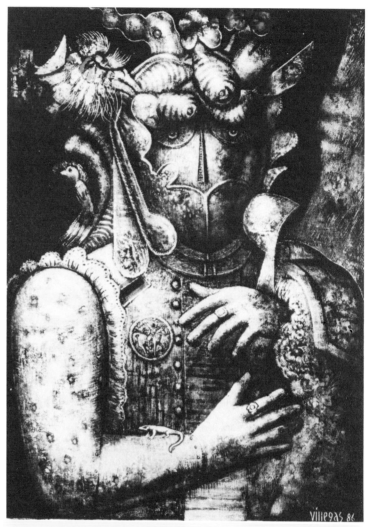

FIG. 33 **ARMANDO VILLEGAS, *NOBLE EN MÁSCARA/MASKED NOBLEMAN*,** 1986

different ways: through the land and landscape; through the Amerindian, Afro-American and mestizo traditions of past and present; through a direct confrontation with the art of the European past and the iconography of spiritual and material conquest; and through reinterpretations of popular culture. This exploration of possible identities and subjects, together with the related theories and debates, can be traced back to Mexico in the second and third decades of this century. A consideration of the muralists, and in particular of Rivera,

Orozco and Siqueiros who – rightly or wrongly – have come to be seen as the Big Three of the movement, therefore forms a bridge from these broader issues to a closer consideration of the relationship between contemporary Latin American art and that of Europe and the United States. Just as Gironella uses the art of the European past as his subject matter, reworking it into something entirely original, so other artists have used modernism in similar ways, transforming not so much its subject matter but rather its styles and techniques into art forms with distinctive, appropriate, Latin American resonance. The muralists are central to this discussion not only because of their international renown but also for the way in which they raised – in theory as well as in practice – so many of the themes which have remained dominant for artists throughout Latin America ever since.

CHAPTER 3

THE POLITICS OF LATIN AMERICAN ART

It is evident from earlier chapters that to talk of the politics of Latin American art is also to discuss the politics of Latin America. The realm of the political cannot be confined to the subject matter of art; it also permeates the entire spectrum of its production and consumption. While the interest of both Picasso and Gironella in Velázquez displays a painterly fascination with the art of representation itself, Gironella's work also refers to the culturally specific nature of the formal languages of art. Similarly, Gamarra's reworking of the accepted myths of Latin American landscape is dependent on an inversion of both the subject matter and the formal devices of earlier European art. The work of these artists reveals a heightened awareness of cultural politics that is symptomatic of Latin American art as a whole.

In one sense, this awareness is the logical outcome of the colonial process, within which cultural forms are traditionally incorporated into political rhetoric. Since the sixteenth century when the Spanish colonists systematically demolished the Aztec capital of Tenochtitlan in order to rebuild Mexico City in the image of Spain, the inseparability of cultural production and political representation has had to be acknowledged.[1] In Latin America there exists a self-consciousness as to the symbiotic

relationship of art and politics, an awareness of the politics of art that is frequently subsumed by aesthetic discourse in Europe and North America.

Any discussion of the relationship of art and politics within the context of contemporary Latin America evokes the Mexican mural movement of the 1920s and 1930s. It is the muralists Diego Rivera (1886–1957), José Clemente Orozco (1883–1949) and David Alfaro Siqueiros (1898–1974) who have come to represent both a specifically Latin American art and a politically committed aesthetic. It is also in the work of these artists that the complexities of Latin America's visual culture, and its relationship to that of Europe, are coherently discussed for the first time. In the 1930s, for many radical artists and intellectuals throughout the world, it was Mexico and not Paris that stood for innovation in the arts. Artists in Mexico were seen to have challenged the authority of a Eurocentric aesthetic and asserted the values of a self-consciously post-colonial culture. The Mexican revolution of 1910 had set the scene for a series of cultural debates as to the nature and purpose of art. The most famous of these emerged from what is frequently known as the 'Mexican Mural Renaissance'. During this period the prolific energies of a group of young painters were unleashed on to the walls of publicly owned buildings with the aim of proclaiming the values of the 'new society'. While ostensibly dealing with specifically Mexican concerns, the work of the muralists also addressed far wider issues of art practice, challenging traditional notions of the materials and ownership of the art work. They were also among the first Latin American artists to refer not just to the outward symbols of the pre-Hispanic past but also to the overall aesthetic of indigenous culture.

The historical emphasis on the collectivity of the Mexican movement, while understandable, often leads to a simplification of the theoretical debates they initiated. Each of the 'Tres Grandes', as these artists are referred to in Mexico, can be seen to manifest conflicting beliefs as to the nature of their shared enterprise. They all embraced the practice of muralism as a means of producing what they called 'ideological works of art for the people'.[2] Yet their attitudes to materials, to the pre-Hispanic past and to the specifics of formal representation varied enormously. Such differences were given added importance by the political arguments implicit in their more general aesthetic disagreements.[3]

The experience of the revolution sharpened an already existing sense of dissatisfaction among Mexican artists

and intellectuals with their country's dependence on European or North American validation of its cultural initiatives. The nationalist interests of painters mentioned earlier such as José Velasco and Dr Atl merged with a growing awareness of the directly political functions of art. The mural movement, originally engendered by José Vasconcelos,[4] the education minister of the government of Alvaro Obregón, fed upon the fertile antagonisms of its protagonists. In the wake of the Mexican revolution Vasconcelos aimed to utilize the skills of his country's artists as part of a more general programme of popular education. Once given access to the walls of public buildings, however, Rivera, Orozco and Siqueiros proceeded to develop their own particular blend of aesthetics and radical politics which was frequently at odds with those of their government patrons.

Diego Rivera was the most prolific and initially the most internationally acclaimed of the muralists, acting as a link between the avant-garde aesthetics of Europe and growing Mexican debate as to the nature of revolutionary art. In 1907 Rivera had travelled to Europe on a state scholarship, and over the next decade he became an active member of the Parisian avant-garde, exhibiting with the Cubists.[5] In 1921, at the invitation of Vasconcelos, he returned to Mexico. The education minister then took pains to confront Rivera with his *mexicanidad*, financing the artist's trips to the pre-Columbian ruins of the Yucatán Peninsular and to the tropical region of Tehuantepec (which was to remain an inspirational image of his native country throughout the artist's life) with the general aim of helping to construct a 'national' art.[6]

Siqueiros also saw the need to formulate a new aesthetic that was less dependent on the seemingly unrelated preoccupations of a Parisian art world. While still studying in Europe in 1921 he had issued a call for 'a new direction for the new generation of American painters and sculptors'.[7] This plea for artists to reject the 'sick branches of Impressionism' had little of the assertively anti-colonial stance of his later writings, yet it highlighted a widely held dissatisfaction with the pre-revolutionary art of his native country. By the next year a collective of artists that included Siqueiros had formed themselves into the 'Syndicate of Technical Workers, Painters and Sculptors'.

The manifesto issued by this group in 1922 was drafted by Siqueiros and signed by Rivera, Orozco and many other idealistic artists in Mexico; it was to set the tone for the aesthetic debates of the next two decades.[8] The 1922 manifesto

directed itself to 'the native races humiliated for centuries' as well as workers, peasants and 'intellectuals who do not flatter the bourgeoisie', thereby outlining the political priorities of its signatories. After asserting that the 'art of the Mexican people is the most wholesome spiritual expression in the world' the authors went on to repudiate the elitist qualities of easel painting and praise 'monumental art in all its forms because it is public property'.

Although highly rhetorical, this formulation of the fundamental issues defined the areas of later discussion. First, the need to address the concerns of their own culture; secondly, to transform the materials and formal conventions of art, and, finally, to destroy the function of the art work as a commodity. To a certain extent similar concerns were emerging internationally, for example among the German Dadaists or the Constructivists in the Soviet Union. The output of these movements was formally and stylistically divergent, but it emerged from a shared desire to transform the traditional criteria of art. However, the racial and cultural mix of Latin America frequently allowed additional levels of political meaning to those produced by radical European artists.

Orozco, like the German artist George Grosz, used the language of caricature and the satirical broadsheet.[9] Both artists developed an often biting yet expressive allegorical style with which to comment on contemporary life. Grosz drew on the melodramatic images of cheap magazines – the so called 'penny dreadfuls' – to impart to his works an accessible vocabulary. Similarly, during the revolutionary decade in Mexico, Orozco produced numerous cartoons and caricatures in the style of the Mexican popular draughtsman and engraver José Guadalupe Posada (1852–1913).[10] The most famous of the devices used by Posada were his irreverently macabre skeletal figures, the *calaveras* which, as an essential feature of the Day of the Dead celebrations in Mexico, have become archetypal images of Mexican popular art. The ability of Posada to capture contemporary events in the darkly humorous form of the *calavera* was greatly admired by Orozco and the majority of his colleagues.[11] They found in Posada's prints an art that was both widely accessible and politically direct.

The influence of Posada is apparent in later murals by Orozco such as *The Gods of the Modern World*, 1932, part of the Dartmouth College cycle.[12] Orozco's allegory of twentieth-century culture depicts the representatives of modern education as clothed in the gowns of academia but with blank skull faces.

They grimly attend the birth of their new messiah, a stillborn foetus emerging from the contorted joints of its skeletal mother, whose bones rest on discarded tomes of defunct knowledge. The work is a homage to the satiric power of Posada, but Orozco instils the wry humour of the *calavera* with a more pervasive darkness. While the popular artist's works had a dry detachment, the mural has the sombre quality of a death march.

FIG. 34 **JOSÉ GUADALUPE POSADA, *CALAVERA*** (SATIRE ON CONTEMPORARY NEWSPAPERS), C. 1889–95

Despite such alterations in tone the reference to the forms of popular art is deliberate and intrinsic to Orozco's aesthetic. Just as Grosz's communist politics had led to the adoption of street literature and graffiti as a stylistic device, so Orozco uses Posada to break from the dominance of academic art conventions. For both artists these aesthetic decisions deliberately challenged the criteria of fine art, yet Orozco's use

FIG. 35 **JOSÉ CLEMENTE OROZCO, *GODS OF THE MODERN WORLD*, 1932**

of popular art also carried explicit reference to his country's mestizo culture. The *calavera* exists not just as an earthy reminder of the ridiculous nature of human pretensions in the face of death but also refers to the elision of pre-Hispanic and Christian religions in Mexico's continuing cult of the dead. Orozco believed strongly in the need to emphasize the hybrid nature of his culture by not simply rejecting the Hispanic in favour of the pre-Hispanic. For him the satiric language of Posada was multi-purpose, allowing for discussion of race, class and aesthetics simultaneously.

Despite changing attitudes towards Mexico's pre-Hispanic cultures, Orozco consistently refused to question traditional accounts of their barbarity.[13] In fact, Rivera's fascination with the pre-Hispanic past caused frequent disagreements with both Orozco and Siqueiros, who viewed his meticulous reconstructions of that past with extreme scepticism. Orozco saw little need for the growing idealization of the Indian roots of Latin American culture, seeing it as a negation of the realities of contemporary existence. He is quoted by Rivera as going so far as to state, 'In a people of Indians we feel as if we were in China.'[14] For Rivera, however, the pre-conquest cultures of the Americas formed a vital political counterpoint to the values of colonialism. He developed an almost obsessive interest in native civilizations, particularly that of the Aztecs. In his National Palace murals the depiction of the pre-Hispanic world and of the famous Aztec market-place of Tlatelolco are instilled with a sense of order and harmony at odds with the planned chaos of the scenes of colonial history. To some extent, Rivera's interest in historical narrative is analogous to the concerns of the Russian film-maker Sergei Eisenstein (an affinity acknowledged by Eisenstein who based part of his uncompleted Mexican project *Que Viva Mexico!* on Rivera's work).[15] Both film-maker and painter were attempting to create a visual equivalent to Marxist historical theory, to use the past to illustrate the political realities of the present. However, unlike his Russian colleague who was utilizing a totally new material, Rivera was attempting to combine the visual languages of Europe and ancient America. His epic narrative compositions, of which the National Palace mural is perhaps the most ambitious, almost 'unfold' along the walls they cover, emulating the pictographic screenfold books of ancient Mexico. Rivera constantly searched for ways to incorporate the artistic conventions of native America into his overall aim of a publicly accessible art. By asserting the complexity of Mexico's pre-colonial civilizations the artist was

able to attack the dominance of European culture, which for centuries had denied the value of that past.

At times Rivera's enthusiasm had disastrous consequences. When working on the murals of the Ministry of Education, a mammoth project covering over 1,500 square metres of wall space, the artist experimented with the use of nopal juice as a binding material for his pigments.[16] The viscous fluid from this native cactus was thought to be a secret ingredient in pre-Hispanic mural painting, and Rivera hoped to 'naturalize' the Italian fresco technique he had revived. Unfortunately, this commitment to the development of a uniquely Mexican material led to opaque staining and cracking of the paint surface as the organic matter in the nopal juice began to decompose. Despite its associations with the Italian Renaissance, Rivera returned to the use of traditional fresco recipes culled from fourteenth-century European sources.[17]

Rivera's use of fresco, and the deliberate integration of his compositions with the forms of colonial architecture, was seen as politically unacceptable by Siqueiros. The materials of art were, for Siqueiros, of equivalent importance to its subject matter and composition. He saw no point in transforming the content of a work of art yet leaving the fundamental substance of the work the same. One could, as he put it 'play a revolutionary anthem on a church organ but it is not an instrument suitable for the purpose'.[18] Believing all aspects of the art work signified the values of the society in which it was produced, he invented ways of incorporating the technologies of modern architecture, factory production and photographic processes into the practice of muralism. The art of Latin America was not being produced in a cultural vacuum, and Siqueiros's ideas reflected widespread concerns. European radicals such as Bertolt Brecht and Walter Benjamin were also urging artists and writers not to 'start from the good old things but the bad new ones'.[19] Designers and artists in Germany, involved in the educative programme of the Bauhaus,[20] addressed the same theoretical issues but from the opposite direction. Art there was taken to mass production rather than the techniques of mass production being taken to art.

It was Siqueiros, however, who, at the beginning of the 1930s, brought modern industrial paints and tools, such as spray guns and nitrocellulose paints, into the repertoire of the artist. In 1936 by means of his 'experimental workshop'[21] in New York these transformations in the materials and techniques of art were introduced to a generation of young North American painters which included figures such as Jackson

Pollock. The need to reassess traditional dependencies on the innovations of the European avant-garde seemed just as pressing in North America as it had done in post-revolutionary Mexico. North American artists were as sensitive to the charge of parochialism as their Latin American neighbours.

All three muralists produced work that both aroused controversy and was acclaimed in the United States. In 1932 the overtly anti-imperialist subject matter of Siqueiros's mural *Tropical America* led to his expulsion from the United States.[22] In 1933 Rivera's patron John D. Rockefeller ordered *Man at the Crossroads* to be destroyed after the artist refused to remove a portrait head of Lenin from his allegory of the modern age.[23] Despite such conflict with the American establishment, or possibly because of it, the Mexican movement continued to be viewed as an inspirational model by many North American artists.

The example of their Latin American counterparts offered the demoralized artists of the US Depression a vision of art as both meaningful and functional. The administrators of President Roosevelt's 'New Deal' for the arts, the Federal Arts Project, promoted state-sponsored murals in imitation of the apparent success of the Mexican government's adventurous cultural policy. Young North American artists who were faced with new forms of patronage and an unfamiliar medium looked to the more experienced Mexican proponents of this 'public art' for inspiration and technical guidance.[24] However, when North America moved into the cold war era of the 1940s and 1950s, New York emerged as the geographic centre of Western culture and links with the politically assertive aesthetics of the Mexican revolution became increasingly unfashionable. As is frequently the case in transferences of power, the new custodians of the faith guarded it more jealously than ever. The North American painters and critics of the 1950s from Jackson Pollock to Clement Greenberg[25] emphatically stressed the formal purity of their art, its universality and its debt to the European tradition represented by artists such as Picasso. The direct influence of Latin American painters whose work questioned the simple causality of such claims was effectively denied. Connections between the 'New American Painters' and the radical aesthetic debates of the Mexican Movement were dismissed and the peripheral nature of the latter reaffirmed.

A line of descent was seen to have passed directly from European Surrealism to Abstract Expressionism. Any offspring from the pre-war flirtation with an art capable of

standing in opposition to the modernist aesthetics of the European avant-garde was denounced as illegitimate. This dual process of exclusion allowed for the appropriation of many of the formal devices of the Mexicans' self-consciously Latin American art, while intensifying North American claims of distance from the debates within which they were formulated. In turning to muralism Mexican artists, such as Rivera and Siqueiros, had questioned the basic premises of art production, asking not only questions of a formal nature but also demanding a right to determine who owned the product of their labours. Their work and extensive discussion as to the desired materials and techniques of revolutionary art had an influence which spread beyond the specifics of muralism and set the agenda for many post-war developments in North American art. The size of the painted surface, the introduction of industrial paints and spray guns, compositional scale and the ritualization of the art process all draw on aspects of the earlier Mexican initiative.

The importance of these contributions was progressively effaced by post-war North American histories of modern art. This point was made forcibly by Siqueiros himself in 1960: 'It is very significant that at this time no figurative artist of the social-revolutionary trend has been invited to exhibit his works in the United States. Is it not extraordinary that the Museum of Modern Art in New York has seen fit to eliminate these painters from their publications? It is obvious that imperialism prefers an art which is deaf and dumb, an art which says nothing, hears nothing, and even sees nothing.'[26]

While Siqueiros held to his belief in the intrinsically reactionary nature of pure abstraction, the justness of his claim is to some extent irrelevant. It is also perhaps futile to argue for the inherently radical qualities of figurative art, the lines of definition between the two forms of representation are themselves blurred beyond distinction. It is, however, a telling fact that in the late 1950s the Organization of American States (OAS) should choose to promote abstract art movements in Latin America.

In this sense a false opposition emerged which posited formal experimentation as antithetical to political meaning. Since the interweaving of art and politics is a determinant of Latin American culture, such an argument becomes tautological. Within Latin America distinctions between formalist concerns with materials and technique and the ability of the art work to address the political realities of the twentieth century are fluid and interactive. Muralism as an art practice

retains its associations with political change and explicitly socialist ideology and has had a notable resurgence in both Chile and Nicaragua.

The speed with which the Pinochet regime in Chile whitewashed the murals produced during the Popular Unity government is indicative of the continuing potency of the muralist tradition. During the Allende years lively debates as to the relationship of art and revolutionary politics had re-emerged. Identifying with the collective ideals of the Mexican movement, the Chilean artists sought to avoid the constraints of a formulaic social realism with all its propagandist associations. The initial muralist brigades were formed during the election campaign that brought Salvador Allende to power, the most famous of these being the Brigada Ramona Parra. These collective groupings of artists flourished on the edge of the law, regularly pursued by the police, leaving behind them hastily executed images of political opposition.

After Allende's election to power in 1970, similar brigades sprang up in towns throughout Chile. In an attempt to preserve the ideals of anonymous collectivity most adopted the name of the movement's most famous exponents and were also known as the Brigada Ramona Parra. Stylistically many of the murals were a cross between strip cartoons and Picasso's work of the late 1930s, transforming the agonized imagery of *Guernica* into joyful images of pride and hope. A whole ideology would be encoded in a few recurring forms; Allende's bespectacled face; the head of Che Guevara; the hammer and sickle; the clenched fist. The Chilean flag was soon referred to obliquely, by either its colours or the star, one motif blending with the next so that a fist would become a face or flowing hair a flag. In Riveraesque style combinations of guns, ears of wheat and factory chimneys symbolized the united aims of military, agricultural and industrial workers.[27]

The violent suppression of muralism in Chile in the aftermath of the Pinochet coup in 1973 merely reinforced the medium's radical associations. Since the overthrow of the Somoza regime in Nicaragua in 1979 muralism has again emerged as a visible manifestation of socialist ideals of art. Many of the murals have been produced by foreign 'brigades' of artists; some Chilean, some from the United States, Canada and even Holland. The overall impetus, however, has come from trained artists, such as Alejandro Canales and the Italian Sergio Michilini who founded the National School of Monu-mental Public Art in 1985. The emphasis in Nicaraguan muralism is, as in Chile, on iconic images of national unity and

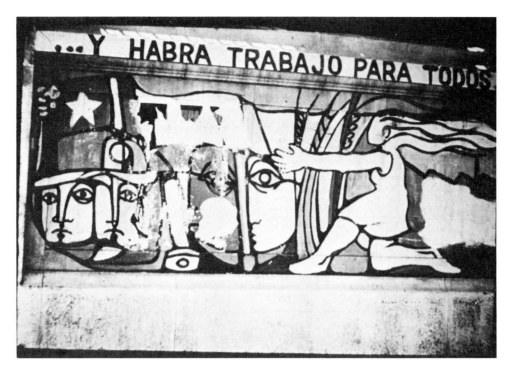

FIG. 36 **CHILEAN MURAL,** *Y HABRÁ TRABAJO PARA TODOS/And There Will*
Be Work for All, SANTIAGO, C. 1972

international solidarity. Sandino himself, allegorical female
revolutionaries or the bespectacled Carlos Fonseca (the founder
of the FSLN who was assassinated in 1976) all join the
international imagery of the clenched fist or the hammer and
sickle. The Mexican muralists, therefore, initiated important
debates concerning art and politics. They also illustrate clearly
the politics of cultural power in an art world that seeks to
divide hemispheres into cultural 'producers' (the First World)
and cultural receivers (everywhere else). One or two further
examples should clarify this important issue.

 The tokenistic assimilation of Latin American
artists into mainstream Western art history would be an
interesting example of cultural interaction, if art production
could be seen as separable from the wider issues of world
politics. Any detailed analysis of Latin American art, however,
demonstrates the impossibility of such a separation. The
criteria of 'modernity' in art, as is the case in the industrial
organization and political structures of Latin America, are
dependent on European prototypes which define marginality in

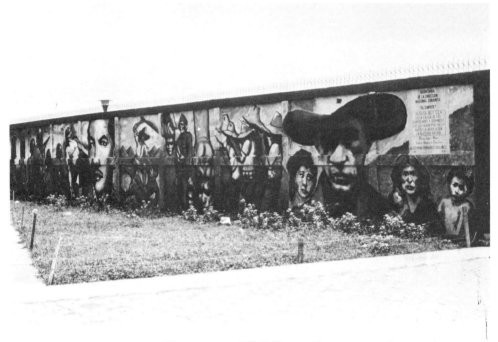

FIG. 37 **MURAL ON THE FSLN (FRENTE SANDINISTA DE LIBERACIÓN NACIONAL) CENTRE,** MANAGUA, NICARAGUA, 1980

Eurocentric terms. The history of modern art, which typically runs from Cézanne to Abstract Expressionism, and insists upon the Paris/New York axis, does not exist as *a* history, it is dependent on being *the* history of modernism. The much lauded '-isms' of twentieth-century art exist within a strict and linear progression which is also rigidly hierarchical, allowing no deviation from its prescribed route. Art production outside of these highly limited terms of reference is by definition peripheral.

While similar observations could be made in relation to the historical development of many other cultural forms, the dominance of a unitary model is particularly unquestioned in the visual arts. The belief in the valedictory power of cultural centres such as Paris or New York exists as a basic tenet of art history and practice, with a hold on those disciplines even greater than that exerted by Hollywood on world cinema.

The centrality of this historical model is also reinforced by the current art historical interest in a multiplicity of 'national' schools of painting. Such categorizations serve as

ancillary forms of the more obviously Eurocentric modernist histories. Essentially, they suggest that regional duplication of the basic paradigms of 'modern art' proves the inauthentic nature of art produced beyond the boundaries of that defined as 'real'. To find Argentine Surrealists or Brazilian Pop artists consigns such work to the realm of peripheral duplication, condemned to be eternally derivative.

In this schema definitions of originality become highly subjective. The stereotypical Latin American artist is frequently characterized as working within outmoded and discarded European idioms; the poor relation for ever clothed in cast-offs.[28] If recognized artists such as René Magritte or Max Ernst refer to the work of the Italian painter Giorgio De Chirico, they are seen to be transforming the original. Yet, when the Argentine artist Antonio Berni does the same it becomes replication. These culturally specific definitions ignore the complexities of the Latin American response to the edifice of European culture. The formal languages might be those of mainstream art practice, but the application and attributed meanings of such languages are transformed by the shift in cultural context.

The work of Antonio Berni (1905–81) is a useful example of this more general phenomenon. Passing through a whole gamut of twentieth-century art styles, from De Chiricoesque Surrealism to the social realism of artists such as the American Ben Shahn, Berni continually elided formal eclecticism with the demands of his own politics. In a work such as Los astros sobre Villa Cartón/The Stars above Villa Cartón/Cardboard City, 1962 (sucesión Berni), the artist uses a style obviously descended from Ernst's grattage technique. By scraping the pigment from a canvas stretched over a variety of uneven surfaces, Ernst produced textured components, which would, as he put it, 'see the importance of the author being reduced to a minimum and the conception of talent abolished'. Ernst used this technique to produce a series of primaeval landscapes, ancient forests of his dreams and childhood memories. Berni, on the other hand, uses the dislocated shapes, forms and textures to describe the cardboard shanty towns which ring so many urban conglomerations in Latin America. The collaged additions of mesh and battered metal become cogent references to the ingenious poverty of such locations, where recycled refuse forms a mainstay of everyday existence. What for Ernst functioned as a subversion of traditional aesthetics in Berni's hands becomes a far more direct political weapon. It is in the ways in which Berni refers to the concerns

of early modernism, however, that much of the power of his work resides. The ironic parody of Ernst's archetypal images of nature underlines the transience of his own materially and politically man-made subject matter.

The growing world dominance of North America in the post-war period presents a further complication of the traditional pattern of colonial relationships, particularly pronounced in the case of Latin America. Within Latin America, the United States frequently occupies an incongruous position as both aggressive interventionist power and political and social ideal. It holds what the poet Octavio Paz calls 'an ambivalent fascination' for Latin Americans, simultaneously functioning as 'the enemy of our identity and the unacknowledged model for what we would most like to be'.[29] North America is, after all, merely the north of the Americas, potentially sharing many of the cultural concerns of its southerly neighbours. It too experienced the clash of cultures, the constraints of colonialism and the fight to assert independence which forms a core of commonality within Latin America. The fact that such a unity exists only in the political dreams of the Organization of American States, underlines the realitites of North America's interventionist policies in Latin America. The ambivalence of the cultural interaction of the two halves of the continent, however, imposes an explicitly ideological reading of North American values.

Recognition of this issue and of the wider implications of the politics of marginalization are well illustrated by the work of Frida Kahlo, and the reception it has been given. As a Mexican and a woman Kahlo represents a dual form of marginalization within the essentially patriarchal norms of modernism. The 1980s has seen a revival of international interest in her work, largely initiated by recognition of the iconic status of her multiple self-portraits. The emphasis given in her work to the body, to personal emotion and to motherhood provided a visual counterpart to a growing feminist art history. However, within the terms of this recent recognition of her art she has also come to represent an archetypal image of woman as victim. As an artist she has been ascribed an almost naive self-absorption and her admittedly great physical and emotional traumas have been seen as the major impetus of her art. Despite the laudable aims of such a reappraisal, it does little to address her active role in the formulation of a language of art which questioned neo-colonial cultural values. In fact, her current status embodies both aspects of the modernist 'other', the feminine and the

unconscious, which are consistently used to characterize Latin America itself.

In a less obvious way, the current interest reinvokes the initial espousal of Kahlo by the European Surrealists who, by imposing upon their chosen 'natural surrealists' the passivity of an anonymous *objet trouvé,* painlessly incorporated the exotic and the unexpected into Surrealist dogma. The very recognition accorded to Kahlo has simultaneously denied her an active and participatory role in the formation of a specifically Latin American art, or as existing within the specifics of her own cultural history.

Few authors have chosen to identify in her work the self-conscious play on such categorizations which gives her paintings their eloquent presence and reveals Kahlo as a highly sophisticated artist. When she chose to depict herself as standing between the cultures of North and South America, she was superficially referring to the actual border between Mexico and the United States. Her *Self-Portrait on the Borderline,* 1932, is a small painting on metal in the style of a Catholic votive image, and shows the artist poised between the technological inhumanity of a capitalist North America and the

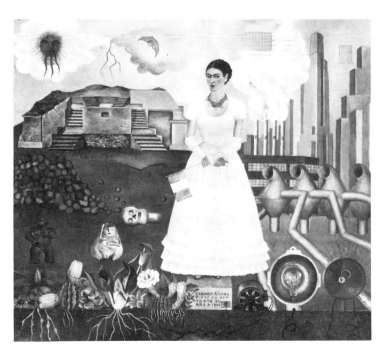

FIG. 38 **FRIDA KAHLO,** *SELF-PORTRAIT ON THE BORDERLINE,* 1932

archaic fertility of Mexico. Interwoven with these images are subtler references to the metaphorical borderlines which separate Latin American culture from that of Europe and North America. This is done by a series of juxtapositions; the past versus the future; female nature versus masculine technology; growth versus exploitation; and in its very material presence, the traditions of fine art versus those of the popular. At the same time, Kahlo uses her own image to highlight the ambiguity of her position. The pre-Hispanic necklace she wears contrasts with the colonial dress, the paper flag of her homeland with the 'modernity' of the cigarette held in her other hand; her role as both painter and wife is underlined by the use of her married name on the commemorative signature beneath her feet. In this work Kahlo presents us with a particularly coherent analysis of the issues which continue to underlie contemporary art practice in Latin America, while at the same time avoiding a denial of her own complex relationship to the cultural myths she uncovers.

The conjunction of the personal with the political, intrinsic to Kahlo's aesthetic, has given her work an almost cult status with an international audience aware of the prerequisites of feminism. In this sense interest in her work can co-exist with the persistent representation of Latin American art as propagandist and as standing in opposition to the formal experimentation of modernism. As has already been seen, such definitions traditionally exclude the Mexican muralists from any causal relationship with the aesthetics of post-war North American art. The emergence of New York as the main setting for post-war avant-garde experimentation has further complicated the position of the Latin American artist. There is indeed a certain irony in the fact that the North American appropriation of the modernist tradition was in itself an attack on the hegemonic authority of European culture, and as such an assertion of aims shared by many radical Latin American artists.

While the mural continues materially to assert the public function of the art work, the debates as to the nature of Latin American art initiated in Mexico underlie a diversity of contemporary art practice. The deliberate appropriation of Catholic iconography by the Mexican muralists, particularly apparent in Rivera's elegiac images of Emiliano Zapata, is continually re-used in the Latin American representation of political leaders. In one of Gironella's versions of *The Death of Zapata* of 1974, the Mexican national hero stands on an altar like a martyred saint, his body peppered with bottle-tops. The famous (though traditionally unattributed) poster of Che

FIG. 39 **ALBERTO GIRONELLA, *MUERTE DE EMILIANO ZAPATA/DEATH OF EMILIANO ZAPATA*,** 1974

Guevara designed by Tony Evora in 1968 in which the head of Che grows out of the continent itself, is an eloquent example of this rhetoric of martyrdom. More recently, Armando Morales's *Adios á Sandino/Farewell to Sandino*, 1985 [Plate 15], uses the deliberately worn texture of his painting of the Nicaraguan revolutionary to evoke the timeless presence of a sanctified Sandino. Like Christ with his disciples, he stands in isolated collectivity – an unashamedly iconic image of national identity.

This heroic rhetoric has a particular resonance in Latin America, yet its very knowingness allows for ironic inversions such as *Collage on Bolivar* of 1979 by the Colombian Juan Camilo Uribe (born 1945). Here the familiar image of a

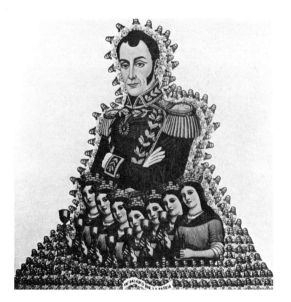

FIG. 40 **JUAN CAMILO URIBE, *COLLAGE ON BOLIVAR*, 1979**

matinée idol version of Simon Bolivar is surrounded by a Christian aura which parodies the humorous vitality of popular art. A similar iconoclasm imbues Nelson Leirner's installation piece, *Altar of Roberto Carlos*, 1967, though here the essential interchangeability of the popular hero is made explicit by Leirner's canonization of one of Brazil's then teen idols, the singer Roberto Carlos. The work of Uribe and Leirner pokes fun at the obsessive deification of the individual in Latin American culture, but it also pays homage to the materials and techniques of popular art by attempting to harness their syncretic energies.

The satire becomes more focused in works such as Jacobo Borges's (born 1931) *Meeting with Red Circle* or *Circle of Lunatics*, 1973, or *Los papagayos/The Parrots*, 1986 (collection of the artist, Bogotá), by the Colombian Beatriz González (born 1936). Both painters use a dark humour to evoke a world of political corruption and menace, the pomp and hypocrisy of the military dictatorship. Borges's painting (the inspiration for a short story by the Argentine writer Julio Cortázar) with a minimum of descriptive detail manages to reveal the terrifying immorality of political oppression. The initial composition derives from an earlier painting *Esperando a. . . /Waiting for . . .* of 1972, in which Borges reworked a posed photograph of Venezuelan officials. As in González's *Parrots*, the rhythmic repetition of studious pomposity in this work undermines the self-proclaiming importance of the subjects. Colour and pattern subsume the individuality of the unspecified political bureaucracy, yet their very anonymity is threatening. *Meeting with Red Circle* is a more studied variation on this theme, however, and Borges juxtaposes this oligarchic grouping with a dramatic expanse of red canvas and includes a naked woman among the seated figures [Plate 16]. The state portrait is transposed to a brothel, the public image slips to reveal its private immorality.

FIG. 41 **NELSON LEIRNER, *ALTAR OF ROBERTO CARLOS*,** 1967

FIG. 42 **JACOBO BORGES, *ESPERANDO A. . . /WAITING FOR. . .*,** 1972

The sharply divided canvas reads as an amalgam of the 'new figuration' and abstract colour field painting, a potentially straightforward aesthetic confrontation. It is a testament to the transformational capacities of Latin American art that the shimmering field of red paint and abstract form is metamorphosed into a blood-soaked carpet.

CHAPTER 4

THE SURREALIST CONTINENT

The formulation of a visual language capable of encompassing the divergent traditions of representation intrinsic to modern Latin America has been the goal of many twentieth-century artists, from the Mexican muralists through to young Brazilian artists such as Fernando Lucchesi. However, in finding a formal signifier of cultural identity it is difficult, if not impossible, to dislocate the work of Latin American artists from the frequently analogous concerns of more traditionally recognized art practice. Throughout the twentieth century the concerns of artists in Europe and North America have had an obvious impact on the art of Latin America, yet it is important to recognize the particular significance of movements such as Surrealism or abstraction within a non-Western context.

Often the ideas of their European contemporaries would themselves contain specific references to issues of particular relevance to Latin American artists. Nostalgia for lost innocence, for the ritual power of the art of the past with its mysterious codes and patterning, had an added political dimension in many Latin American countries. The pre-conquest past, though often just as alien to their contemporary life as it was to a Parisian avant-garde, constantly served to differentiate Latin American culture from that of Europe.

Reference to that past carried with it the implicit awareness of the colonial conflict. Interest in the art of the continent's ancient inhabitants was not a simple rejection of accepted traditions of representation as it was for artists such as Picasso; it was also an assertion of the special identity of their own culture.

On another level the incorporation into the practice of fine art of the art forms of subcultures and the whole spectrum of material which falls into the Latin American categorization of 'arte popular' called into question not just class and gender but also race. Even in the work of those exiled artists absorbed into the mainstream of Western art, the governing criteria of their art appear different from a Latin American perspective. The processes of cultural syncretism at work are frequently overlooked but can add greatly to the understanding of particular artists' output.

It would be difficult, for example, to locate the work of the Uruguayan artist Joaquín Torres García (1874–1949) without some knowledge of the aesthetic debates of Piet Mondrian and Theo van Doesburg.[1] Yet his paintings are equally dependent on an understanding of the aesthetic conventions of the pre-Columbian civilizations of ancient America. Most of Torres García's creative activity emerged outside of Latin America. At seventeen he had returned with his family to Spain, spending the bulk of his working life in either Barcelona or Paris. His first contact with the pre-Columbian past was probably in the collections of the Musée de l'Homme in Paris rather than in his birthplace.[2] Yet it is equally obvious that the impact of that past on his work was of a very different nature to, say, that of Toltec sculpture on Henry Moore.[3] A work such as his *Indoamérica* of 1938 is a homage to both the Neoplatonic ideals he shared with his Dutch contemporaries and the stylized geometry of ancient America. As such it is not an exploration into the exotic but an attempt to unify the shared characteristics of his separate heritages. Torres García's attempts to find universal proof of the validity of abstraction as a basis for contemporary art practice were dependent on an awareness of difference and collectivity: the separate traditions of the old and the new world and the need to negotiate the space between the two, to find the space that he himself occupied. The need to explore the past, to locate the distant body of the many-headed Hydra of contemporary culture, remains a strong motivating force for many Latin American artists, whatever the specific idiom of their work.

While the modernist recognition of early forms of

abstraction has a specific resonance in Latin America, it is not the most powerful of conjunctions of interest. Surrealism, of all twentieth-century categorizations of artistic form, technique and subject, has had the most pervasive impact on the art of Latin America. The concerns and priorities of the movement, originally formed around the pronouncements of the French poet André Breton[4] were both nourished and consumed by the diverse art practices of Latin America. Breton was initially involved with the anarchic Parisian Dadaists, but from the 1924 publication of his *First Manifesto of Surrealism* he became an increasingly power-ful force in the European avant-garde. The relationship of the

FIG. 43 **JOACHÍN TORRES GARCÍA, *INDOAMÉRICA*,** 1938

mainstream of Surrealism to what was perceived as the marginalized, yet truly authentic, world of art production beyond the boundaries of European art represents a complex model of artistic symbiosis.

The doctrines of Surrealism developed out of the European experience of the First World War and the trans-formations of art and literature engendered by that cataclysmic event. However, its continued survival was at least to some extent based on its claims to be both international and subversive. Breton's search for the fixing of 'a certain point of the mind at which life and death, the real and the imagined, past and future, the communicable and the uncommunicable, high and low, cease to be perceived as contradictions'[5] gave Latin America, in particular Mexico, a privileged place within Surrealist writing. He saw Mexico as a 'naturally surrealist' location, embodying the very contradictions essential to Surrealism.[6]

The conflicts within the post-colonial cultures of the continent presented fertile new pastures for the Surrealist explorer, who found in the ancient, the popular and the self-consciously political art of Latin America a visual language of

opposition. The fascination with Mexico, evidenced by Breton's *Souvenir du Mexique* of 1939, in which both the poet's visit and the place itself take on iconic importance, played upon the country's function as cultural gateway. On one side lay the rational, ordered oppression of the established European civilizations so hated by the Surrealists, on the other the mysterious chaos of the irrational and unknown represented by the native cultures of America. The complex blend of race and religion, of native and exile, oppressed and oppressor was seen to manifest itself in the visual culture of Latin America, which like a bilingual text functioned as an access point – that fixed conjunction searched for by Breton between the perceived polarities of human existence.

At the same time Surrealism offered the Latin American artist a place at the high table, welcoming proof of the movement's internationalist aspirations. The Cuban Wifredo Lam (1902–82) and the Chilean Roberto Matta (born 1911), though both working primarily outside of Latin America, embodied those aspects of their native culture most admired by the European exponents of Surrealism. It is ironic that the very process of their acceptance into that movement simultaneously defused the most explosive components of the two artists' work, absorbing the specific into the general, transforming the original into the derivative. Lam has been continually overshadowed by his role as Picasso's protégé,[7] while Matta has been consigned to the position of go-between: the Surrealist disciple evangelizing the New York art world.[8] It is rare for either artist to be recognized as directional, as addressing specifically Latin American issues or as manifesting the problematic relationship of colonial and post-colonial cultures. Nevertheless, the work of these artists provides an important precedent and highlights issues of continuing relevance to a younger generation of Latin American artists.

The international reputations of Lam, Matta and their Mexican contemporary Rufino Tamayo (born 1899) also serve to illustrate some of the generally held stereotypes of the Latin American artist. Surrealism defined itself as primarily preoccupied with 'otherness', whether expressed through insanity, social deviancy or the strangeness of differing cultural norms. The function of the Surrealist was to act as a catalyst, transforming banalities into bayonets, seeking out and unleashing subversive tendencies within his own culture, to undermine from within a society seen by Breton as a 'petty system of debasement and cretinization'.[9] The movement subjected to particular attack the belief in a rational ordered universe

governed by an all-seeing beneficent deity, represented by the accumulated heritage of classical philosophy and Christian morality.

Traditional contraventions of this Graeco-Christian model of social order were embraced as revolutionary anteced-ents of the Surrealists themselves. The perceived opposites of 'civilized' values were sought out and adopted as emblems of the Surrealist cause. In Third World countries caught in a battle for some measure of cultural independence, Surrealism offered a validation of their own internal languages of rebellion. Dreams and magic replaced reason and morality, the shaman usurped the priest.

Latin American artists attempting to confront the contradictions of their heritage, to forge a cultural identity which encompassed the divergent strands of colonial history, could find within Surrealism a prioritization of their own concerns. The interest of an artist such as Lam in the Afro-Caribbean roots of his own and Cuba's past, could be easily absorbed into the European avant-garde's fascination with African sculpture and 'voodoo' ritual. It is important, however, to distinguish between attempts to consolidate a fragmented culture and the symbolic appropriation of others. Lam's paintings debate the nature of syncretism as a means of understanding his own culture and in that sense have radically different aims to superficially similar works by Picasso. Lam had been introduced to the Spanish painter in 1938 and both artists had recognized in each other's work a shared fascination with African art. In a painting such as *Luz de arcilla/Light of Clay*, 1950 [Plate 17], the reference to Picasso's *Guernica* (1937) is obvious, a self-conscious play as knowing as Picasso's own numerous reworkings of Manet or Velázquez. The sombre tonality and explicitly parodied outstretched hand look back to the form and iconography of Picasso's monumental treatment of the inhumanity of war. The sexual ambiguity of the composite forms of Lam's mysterious creatures also refer to Picasso's fascination with the visual pun, with the shifting identity of the drawn image. It is important to remember, however, that such fascination itself grew from Picasso's interest in African sculpture.

The angular forms of African sculpture, first encountered by Picasso in the ethnographic collections of the Palais du Trocadéro, continued to permeate his work throughout the century, became a standard component of his visual vocabulary, and were eventually absorbed into the wider languages of twentieth-century art. It is that interest, and the

FIG. 44 **PABLO PICASSO, *GUERNICA*,** 1937

issues raised by the modernist recognition of the existence of culturally divergent forms of visual representation, which serve as the starting point of Lam's aesthetic. In *Luz de arcilla* the tripartite division of the composition presents the spectator with a complex *ménage à trois*; strange creatures with both human and animal characteristics confront each other in an enclosing darkness. The shadowy background has the warm brownness of Velázquez or Goya rather than the deliberately modern cinematic monochrome of *Guernica*, immediately putting Lam's painterly discussion into the past tense. This darkness of the picture surface congeals and evaporates; like primaeval mud it both forms and conceals its inhabitants. These figures seem caught for ever in a sexual ritual evoking memories of Marcel Duchamp's *Large Glass*[10] with its fixed co-ordinates of desire and frustration, yet that work was suffused with the bright light of the scientific laboratory. Here the setting has the mysterious drama of a jungle clearing and the almost sweaty darkness of the tropical night.

The background figure on the left stands alone, a homage to Lam's distant African heritage, the abundantly female buttocks and belly surmounted by an impassively masked head. The sharp lines associated with African sculpture overlay the unmistakable form of the famous 'Venus of Lespugue', the prehistoric fertility figure referred to over and over again by Picasso in the 1930s. The combined phallus/vagina imagery of this ancient figure serves to emphasize the antagonistic duality of the principal characters, while simultaneously

representing an idealized unification of both physical and cultural divisions. The composite forms of the two central figures are dominated by the recognizably equine characteristics of hoof, tail and muzzle. This horse may belong to the stable of Picasso but it is equally that of the sixteenth-century conquistador, it carries with it the ambivalent relationship of Lam to the European legacy in the Caribbean. The light which both illuminates and activates the protagonists, however, is the ritual light of *santería*, the syncretic Afro-Cuban religion of Lam's childhood memories.

If the iconography of a work such as *Luz de arcilla* is given meaning by the specifics of Latin American history, it is also important to recognize the formal self-consciousness of Lam's visual language, since it is this level of conscious play which is so consistently denied to artists defined as outside the mainstream of the 'modern'. Lam's painting is as much about painting as it is about history. European conventions interweave with those of Cuba's racially disparate cultures, producing a complex reflection on the nature of representation itself.

In this context the relationship of Lam's art to that of Picasso becomes particularly interesting. As a Spaniard in Paris, Picasso had been constantly aware of the icons of Spain's 'Golden Age', and his work abounds with references to El Greco, Velázquez and Goya. This glorification of his own past vied with the need constantly to redefine the parameters of his visual vocabulary, plundering at will the varied non-European art forms that caught his eye. The 'Hispanic' Picasso, frequently subsumed by his Parisian gloss, has a particular resonance in the Latin American context. He can be seen to embody the contradictory values of that continent's colonial heritage – Cortés and Velázquez, exploiter and redeemer, rapist and father. As the exiled Picasso, the painter of *Guernica* and the political radical at odds with the Spanish Church and the regime of Franco, he could stand for the positive strands of Latin America's Hispanic past. However, as an archetype of revolutionary modernism he continues to represent the exclusively colonial characteristics of modernity itself. In painterly terms Picasso was often a beneficent colonial explorer, proudly parading the spoils of his conquests. Lam wryly inverts such practices, revealing the cultural politics at the heart of the languages of art. At the same time as traditional appraisals of Lam's work frequently see no further than the exotic, the problems addressed by his paintings are masked by an unshakable faith in the unique authenticity of Picasso's art.

Picasso can construct languages, others merely use them; the conscious manipulation of Picasso's style does not conform to Lam's perceived role as acolyte.

While Lam is seen as stylistically derivative, few question the uniqueness of the contribution of Roberto Matta. In fact, the opposite can be said to be true; Matta is, if anything, isolated in his uniqueness. Breton espoused Matta with the fervour of an ageing Don Juan faced with impotency. He initially found in the work of his new protégé all the Surrealist virtues by then perceived as lacking in artists such as Dali. In 1944 he could declare, 'It is Matta who holds the star most steadily above the present abyss which has swallowed all the features of life that might make it priceless.' At Breton's prompting Matta had produced what amounted to a Surrealist critique of the rationalist strands of modernist practice; his 'Mathématique sensible – architecture du temps'.[11] In this short written 'presentation' piece (which appeared in the spring edition of the Surrealist magazine *Minotaure* in 1938) Matta recanted the teachings of the great modernist architect Le Corbusier in whose architectural practice he had been training since 1934. Deliberately parodying his former teacher's credo of 'Mathématique raisonnable',[12] Matta called for 'walls like damp sheets which deform themselves and marry our psychological fears', and offered a denunciation of a logically pure modern architecture.[13]

For fellow Surrealists, Matta's conversion to the movement represented a victory over the forces of scientific law and designed order, but also symbolized the unleashing of his Latin American soul from the constricting body of Eurocentric rationalism. Matta's work, during his decade as Breton's chosen Surrealist painter, exemplifies not only Surrealism but also the values of otherness traditionally imposed upon the colonized subject. Such an elision was intrinsic to the subversive practice of the Surrealist, yet simultaneously reinforced restrictive stereotypes of Latin American culture.

The intrinsic characteristics of post-Renaissance European art were seen to be dependent on the mathematic surety of perspectival space, the painter's skill lying in the ability to manipulate and mask the strict conventions of art's secret geometry. Earlier twentieth-century painters, such as the Cubists, had attacked the European dependence on illusionism, emphasizing the flatness of the canvas and the process of painting as an end in itself. Matta's work of the 1940s broached similar issues but viewed them through the optical distortions of Surrealist automatism. His approach was not to deny the

existence of an illusionistic picture space but to create a giddy world of shifting floors, collapsing skies and literally vanishing horizons. To enter into the painted universe of Matta is to lose all certainty in the governing laws of matter, a pun much played upon by the artist himself. A painting such as *A Grave Situation*, 1946 [Plate 18], presents the spectator with a series of contradictions; the room without walls, an interior exterior inhabited by strange objects which seem in the process of constant assembly and deconstruction. Dominating the composition is an authoritative composite figure – a living machine, both insect and human, with the timelessness of an Egyptian deity. It stands like a science-fiction school teacher surrounded by the spinning desks of absent pupils. Matta presents us with the perfect world through the looking glass, where solids dissolve and past and future converge.

In Matta's paintings from this period perspective is not confronted and discussed, as it was by the Cubists, it is inverted. As a Surrealist painter he revealed the parallel universe of contradictions so constantly evoked by his colleagues. Within a Latin American context, however, his imploded and chaotic worlds are typical of the obverse nature of otherness. It seems too cogent a coincidence that Matta's fall from Surrealist favour and ensuing expulsion from the movement in the late 1940s was initiated by his desire to evolve a more assertively cerebral art form. His growing interest in the work of Einstein and search for a 'form of reason that can reason the eternal new' (Matta, May 1977)[14] challenged his role as representative of unreason.

More recent works, particularly his *Storming the Tempest* drawings of 1982, reveal an awareness of Latin America's complex relationship to Europe. The drawings illustrate the colonial myths at the heart of Shakespeare's *Tempest*[15] and construct a contemporary allegory of cultural co-existence. Matta's 'Brave New World' is one able to accommodate both the magical technology of a colonialist Prospero and the native energy of its indigenous Ariel. Despite his long-standing appreciation of the pre-Columbian cultures of America, Matta recognizes that the rigid oppositions of the initial conflict – Prospero versus Caliban, Spanish conquistador against Aztec warrior – have lost definition in the racial mix of colonial Latin America.

Nostalgia for the pre-conquest past of the continent carries with it a constant reference to the colonial process but at the same time can serve to deny the complex realities of the culturally hybrid present. For Matta, Ariel is that indefinable

FIG. 45 **ROBERTO MATTA, *STORMING THE TEMPEST,* 1982**

spirit of the New World, free yet enslaved, elusively denying characterization. He both serves Prospero and plots against him but through all retains his own magical identity. On a formal level the drawings employ both the stark pictographic qualities of an ancient Mexican codex[16] and the automatist unpredictability of Matta's familiar style. Both the protagonists and the formal languages are endowed with culturally symbolic meanings, the pre-conquest, colonial and post-colonial being articulated by alternating visual means.

For Torres García, Lam and Matta the problem lay in bridging the gap between the current languages of the modernist avant-garde and the requirements of being Latin American artists. The Mexican Rufino Tamayo's work responds to rather different demands. Like his contemporaries Lam and Matta, he has a recognized presence within traditional art history and like them he spent much of his working life outside of Latin America. Admired as a great colourist, Tamayo is seen to unite the concerns of Picasso, whose work has had an acknowledged influence on his own, and Matisse. However, his primary reputation outside Latin America rests upon his opposition to the didactic aims of the Mexican muralists.

At the height of the mural movement in the 1920s and 1930s, Tamayo chose to disassociate himself from his contemporaries. In so doing he initially excluded himself from the mainstream of Mexican art. Opting, as Octavio Paz has put it, 'for solitude, criticism. He refused to reduce his art to yet another form of political rhetoric and he decided to pit his own idiom against the so called national style of painting.'[17] In the long term this 'criticism' has tended to enhance rather than detract from his work. In terms of the continuing marginalization of the self-consciously political art of Latin America, Tamayo's work is traditionally judged as exemplifying the return to painterly values, a defusing of the threatening aspects of the Mexican aesthetic debates. While the muralists publicly denied the function of painting as a commodity, the work of Tamayo

is both decorative and assertive of painting as an object unto itself. His highly collectable works embody, more so than those of any of the other artists being discussed, the acceptable face of Latin American art: not too different to be challenging but manifesting an exoticization of recognizable and familiar painterly forms.

Tamayo's status within Mexico is also helped by the international, particularly North American, approval of his work but his unquestioned pre-eminence is evidence of a more substantial basis to his reputation.[18] Whatever the reasons for Tamayo's popularity abroad, for many Mexicans he also epitomizes vital characteristics of their culture. This is not just by virtue of longevity (although he does represent a physical link with the most dynamic period of art production in Mexico, managing to outlive his exact contemporaries Orozco and Siqueiros, and the younger Kahlo). Probably the most telling of the characteristics of Tamayo's work is his ability to synthesize coherently the prevailing trends of mainstream art practice and the specific concerns of contemporary Latin American culture, while maintaining a formal originality. References to other artists seem strangely distanced from the often subtle yet haunting presence of the paintings, with their dense, worn surfaces. Picasso, Dubuffet and Rothko are all evoked in terms of their formal languages but Tamayo does not appear interested in the more knowing modernist game of deliberate reference.

A possible exception is Picasso's *Guernica*, which emerges again as the primary source of a language of Latin American modernism. After seeing the painting in New York where it was installed in 1939, Tamayo's work of the 1940s revealed his increasing interest in allegory and animal archetypes. In such paintings as *Animales/Animals*, 1941, and *Leon y caballo/Lion and Horse*, 1942, the debt to Picasso is made clear in the upturned heads, taut bodies and expressive distortions of the animal subjects. At the same time there are important differences between the animal imagery of the two painters. Picasso uses such references emblematically, as familiar cultural symbols, and plays upon their long histories of associated meanings. In Tamayo's work the animal protagonists are stripped of these references to a literary and artistic tradition; they have none of the deliberate artificiality of Picasso. They are more the *nahual* spirit guides of the shaman than the heraldic representations of abstract concepts.[19] In this transformation of shared motifs, Tamayo articulates the preference of many of his contemporaries for the generalities of the Jungian

FIG. 46 RUFINO TAMAYO, *ANIMALES/ANIMALS,* 1941

FIG. 47 RUFINO TAMAYO, *LEON Y CABALLO/LION AND HORSE,* 1942

archetype over the classicism of Freud. This preference, however, is also determined by the importance placed in Jung's writing on native American cultures.[20]

Like most twentieth-century Mexican artists the pre-Columbian past features prominently in Tamayo's work, not as the specific narrative of the work of Diego Rivera or as the political metaphor of Siqueiros, but as distant archetypes of human behaviour. The dogs featured in *Animales* are related to the famous pre-Columbian clay effigies from Colima but in the final instance they are not to be read as specifically Mexican dogs.[21] They are generic dogs, whose existence outside of Tamayo's painting is not important. Similarly, in a later work such as *Carnavalesca*, 1974, the presence of pre-Columbian sculpture is evoked but never described.

It is in the surface of the paintings themselves that the links between past and present are made most forcibly. However brightly coloured, Tamayo's images seem sun-bleached and weather-beaten, as if discovered by an archaeologist rather than an art critic. The textured surfaces of his paintings have a false patina of age which constantly contradicts the self-conscious modernity of their formal composition. They assert their distance from the conspicuous 'newness' of much modern art, claiming a similar appearance of artistic prescience to that of an ancient Cycladic sculpture in a collection of modern art. This formal denial of modernity, deliberate masking of the textures of the industrial world, is a frequently used device among Latin American artists. It serves as a visual proof of the uneasy relationship seen by many Latin Americans to exist between the colonial past and the technological power of their North American neighbour. It reinvokes the divide set out so cogently by Kahlo's *Self-Portrait on the Borderline* [see Fig. 38].

The archaic fragility of Tamayo's paintings is also a feature of the work of artists such as the Nicaraguan Armando Morales or the Peruvian Tilsa Tsuchiya. In a work such as Morales's *Two Figures*, 1970, the distressed texture is reinforced by the subject matter. Here the reference to the archaeological past is more explicit. The two female figures of the title sit astride strange plinths reminiscent of Mexican temple platforms. Both have articulated limbs which evoke memories of the Surrealist Hans Bellmer's fetishistic dolls.[22] The figure on the left merges into the stone of the architectural setting, while her upper torso with its missing arm has the sculptural qualities of a classical Venus. Like the rock from which she has been carved, dark forms twist and converge behind her. By contrast, the figure facing her is flesh and

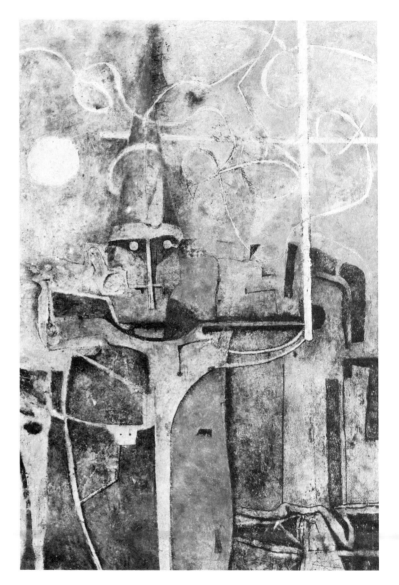

FIG. 48 **RUFINO TAMAYO, CARNAVALESCA,** 1974

blood, with an almost photographic reality clothed by the artificiality of her doll-like legs. The artistic signifiers of the ancient world of both Europe and America serve as the mirrored image of a not quite formed present.

Tilsa Tsuchiya's *Machu Picchu*, 1974, which has already been discussed in a different context, deals with a

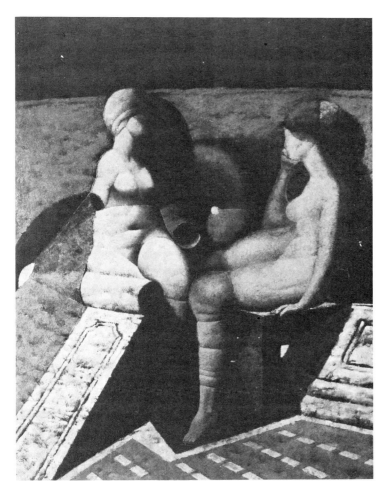

FIG. 49 **ARMANDO MORALES, *TWO FIGURES*,** 1970

similar theme. Here the translucence of the surface is also used
to connote the oxygen-starved altitude of the eponymous Inca
city. Again, a female nude emerges out of obviously pre-
Columbian stonework, yet none of the components of
Tsuchiya's picture seem fixed. They float between an alternating
series of meanings, as nebulous as the mists which cover the
bulk of the painting's surface. The twin peaks of Machu Picchu,
which flank the central figure, seem to have split apart to reveal
her. Horned shadow spirits flit across their surface, like the
onlookers of a darkened theatre auditorium. The Inca stonework
on which the figure rests reflects the rounded curves of her
body. Navels, breasts, feet and schematic faces emerge from

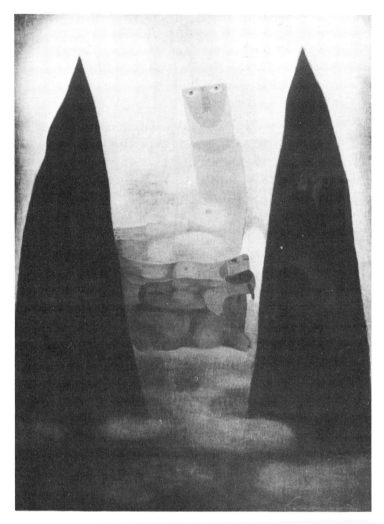

FIG. 50 **TILSA TSUCHIYA**, *MACHU PICCHU*, 1974

the stone and then slip back into the coiled form of a sculpted serpent, yet no one facet of its shifting appearance dominates. While recognizably female, the main figure takes the unmistakable shape of the famous Intihuatana or 'hitching post of the sun', the most prominent of Machu Picchu's sacred stones.

As in the Morales work, there is an obvious formal conflict at play; in this instance between the illusionistic curves of the torso and the geometry of the mask-like head. The painting is made up of such oppositions; the phallic form of the Intihuatana contrasts with both the female contours that

encompass it and the womb-like parting of the peaks; the solidity of the Andean rock is denied by the surrounding clouds; while the painting is also a battleground for conflicting traditions of representation. The visual languages of the Old World and the New, of illusion and abstraction, fuse, denying the polarity of the two. Tsuchiya, like many Latin American artists, seems fascinated by the formal dialectics presented by the conjunction of Amerindian and European art. Through the discussion of essentially painterly concerns the political realities of contemporary Peru emerge, the artist addressing the problematic relationship of a mestizo culture to its disparate forebears. Moreover, the work is assertively gendered, from the self-consciously sexual composition to the choice of subject matter, Machu Picchu being frequently associated with the virginal priestesses of the sun god.[23]

The deliberate archaizing of the paint surface is also a recognizable feature of the work of the direct heir to Tamayo's position as official representative of Mexican art, Francisco Toledo (born 1940). Like Tamayo, Toledo is a native of Oaxaca. Of Zapotec descent, his paintings, prints and ceramics attempt to unite the themes of folk culture and high art. The hieratic animal and human figures he depicts are transformed, by the large scale of the paintings, into iconic symbols of his own special system of ritual. The surface of his paintings is frequently enriched with sand, enamels, acids and even gold dust and appears to have been etched and rubbed to a glowing iridescence. More directly symbolic than the work of Tamayo, their physical presence is reminiscent of early cave paintings. In *Mujer con liebre/Woman with Hare*, 1970, this archaic gloss is so convincing that it comes as a shock to see the frivolous stilettos worn by this archetypal woman, or the mischievous smile on the face of the hare. Despite the wry playfulness of such features, the image retains a ritual power.

Toledo's knowledge of the literary traditions of native Mexico frequently surfaces in his work. The complex Maya Books of Chilam Balam, scenes from which he has illustrated as prints, are a particularly favoured source.[24] These seventeenth- and eighteenth-century records of Maya ritual and belief are based on a principle of secret codes and rhythmic repetition which is echoed in Toledo's own painterly style. The rich texts also contain an earthy humour and sexuality akin to that of Toledo, whose work abounds with sexual metaphor. The *nahuatl* sources of the sixteenth-century Franciscan author Bernadino de Sahagún provide Toledo with some of his animal iconography, frequently unheroic creatures such as grasshoppers,

FIG. 51 **FRANCISCO TOLEDO,** *MUJER CON LIEBRE/WOMAN WITH HARE,* 1970

scorpions and fish.[25] This interest in the native traditions of Mexico avoids explicitly pre-conquest sources; his frame of reference is linguistic rather than archaeological. The cultural forms that interest him appear to be those with a continued, if changing, existence; the organic heritage of language as opposed to the unchanging distance of the archaeological object.

In this sense, he deals not so much with the pre-Columbian past as the continued presence of that past in the Indian cultures of the present. While this aspect of his work draws analogies with the syncretic traditions of Mexico's popular art, Toledo is no more a naive artist than the great doyen of contemporary art, Joseph Beuys, with whom he shares a fascination with shamanistic practice.[26] Toledo's aesthetic, however, has none of the automatist character of Beuys's graphic work. While the German is primarily interested in the ritual process of creativity, Toledo looks for recognizable talismans. This allows him to avoid the emphasis on the uniqueness of the self which has turned Beuys into a superstar. The magic of a work by Beuys is derived from it being just that, Beuys's work. Toledo's images make equal claim on an aesthetic ritual intensity, yet their magical powers emanate from their illusion of collectivity. They profess to speak for many, not a single isolated spirit. Within the context of Latin American culture this elision of traditions allows Toledo to lay claim to both the sophistication of the avant-garde and the unselfconscious authenticity of the continent's popular artists.

The Surrealist perception of Latin America, in which so many European myths about the 'New World' coalesced, served to perpetuate the image of the continent as a location of dreams and inversions of rational order. Yet the aesthetic framework of European Surrealism has itself been appropriated by many Latin American artists as a means of articulating their own culture. If the continent dreams, then they are the politically charged revelations of Antonio Ruiz's *Malinche's Dream* [see Fig. 2] where the collective memories of the past challenge the realities of the present.

CHAPTER 5

FORMS OF AUTHENTICITY

In Latin America there is
no shortage of art produced outside the essentially bourgeois
network of galleries: weavings, tapestries, embroideries and
knitwear; basketry, pottery, metalwork, carpentry; figures or
little scenes modelled in wax, or bread dough or sugar; items in
leather, feathers, straw or wood; enamel ware, painted or
engraved gourds, papier mâché masks; paintings on tin, cloth,
hide, wood or bark paper. The *artesanía* of modern Latin
America constitutes a significant part of many Latin American
economies as well as an important tourist attraction. It is
marketed by the makers themselves in rural village squares, by
entrepreneurs in smart shops in downtown Bogotá or Buenos
Aires, and by the aid agencies of Europe and North America
through catalogues and charity shops. In Latin America the
various forms of *artesanía* have tended to be grouped loosely
together under the heading *arte popular*. This is often translated
into English as *folk* art,[1] a term which suggests forms of art that
are essentially survivors from the past – static and quaint – but in
Latin America the term 'popular art' has a much stronger
resonance, and has been the subject of debates amongst
intellectuals since the beginning of the century.[2] There are two
main reasons for this. First, a great deal of Latin America's
artesanía is produced by the peasantry, which in many countries

is of largely Indian stock.[3] It is, therefore, not only socially and economically but also ethnically and culturally 'other', while at the same time being unequivocally Latin American. Secondly, the *arte popular* of the urban poor includes artistic productions associated with popular religion and with movements for social change – categories which are often interlinked. This urban *arte popular* is frequently confident, innovative and – as in the most renowned example, the *arpilleras* of Chile – highly political in expression; all of which has little in common with the anodyne associations of the English term *folk art*.[4] It is scarcely surprising, given the vigour and variety of these forms of art, that avant-garde artists return to them repeatedly in search of a sense of authenticity, of cultural identity.

This has not been without its problems. The idea that all such art is 'natural', innocent, untroubled by the intricacies of debates about the nature of cultural identity is deeply unsatisfactory, but *arte popular* in the broadest sense and indeed more purely Indian art as well have both continued to offer artists a set of alternatives in much the same way as Surrealism has done, but without the attendant overtones of a borrowed style from a non-Latin-American source. Our central concern here is not with these forms of art themselves – these are to be dealt with in a subsequent volume in this series – but with the ways in which certain aspects of popular or Indian art or the various hybrids in between have been re-used by artists of the art school and gallery tradition. As in the case of artists borrowing from the cultural legacy of Europe, there are a number of different possible ways in which this can be effected, and to different ends. The intention can be to pay homage to an idea or an ideal, as in the way in which artists like Gamarra or Morales incorporate the unmistakable image of Sandino into their work, an image that has been sanctified by repeated use on the walls and buildings of Nicaragua. Aspects of popular art may be used to express things which are perhaps inexpressible within the available forms of modernism. The choice of a deliberately naive style by the Uruguayan Pedro Figari (1861–1938), for example, allowed him to caricature the social conventions of the bour-geoisie in his native Uruguay with a sort of wide-eyed innocence. Artists have drawn on the techniques of popular art or *artesanía* in an attempt to get away from the elitist overtones of paintings in oil on canvas, or perhaps more straightforwardly, simply to try and capture some of the sense of exuberance.

Interest in pre-conquest and contemporary Indian art often implies a rejection of colonial values and a glorification of mass culture above that of a 'European' oligarchy.

Throughout the nineteenth century, in the visual arts of Latin America, there had been a growing awareness of the rhetorical power of references to non-European aspects of the continent's culture, but such references were conveyed in a recognizably conventional format. Indigenous myths and legends were used to assert the existence of a pre-conquest past which could validate the authority of the many newly independent Latin American states. The work of nineteenth-century painters such as José Obregón, while incorporating this new subject matter retained all the formal characteristics of the academic European tradition. Obregón's *Descubrimiento del pulque/Discovery of Pulque*, 1869 (Coll. Instituto Nacional de Bellas Artes, Museo Nacional de Artes, Mexico) attempted to elevate the ancient Mexican past to the position of classical myth by the use of a neo-classical style reminiscent of David. However, its only claims to difference from the dominant trends of European art are the occasional decorative feature.

A belief in the pre-eminence of the formal languages of the European salon was maintained by the exaggerated conservatism of many of Latin America's art academies. Well into the twentieth century these institutions continued to emphasize drawing from plaster casts of classical antiquity and outdoor sketching parties were seen as radically avant-garde some forty years after their inception in France. There was, in this sense, an even more polarized division between definitions of the fine and the decorative arts; a European form was the main prerequisite of high art.

It was Dr Atl and his contemporaries in the 1920s who, in their search for authentically Mexican art forms, Mexican roots, were to lay the foundations for a new appreciation of the arts of the people as an authentic expression of *mexicanidad*, and numerous artists have borrowed from these traditions ever since.[5] This search was problematic: when, in the aftermath of the Mexican revolution, radical artists attempted to confront this issue, seeing it as intrinsic to their anti-colonialist politics, they were frequently haunted by the inconsistencies produced by earlier attempts to formulate a national culture. Siqueiros had praised the modernist interest in 'Negro and Primitive art' but called for the rejection of 'the lamentable archaeological reconstructions (Indianism, Primitivism, Americanism) which are so fashionable today and are leading us into ephemeral stylisations. . . . Let us further reject theories postulating a national art. We must become universal; our racial and local elements will inevitably appear in our work.'[6] He and the other muralists were searching for an art

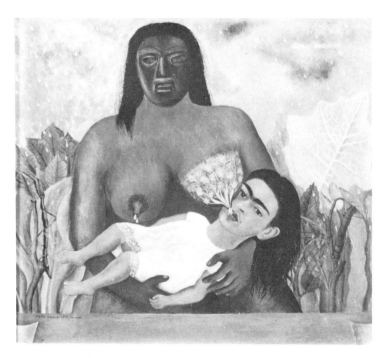

FIG. 52 **FRIDA KAHLO,** *MY NURSE AND I,* 1937

that 'should aim to become a fighting educative art for all' and which would attack art's dependence on what they saw as bourgeois individualism.

Despite the bombastic stand often taken by artists such as Rivera, Orozco and Siqueiros, it was not their work but that of Frida Kahlo that most effectively united the concerns of popular art with those of the modernist avant-garde. A major factor of this success lay in her elision of the differences between the personal and the political which allowed her to identify her concerns as a woman with those of Mexico's peasantry. Kahlo's paintings manage to reconcile the directness of Mexican popular art with both the theoretical arguments of her male contemporaries and her own acute awareness of her role as a woman. Taking her own body as her primary subject matter, she utilized many of the recognizable formal characteristics of Mexico's popular heritage.

The small scale of her intense images, her frequent use of tin instead of canvas and the incorporation of the frame into the picture all emphasized her recognition of popular religious imagery and Indian art forms. A painting such as *My Nurse and I,* 1937, manifests many of the primary concerns of

her work. Its physical presence is that of an ex-voto, the small paintings on tin detailing miraculous deliveries from death or disaster which would be offered in thanks to a particular saint – an art form avidly collected by Kahlo. The simple planular space and clear delineation of forms also refer to the accessibility of much popular art.

Within this straightforward style, however, Kahlo encodes several complex themes. The nurse of the title dominates the composition, her comfortingly large and fecund body contrasting with the stony inhumanity of her masked face. In her arms she holds the artist, portrayed as both adult and infant, reflecting the disjunction between the head and body of the nurse. Milk drips from both of the nurse's breasts, falling on to Kahlo's lips and uniting with the white folds of her dress. The internal structure of the breast is revealed and is echoed in the delicate webbing of the large background leaf and the lace edging of the dress. Behind the two figures milky raindrops fall on the leaves of tropical plants, like manna from heaven.

On one level the painting is an obvious reference to a Catholic madonna and child, but it is not a simple substitution of pre-conquest for Christian imagery. The distinction between the wet nurse and the mother is an important one. The past to which Kahlo is claiming a relationship is admittedly not her own, yet it is also essential for her survival. *My Nurse and I* is an allegory of cultural identity which attempts to unite the diverse strands of Latin American history. The relationship of the mestizo present to the distant pre-conquest past is articulated with wonderful clarity, as one governed not by nature but by nurture.

The image of the wet-nurse carries with it the implicit failure of the natural mother (the colonial past) to sustain the life of the infant (the revolutionary present), yet also reveals racial and class distinctions between nurse and child. Kahlo resolves these inconsistencies visually by references to her own identification with the Indian and pre-Hispanic past; the similarity of her own and her nurse's hair; the converging eyebrows of the Olmec-like stone mask serving as a precedent for Kahlo's own characteristically joined brows.[7] To underline the central symbolism of the painting Kahlo includes two organic metaphors of her own hybrid culture. On either side of the nurse and child, branches stand out from the jungle foliage. On the right a cocoon rises up in the place of a broken twig, while on the left the branch supports the symbiotic image of a camouflaged stick insect, parasitic yet dependent; a succinct

reference to the complexities of the Latin American search for cultural identity.

The success of Kahlo's work is also dependent on the conjunction of her self-consciously female iconography with the traditionally gendered image of colonization – that of the female land taken by force and condemned to give birth to a bastard culture. Kahlo transforms the metaphor to allow for a more positive reading of the indigenous. Her allegorical female is not the victimized, raped, essentially passive *chingada* (eloquently described in Octavio Paz's *Labyrinth of Solitude*[8]) but an assertive presence with the power of life or death. This ability to invert negative readings of gender and race is apparent in her adoption of the formal values of popular art. Instead of capturing the appearance of that art in a recognized material of fine art, as did her husband Diego Rivera in his many frescoed descriptions of peasant life, Kahlo denies the accepted hierarchies of art practice. The inherent meanings of a cultural form such as an ex-voto are harnessed rather than parodied, producing much of the emotive power of her work.

The same identification with the popular is evident in the work of Kahlo's contemporary María Izquierdo (1906–55), although her paintings lack Kahlo's complexity. The colour and patterning of *Altar de Dolores*, 1943 [Plate 19], for example, is a more literal homage to the decorative aesthetic of Mexican folk art. While Kahlo self-consciously plays upon the 'separateness' of the cultural meanings she incorporates, Izquierdo denies distinctions between her own work and the popular. Their different responses are interestingly evoked by the preference of the Surrealist poet Antonin Artaud for Izquierdo. Artaud saw in her work an innocence and distance from European conventionality lacking in her contemporaries.[9] Her art was genuine and intuitive in much the same way as the Indian cultures which so fascinated Artaud. The divisions within Surrealism represented by the differing positions of Breton and Artaud are exemplified by their respective interests in Kahlo and Izquierdo.[10] The work of Izquierdo manifested a difference in culture and gender that Kahlo's art discussed.

This subtle distinction highlights a number of the preoccupations of Latin American artists with the languages of the avant-garde and the popular. The naivety of the popular is envied, not just for its avoidance of academic theorizing, but also for its unselfconscious ability to unite the multiplicity of cultural forms at play in Latin America. Its paramount virtue, however, resides in the popular artists' certainty in their own cultural identity. They are not caught up in a continual

questioning of their own languages of representation. The work of an untrained artist such as the Venezuelan Bárbaro Rivas, produced outside of the traditions of fine art, confronts almost effortlessly the major concerns of contemporary Latin American art. Its hybrid mix of history and anecdote with religious imagery is produced in a painterly language of simple expressiveness. The formal appearance of his work, however, confronts many of the same issues as that of his modernist contemporaries. The collaged image of the Virgin of Guadalupe in his *La procesión de la Virgen/The Procession of the Virgin*, 1965, could equally well be read as a reference *to* popular culture as an expression *of* it. Its use of a cut-up reproduction as a formal device, functioning as the statue of the Virgin as it is carried through the town, is as multi-faceted in meaning as any of Picasso's Cubist col-lages. The very fact of its production outside such a frame of reference, the con-junction of image and reflection, gives the work aesthetic authority.

FIG. 53 **BÁRBARO RIVAS, *LA PROCESIÓN DE LA VIRGEN/THE PROCESSION OF THE VIRGIN,*** *1965*

It is that same sense of authority that Kahlo and Izquierdo strove to appropriate and that younger artists following them, such as the Mexicans Rocío Maldonado (born 1951), Germán Venegas (born 1959) and Alejandro Colunga (born 1948) try to impart to their work. For Maldonado and Venegas, the earlier perception of the popular has been mixed with an understanding of 1960s Pop Art, while Colunga combines the forms of carnival and austere Catholicism to produce a typically 1980s style of expressionism. All three of these artists, however, explore the territory mapped out by

FIG. 54 GERMÁN VENEGAS, *MÁRTIRES/MARTYRS*, 1983

Kahlo and are aware of the culturally symbolic nature of their own formal languages.

In Venegas's *Mártires/Martyrs*, 1983, carved wood and automobile parts are combined with the bright primary colours of Mexican decorative arts, giving an overall impression of playfulness. The humour is the black humour of the fiesta, the ritual celebration of death and catastrophe so characteristic of Latin American Catholicism. Iconic symbols of both pre-Hispanic and Christian religion combine in a manner symptomatic of the syncretic tradition of folk culture. The work is dominated by a roaring Mexican lion/jaguar, which, stretching across a blood red landscape, bursts like the *piñatas* of popular celebrations, disgorging human bodies as party favours. In the night sky above is the comet-like composite of a plumed serpent and a Judas figure, made up of the collaged motor parts and a traditional carnival mask.

The proportions and spatial relationships of both main images are suggestive of a sixteenth-century illustration, such as those in Bernadino de Sahagún's *Florentine Codex*,[11] with the deity-figures imposed over a microcosm of Mexico. In this reading, the bleeding, haloed head beneath the feline functions as a place sign on a map, pictographic rather than emotive. Venegas fills his work with references to his country's past and to the continued popular absorption of political events

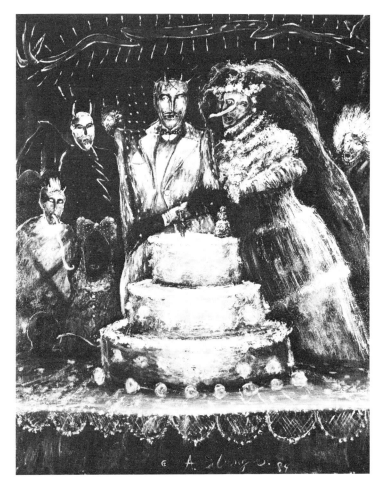

FIG. 55 ALEJANDRO COLUNGA, *LA BODA DEL CHAMUCO Y LLORONA/*
THE MARRIAGE OF CHAMUCO AND LLORONA, 1984

into celebratory purgations of pain and oppression. In choosing
the formal languages of such processes, in combination with
the materials of modern industry, the artist attempts a similar
synthesis of fine and decorative arts, of past and present, of
history and ritual.

The formal references to the popular are less
immediate in the work of Alejandro Colunga, although the
syncretic aims are equally strong. These concerns are openly
expressed in his painting *La boda del Chamuco y Llorona/The
Marriage of Chamuco and Llorona*, 1984. The painting parodies
the composition of family wedding photographs, but the

127

protagonists are the hybrid offspring of Mexico's past. Again the humour is funereal, as sentimentality competes with the macabre. The conventional excesses of a white wedding clothes the union of two of Mexico's cultural demons, the devil Chamuco and La Llorona, 'the weeping woman' of popular myth. Descended from an Aztec mother goddess, Cihuacóatl, Llorona is a long-suffering mother figure, seen to be symbolic in the wider sense of the trauma of the Spanish invasion. Driven mad with grief by the loss of her own child, she is thought to wander the streets weeping and crying out, a ghostly memory of the pre-conquest past. The figure is an ambivalent one in its conjunction of both grief and revenge. In alliance with Chamuco, Llorona is supposed to re-enact her own pain by the murder of any children she encounters on her nocturnal visitations. As usual in Latin America, popular legend weaves together disparate strands of local and Catholic iconography, combining the characteristics of the Aztec deity with 'La Dolorosa', the grieving madonna. In his presentation of the unholy alliance, Colunga offers an ironic critique of modern Mexico, like a child recognizing the true nature of its less than perfect parents. The elaborate wedding cake serves as a key to the wider concerns of the painting, the miniature figures of the bride and groom standing distant from each other, revealing the hypocrisy behind Chamuco and Llorona's linked arms.

Understandably, Rocío Maldonado refers more directly to the work of Frida Kahlo than her male contemporaries, Venegas and Colunga. Like Kahlo she uses the female body to articulate wider social and political meanings. Kahlo frequently used her own face as a mask, disguising and revealing at the same time. Maldonado uses fetishistic dolls to similar effect, as in *The Virgin*, 1985 [Plate 20]. The passive figure of a doll stares out of the picture, the surface of which is covered with dislocated signs, like a saint surrounded by symbols of martyrdom. These emblematic objects, however, are instruments of sensual rather than spiritual passion; vaginas and phalluses. Together with dismembered feet and hands, pouting lips and excised hearts they float on to the frame, as if trying to escape out into the real world beyond. In the lower corner of the painting a classic sculptured torso also appears to be falling outwards from the surface of the work. Linking the torso to the doll is an exposed heart, the vibrating colours of which make it the only living part in a sea of red and black. The open palms of the recognizably Mexican doll give the central figure a tragic, pleading air, as though the impassive features masked an

imprisoned being, condemned to silence within an alien body.

Maldonado's painting juxtaposes the traditions of Mexican popular art (the doll) and those of fine art (the classic torso), not to imply a desire for formal synthesis but to highlight the equally invidious position of women within both cultures. This more actively feminist stance is underlined by the scale of her work, which rejects the intimacy of Kahlo's delicate images in favour of the dramatic power of life-size creations. This shift in scale also affects the implied relationship of her work to the popular, its imposing dimensions denying mimicry while upholding the validity of Mexico's popular aesthetic.

The avant-garde of Brazil has had a closer relationship to the modernist mainstream than other Latin American artists. From the influential Semana de Arte Moderna (modern art week)[12] in 1922 through to the continuing São Paulo Bienal first held in 1951,[13] Brazilian artists and intellectuals have expressed great enthusiasm for the assertive energy of modernism. The embracing of modernism's claims to universality and rejection of the past found concrete expression in the construction of Brasilia in the 1950s and 1960s. The architectural innovations of Lucio Costa and Oscar Niemeyer stand as exemplary models of Latin American modernism, with all its inherent contradictions. The less than perfect realities of modern-day Brasilia cast a shadow on earlier aesthetic idealism.

The recent art movements of Brazil have manifested a greater interest in formal abstraction and minimalism than apparent elsewhere in Latin America. The meanings attributed to the pre-colonial past differ from those discussed in relation to Mexico or, say, Peru. The continuing presence of indigenous peoples, and the whole complex mythology surrounding the Amazon and its inhabitants, is frequently seen as a separate component of the country's colonial legacy; it is integrated into contemporary Brazilian culture through rhetoric rather than lived relations. The strong African presence has produced alternative readings of the meanings of popular art, placing greater emphasis on the distinctions between the hybrid artificiality of urban culture and the 'natural' existence of the forest dweller.

As has been seen, the iconic status of the Amazonian landscape and the ecological issues raised by its destruction are persistent themes within Latin American art. Among Brazilian artists reference to 'nature' frequently evokes a particularly localized set of meanings. The organic is

FIG. 56 **FRANS KRAJCBERG, *INSTALLATION*,** 1986

extended beyond its function as an alternative to the artificial
and is endowed with a more explicitly political reading. Artists
such as Frans Krajcberg (born 1921) and Ione Saldanha (born
1921) give the modernist appropriation of organic form a
specifically Latin American application. Krajcberg's installations
play on the interest of early twentieth-century European artists
such as Hans Arp in the 'illogically senseless' principles of
nature, yet they function far more explicitly than any of Arp's
Dadaist compositions.[14] The components of his 1986 *Installation*
at first sight appear like props from a science fiction drama,
abandoned by a tired film crew. The enormous sculptures seem
out of scale, enlargements of exotic seed pods, fallen to the
earth. Seen in conjunction with his photographic images of
damage to the rain forest, however, the sculptures take on a
more disturbing appearance, becoming charred distortions of
nature's coherent aesthetic.

When Arp constructed his *Traveller's Bundle* in
1920 (private collection) the pieces of flotsam and jetsam nailed
so carefully to a piece of rough plank showed the transforma-
tional powers of nature; the effects of sea, wind and decay. The
skills of the artist were juxtaposed to those of nature. Such

references are still apparent in Krajcberg's work, yet here we are presented with the horrific beauty of man's destructive instincts. Aesthetic pleasure in the elegant asymmetry of the sculptures or their complex construction is denied by the realization of their lifelessness. While the work of Arp, or that of contemporary artists interested in the interaction of man and nature such as the British sculptor Richard Long,[15] deal primarily with the relationship of the individual to the essential forces of nature, Krajcberg's work remains deeply rooted in place and time, discussing the specific rather than the archetypal.

In a less dramatic, though equally coherent manner, Ione Saldanha's *Bamboo Installation*, 1969, and Waltércio Caldas's (born 1946) *Convite ao raciocínio/Invitation to Thought*, 1980, transform traditional materials in order to situate the concerns of modern painting and sculpture within the context of Latin America. Saldanha's large bamboos stand as if testament to a past ritual activity. The rings of colour roughly painted around their trunks appear systematically arranged despite their simplicity, again suggesting ritually encoded messages. The painted surfaces undermine any modernist concern with the material as the sole determining characteristic of the art work, and the organic structure of the bamboo denies the otherwise geometrically patterned colour arrangement. Here abstraction is used to connote the magical distance of an alien culture rather than the assertive modernity of colour field painting. The frame of reference is anthropological although the formal language is recognizably that of 1960s minimalism.

FIG. 57 **IONE SALDANHA, *BAMBOO INSTALLATION*,** 1969

Although *Invitation to Thought* is quite a restrained

FIG. 58 **WALTÉRCIO CALDAS, *CONVITE AO RACIOCÍNIO/INVITATION TO THOUGHT*,** 1980

assemblage, it is more explicitly Latin American in its concerns than Caldas's frequently minimal sculptural works. Caldas juxtaposes the industrial symmetry of steel piping with the encrusted texture of turtle shell, highlighting their shared hollowness with a wry humour. At the same time, the play on the contrasting formal languages of nature and technology, on co-existence and absorption, gives this work a metaphorical immediacy often lacking in the artist's more severely conceptual pieces.

In a similar manner to Saldanha's work Fernando Lucchesi's (born 1955) translucent painted hangings function as ritually suggestive environments. In his untitled installation of 1986 the paper-thin painted surfaces build outward, creating a series of frame-like openings, suggestive of decorations around an altar. However, the patterned contours of these planular hangings and the empty spaces they define form the substance of the work rather than any iconic central image. The materials and techniques of the popular art of the mineira[16] region are used to locate the work within a specifically Brazilian context, yet, as with Saldanha and Caldas, Lucchesi's concerns are recognizably formalist.

The four works all draw their power from the shifting meanings of abstracted form in the Latin American

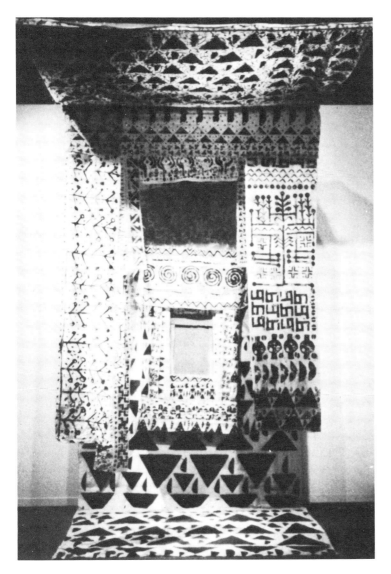

FIG. 59 **FERNANDO LUCCHESI, UNTITLED INSTALLATION,** 1986

context. The concern with process and materials is present as is the denial of a predominant subject, yet the works remain accessible and assert a particularly Brazilian cultural identity. Their claims to that identity are dependent on the elision of nature with nation – a recognition of the iconic function of the Amazonian region as a metaphorical setting for man's natural state. The nostalgia for a ritual harmony with nature, so

frequently seen as manifested by Amazonian peoples, becomes an implicit condemnation of the exploitation and destruction of the mythical heart of their national culture, the rain forest itself.

The elision of the indigenous with the popular also occurs in reference to cultures of the urban poor, where issues of racial identity are frequently subsumed within a more explicit awareness of social hierarchy. This is particularly apparent in the late work of the Argentine painter Antonio Berni (1905–81), whose earlier transformations of painterly Surrealism have already been discussed. Although eclectic in its formal language, Berni's work reveals a consistent concern with social inequality and the need for a politically committed art capable of engaging with Latin American culture. As a young artist in Paris he was briefly involved with the Surrealists, into whose circle he was introduced by Louis Aragon. On returning to Argentina in 1930, Berni's paintings began to exhibit a far greater debt to the Mexican movement. In 1933 he collaborated on the mural *Plastic Exercise*,[17] an often ignored but seminal work by Siqueiros, in which the Mexican artist first successfully incorporated industrial tools and materials into his wider aesthetic.

Berni's images of the unemployment of the 1930s, the horrors of war and the poverty of the displaced peasant farmers of the 1950s, led him to be classed as a national painter of the stature of Rivera or Portinari. Yet some of the most coherent of Berni's work was produced in the last decades of his life and emerged from the creation of his two enduring fictional characters, Juanito Laguna and Ramona Montiel. Both the street urchin Juanito and the prostitute Ramona are embodiments of urban poverty, but the worlds they inhabit are described with humour and compassion rather than social proselytizing [Plate 21]. Berni's large canvases combine a simple figurative style with more knowingly modernist collage technique.

In *Juanito Laguna remontando su barrilete/Juanito Laguna Flying His Kite*, 1973, the frail figure of Juanito stands amid the mounds of refuse and shanty dwellings which form his universe, staring with dogged optimism at his kite as it pulls away into the dramatically realist sky. Berni uses the associated meanings of the different formal languages he unites to articulate the complexities of the period of Peronist restoration. The various components of the canvas are arranged with deliberate simplicity so that even the painted sections appear like ready-made parts of a self-assembly kit. The formal naivety of the figure of Juanito is appropriate to the boy

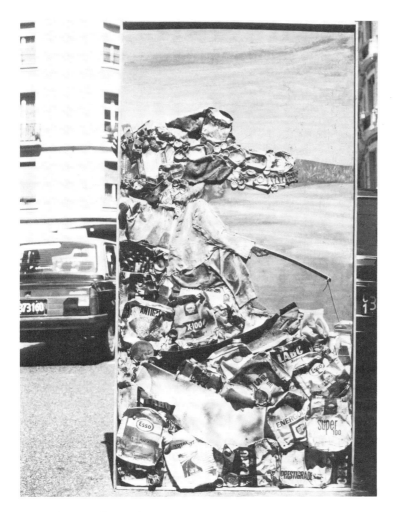

FIG. 60 **ANTONIO BERNI,** *JUANITO PESCANDO ENTRE LATAS/JUANITO FISHING AMONGST TIN CANS,* 1972

himself, as he finds a rare moment of childhood pleasure in his crudely made kite. The refuse that surrounds him is real – collaged pieces of tin cans, plastic and cardboard – the arranged chaos of the foreground contrasting with the geometric precision of the flimsy shanty dwellings. The kite hangs like a fragile substitute for the sun, an illusory symbol of optimism about to be blown from the boy's hands by the lowering storm blowing in from the right. The formal conventionality of the cloud, the self-conscious modernity of the collaged setting and the naive realism of the figure, all enhance the overall meaning

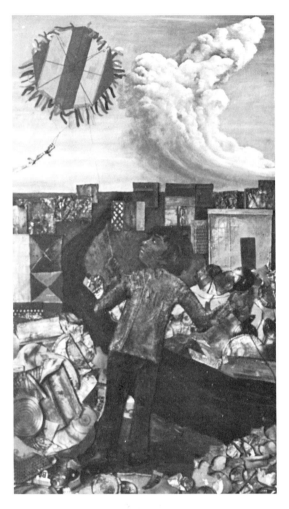

FIG. 61 **ANTONIO BERNI, *JUANITO LAGUNA
REMONTANDO SU BARRILETE*/*JUANITO LAGUNA FLYING
HIS KITE*,** 1972

of the work. Classicism, modernism and the transformational power of popular art become formal metaphors of Argentina's political realities.

The most positive component of Berni's work in general is the adoption of the ingenious character of popular crafts, as a paradigm of creativity itself. The ability of the urban poor to give new shape and meaning to the detritus of modern consumer culture allows Berni to reformulate the techniques of Dadaist collage within a more directly political aesthetic. It is this same wonderfully simple elision of naivety and self-consciousness that endows the Chilean *arpilleras* with such popularity, even beyond the bounds of their political meanings.

On one level the formal languages of an artist such as Berni and those of anonymous women producing patchwork pictures of the political realities of Pinochet's Chile are difficult to reconcile, yet the two are linked. They are both based on a view of creativity dependent on reordering existing material and reclaiming political meaning from the banalities of everyday existence.

PLATE 14 **ARMANDO VILLEGAS,** *CABALLERO DEL CARDO/*
KNIGHT OF THE THISTLE, 1978

PLATE 15 ARMANDO MORALES, *ADIOS Á SANDINO/FAREWELL TO SANDINO*, 1985

PLATE 16 JACOBO BORGES, *ENCUENTRO CON UN CÍRCULO ROJO O RUEDA DE LOCOS/
MEETING WITH RED CIRCLE OR CIRCLE OF LUNATICS,* 1973

PLATE 17 **WIFREDO LAM,** *LUZ DE ARCILLA/LIGHT OF CLAY,* 1950

PLATE 18 **ROBERTO MATTA,** *A GRAVE SITUATION,* 1946

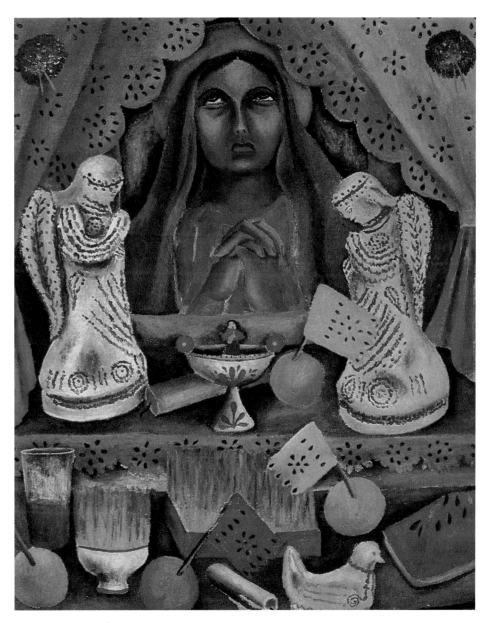

PLATE 19 **María Izquierdo,** *Altar de Dolores,* 1943

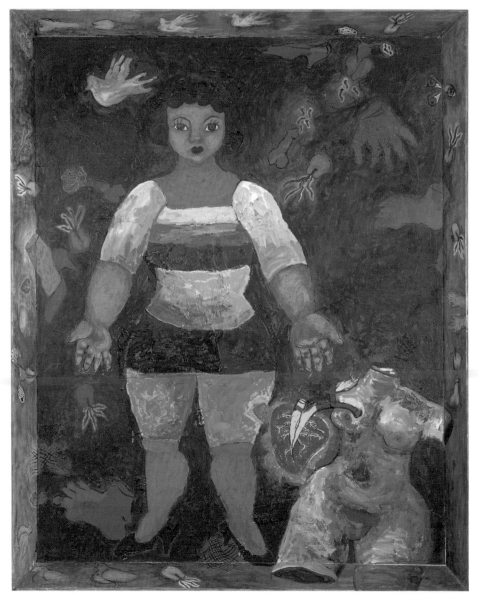

PLATE 20 ROCÍO MALDONADO, *LA VIRGEN/THE VIRGIN* 1985

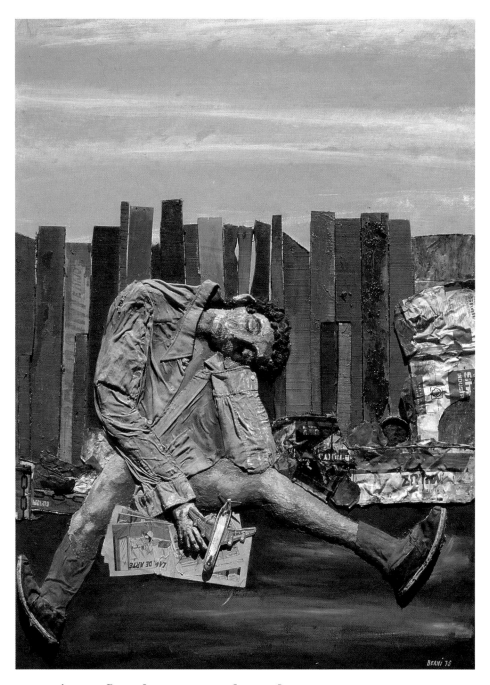

PLATE 21 ANTONIO BERNI, *JUANITO DORMIDO/JUANITO SLEEPING*, 1978

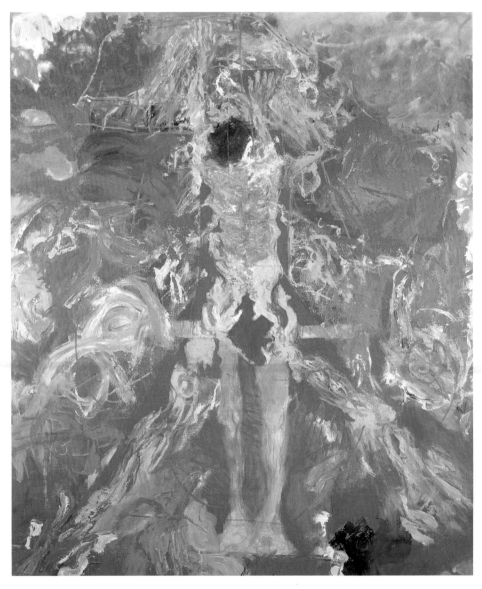

PLATE 22 JACOBO BORGES, *UPWARDS,* 1988

AFTERWORD
DRAWING THE LINE

Arnaldo Roche Rabell's large drawing *Una vez más, el ciego se pregunta a si mismo sí hay alguien alla afuera/One More Time The Blind Man Asks Himself if There Is Anybody Out There*, 1987, represents a macabre ritual involving two nude male figures, one black and one white.[1] The scene is in an apartment with large windows overlooking a city full of skyscrapers. Across the dinner table in the foreground the white figure lies like a crucified Christ, his halo formed by the plate beneath his head, the crown of thorns suggested by sharp cutlery, and a glass carefully positioned as if to catch the blood from a spear-thrust in his side. This figure, the ultimate sacrificial victim, holds up a mirror in his left hand, but the surface is pure white, reflecting nothing. To the right-hand side of the picture a large, semi-transparent black figure reaches desperately up into the air above the table, clutching at nothing. This work touches on many of the ideas which have recurred throughout the previous pages: violence, passion and sacrifice with undertones of sexuality; questions of race, colour and ethnicity; of Christian and non-Christian; of civilization and barbarism; of self and other. There are references to pre-Columbian culture: the Aztec sun stone appears to be placed like an ornament on the dresser to the right, and the mirror suggests the obsidian mirrors of the

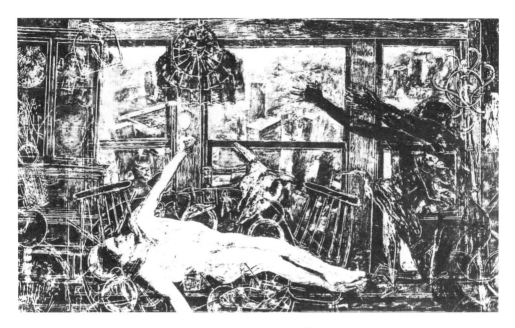

FIG. 62 **ARMANDO ROCHE RABELL,** *UNA VEZ MÁS, EL CIEGO SE PREGUNTA A SI MISMO SÍ HAY ALGUIEN ALLA AFUERA*/**ONE MORE TIME THE BLIND MAN ASKS HIMSELF IF THERE IS ANYBODY OUT THERE,** 1987

Aztecs and so the Aztec god of darkness and sacrificial death, Tezcatlipoca or Smoking Mirror. As in other works discussed earlier, there are distant echoes of Picasso's *Guernica*, not only in the absence of colour but in the overall composition and in the fraught atmosphere. The technique – a combination of drawing, painting, rubbing and scratching – is unorthodox and experimental in a way that is typical of much recent art in Latin America and which contributes to the sense of nervous energy and unsatisfied questing. In *One More Time* the room is cluttered; there is no shortage of objects for the mirror to reflect or the empty hands to catch, but everything is unresolved. The blind man's question remains unanswered. Roche Rabell's art, as has been mentioned before, grows out of his experience as a Puerto Rican who spends half his time in Chicago, and this drawing is in some ways both an exposition of and a metaphor for the problems of cultural identity in Latin America. In this drawing, as in so many of his works, there is a sense of searching, of displacement, of incongruity, of not belonging.

A recent painting by Jacobo Borges, *Upwards*, 1988 [Plate 22], shows a figure similarly reaching for an

unseen, unknown goal. Is this a representative of Promethean ambition, someone who has become ensnared in a fiery web of colours, or – for once again there are echoes of the crucifixion – is this a martyred saint stretching up to receive salvation? Carlos Fuentes, in discussing the work of Borges, suggested that Latin American identity consists in the search, and that to believe that one has found an identity is but to lose it again.[2] He may be right but the search, if search it is, will go on and the impossible contradictions that go to make up Latin America will continue to nourish artists whose work is as various, as vital and often indeed as contradictory as the continent itself. Even the imagery of the search has a particular poignancy in a continent where many different but equally oppressive political systems have caused individuals to disappear without trace, leaving their friends and families to queue endlessly in government offices and courthouses in hope of information about their whereabouts. Not surprisingly, this is another recurrent theme in Latin American art, in works as different as the *arpilleras* of Chile and the paintings of the young Argentinian, Guillermo Kuitca (born 1961).[3] Kuitca's images of empty stage sets are metaphorical allusions to the world of the *desaparecidos*, but they also suggest a more personal sense of emptiness. In Borges's work too the distinctions between the search for personal identity and the search for political justice is often unclear.

But despite – or perhaps because of – the problem of cultural identity, in the present century Latin American artists have achieved a great deal. They have succeeded in mapping out new territories, disrupting the traditional boundaries between high and low art, between art and craft, between painting and sculpture and painting and drawing, between abstraction and figuration, between form and content, between art and propaganda, between landscape and history, between the past and the present. Latin American artists have reclaimed their own landscape and its inhabitants, and the varied cultural traditions of those inhabitants from foreign travellers and from foreign artists in search of exotic subject matter; they have reclaimed the imagery of the pre-Columbian as of the colonial past from foreign archaeologists, anthropologists and historians; they have reclaimed the art of the European past from the museums and galleries and from the art historical text books; they have demonstrated that modernism and a political content are not incompatible; that New York or Paris are not essential ingredients in artistic creativity.

In any consideration of contemporary Latin

American art there are many lines which need to be drawn, themes which need to be traced, boundaries which need to be demarcated. Most important of all, perhaps, is the need to keep the dividing line clear between what it is to be a Latin American artist and what it is to be a European or North American artist. To slip into easy comparisons between the work of Lam and Picasso, of Gironella and Jasper Johns or Joseph Cornell, of Gamarra and Le Douanier Rousseau and so on is to avoid the central issue of difference. Many European artists in recent years, for example, have reworked famous paintings of the past; it has become a fashionable game. But for Gironella or Botero to do so is very different. For them the European past both is and is not theirs for the taking; they belong to European culture and at the same time they are excluded from it. The lines have been drawn by history. This is what gives their works that special cutting edge and what distinguishes them from mere cleverness or game-playing. It is hard to imagine a neutral Latin American art, an art which is either so confident or so unaware as to be able to play games in such a way that the game is the end in itself. Art is not a matter of playing games; it is for real.

NOTES

Preface

1. See, for example, Shifra Goldman, *Contemporary Mexican Painting in a Time of Change*, Austin 1977, or, although it is not specifically about art, John King, *El Di Tella y el desarrollo cultural argentino en la década del sesenta*, Buenos Aires 1985.

2. Especially Marta Traba, *Dos décadas vulnerables en las artes plásticas latinoamericanas, 1950–1970*, Mexico 1973.

3. As in Damian Bayón, *Artistas contemporáneos de América Latina*, Barcelona/Paris 1981; *Aventura plástica de hispanoamérica*, Mexico 1974.

Introduction

1. *Cambridge Encyclopedia of Latin America and the Caribbean*, S. Collier, H. Blakemore and T. Skidmore (eds), Cambridge 1985, p. 9.

2. Gabriel García Márquez, 'The Solitude of Latin America', reprinted in *Granta*, 9, Harmondsworth 1983, pp. 56–60.

3. Oxford 1980, pp. 167–8. The title inevitably evokes E.H. Gombrich's best-selling *The Story of Art* (first published 1950), demonstrating that Lynton intended his work to be seen as the direct sequel: one story, one art.

4. Quoted in *The New York Times Magazine*, 5 June 1988, p. 26.

Chapter 1

1. *Nicaráuac*, 4, Managua 1981, p. 180.

2. See John Barrell, *The Dark Side of the Landscape: The Rural Poor in English Painting 1730–1840*, Cambridge 1980.

3. On this subject see, for example, Hugh Honour, *The New Golden Land: European Images of America from the Discoveries to the Present Time*, New York 1975; Freddie Chiappelli (ed.), *First Images of America: The Impact of the New World on the Old*, 2 vols, Berkeley 1976.

4. Quoted in *The New Golden Land*, p. 170.

5. For example, John Boorman's *The Emerald Forest*, 1985. For an account of Boorman's own ideas in making this film, see his *Money into Light: The Emerald Forest. A Diary*, London 1985.

6. For a fuller discussion of this, see Valerie Fraser, *The Architecture of Conquest: Building in the Viceroyalty of Peru, 1535–1635*, Cambridge 1989, Ch. 2.

7. For Mexican artists of this period, see Justino Fernández, *El Arte del Siglo XIX en México*, Mexico 1983.

8. For further details and illustrations, see the exhibition catalogue *Imagen de Mexico: Der Beitrag Mexikos zur Kunst des 20. Jahrhunderts*, Frankfurt 1987.

9. Francisco Stastny, *Breve historia del arte en el Perú*, Lima 1967, p. 53.

10. These artists are discussed and illustrated in *Arte y Tesoros del Perú: Pintura Contemporánea* (Part 2, 1920–60), Lima 1976.

11. *Cultures: Cultural Identity in Latin America*, Unesco, Paris 1986, p. 27; Holliday T. Day and Hollister Sturges, *Art of the Fantastic: Latin America, 1920–1987*, exhibition catalogue, Indianapolis 1987, pp. 66–75.

12. Rudolph Wittkower, 'Marvels of the East: A Study in the History of Monsters', *Journal of the Warburg and Courtauld Institutes*, V, 1942, pp. 159–97.

13. *Imaginários Singulares*, 19th Bienal of São Paulo, 1987.

14. Antonio Callado, *Retrato de Portinari*, Rio de Janeiro n.d.

15. For example, Damian Bayón, *Artistas contemporáneos de América Latina*, Paris/Barcelona 1981, p. 53.

16. Dave Treece, *Bound in Misery and Iron: The Impact of the Grande Carajás Programme on the Indians of Brazil*, a report from Survival International and Friends of the Earth, London 1987, pp. 5–6.

17. Quoted in *Colombie: L'art de l'atelier, l'art de la rue*, catalogue of an exhibition held at the École Nationale Supérieure des Beaux-Arts, Paris 1983, p. 26.

18. *Art of the Fantastic*, pp. 166–9.

19. 'Neruda Among Us', in *Cultures: Cultural Identity in Latin America*, Unesco, Paris 1986, p. 162.

20. See Mario H Gradowczyk, *Alejandro Xul Solar*, Buenos Aires 1988.

21. Teresa Gisbert, *Iconografía y mitos indígenas en el arte*, La Paz 1980, pp.17–20.

22. Felipe Guamán Poma de Ayala, *Nueva Crónica y Buen Gobierno*, facsimile edition, Paris 1936.

23. *Art of the Fantastic*, pp. 128–33. Her date of birth is given here as 1932, although in other sources it is given as 1936.

24. Hiram Bingham tells his own story of the discovery in *Lost City of the Incas*, first published in 1948 (Greenwood Press 1988); see also John Hemming and Edward Ranney, *Monuments of the Incas*, Boston 1982, pp. 118–64.

25. Alejandro Ortíz Rescaniere, *Huarochirí, 400 años después*, Lima 1980, pp.21–36.

26. Luis Eduardo Wuffarden, *Tilsa Tsuchiya*, Lima 1981, p. 19.

27. John Hemming and Edward Ranney, *Monuments of the Incas*, Boston 1982, pp. 171–3.

28. The various versions and significance of this myth are discussed in José María Arguedas, *Formaciones de una cultura nacional indoamericana*, Mexico City 1975, pp. 34–79.

29. *Art of the Fantastic*, p. 191.

Chapter 2

1. This apparent paradox has often been remarked upon, for example, by Fernando de Szyszlo, in *El artista latinoamericano y su identidad*, Damian Bayón (ed.), Caracas 1977, p. 35.

2. This problem is discussed by Marta Traba, *Dos décadas vulnerables en las artes plásticas latinoamericanas, 1950–1970*, Mexico 1973.

3. For a discussion of Tamayo's own work see Chapter 4, pp. 108–11.

4. From the supplement to *Siempre!*, no. 139, 14 October 1964, reprinted in Rita Eder, *Gironella*, Mexico 1981, p. 101.

5. There is an extensive recent bibliography on El Greco. On this picture see, for example, the exhibition catalogue *El Greco of Toledo*, Toledo, Ohio 1982, pp. 255–6.

6. *El Greco of Toledo*, pp. 123–8.

7. Rita Eder, *Gironella*, pp. 53–4.

8. Among recent studies of Velázquez see in particular, Enriqueta Harris, *Velázquez*, Oxford 1982, and Jonathan Brown, *Velázquez: Painter and Courtier*, New Haven 1986.

9. Holliday T. Day and Hollister Sturges, *Art of the Fantastic: Latin America, 1920–1987*, exhibition catalogue, Indianapolis 1987, pp. 138–41.

10. Lelia Driben, 'Alberto Gironella: entre la pintura, la literatura y la paráfrasis', *México en el Arte*, 11, Winter 1985/6, p. 18.

11. A number of these are reproduced in Edouard Jaguer, *Gironella*, Mexico DF 1964, and in Rita Eder, *Gironella*. For the interesting views of Octavio Paz on this artist, see his *Los Privilegios de la Vista: Arte en México*, Mexico 1987, pp. 437–47.

12. See Shifra M. Goldman, *Contemporary Mexican Painting in a Time of Change*, Austin 1981, pp. 177–8.

13. Driben, 'Alberto Gironella' p. 19.

14. J.G. and J.J. Varner, *Dogs of the Conquest*, Norman, Oklahoma 1983.

15. *Art of the Fantastic* pp. 146–50.

16. Cynthia Jaffee McCabe, *Fernando Botero*, Washington, DC 1979 p. 10.

17. Quoted in *Fernando Botero*, p. 10.

18. From Marta Traba, *Seis pintores colombianos*, Bogotá n.d. (1965?), quoted in Jean Franco, *The Modern Culture of Latin America,* Harmondsworth 1970, p. 221.

19. Quoted in *Fernando Botero*, p. 93.

20. E. Valdivieso and J.M. Serrera, *El Hospital de la Caridad de Sevilla*, Seville 1980.

21. Quoted in *Fernando Botero*, p. 42.

22. On this aspect of female sainthood, see Rudolph M. Bell, *Holy Anorexia*, Chicago 1985.

23. Jacques Lafaye, *Quetzalcóatl and Guadalupe: The Formation of Mexican National Consciousness 1531–1813*, Chicago 1974.

24. Craig W. Nelson and Kenneth I. Taylor, *Witness to Genocide: The Present Situation of Indians in Guatemala*, Survival International, London 1983, p. 14.

25. Quoted in *Art of the Fantastic*, p. 148.

28. Walmir Ayala, *O Brasil por seus artistas/Brazil Through Its Artists*, Rio de Janeiro n.d. (1979?), p. 154.

27. *Imaginários singulares*, Bienal, São Paulo 1987.

28. *A via Crucis de Raimundo de Oliveira* (posthumous tributes from various authors), Salvador 1982.

29. See *Frida Kahlo and Tina Modotti*, catalogue of an exhibition at the Whitechapel Gallery, London 1982.

Chapter 3

1. For an extensive account of the European responses to Aztec culture, see Benjamin Keen, *The Aztec Image in Western Thought*, New Jersey 1971.

2. *Manifesto of the Syndicate of Technical Workers, Painters and Sculptors*, Mexico City 1922.

3. Both Siqueiros and Rivera were members of the Mexican Communist Party during various periods of their lives, and the changing cultural doctrines of the Soviet Union lay behind some of their more public disagreements. This was particularly apparent during the late 1930s when Rivera, having left the party, became the host and supporter of Leon Trotsky.

4. Vasconcelos encapsulated his own ideas on art and life in *Pythagoras: A Theory of Rhythm*, which was published in Havana in 1916. He moved progressively further ideologically from artists like Rivera, eventually denouncing their work altogether.

5. See Ramón Favela, *Diego Rivera: The Cubist Years*, Phoenix 1984.

6. The allegedly matriarchal society of Tehuantepec occupies an iconic position in Mexican culture. The familiar costume of the Tehuana, adopted by Frida Kahlo as her public assertion of *Mexicanidad*, is frequently used to represent the strong, unvanquished Indian presence in Mexico.

7. See D.A. Siqueiros, *Art and Revolution*, London 1975.

8. The co-signatories included Jean Charlot, Xavier Guerrero, Roberto Montenegro and Carlos Mérida, among others.

9. *A Small Yes and a Big No: The Autobiography of George Grosz*, Arnold J. Pomerans (trans.), Allison and Busby 1982.

10. *José Guadalupe Posada: Illustrador de la Vida Mexicana*, Mexico City 1963.

11. Rivera was also to claim descent from Posada, quite literally in his mural in the Hotel del Prado, *Dream of a Sunday Afternoon in the Alameda* (1947–8), in which he depicted Posada in the role of his father.

12. For an introduction to Orozco's work see the catalogue of the exhibition *¡Orozco!*, Oxford 1980.

13. *The Aztec Image in Western Thought*, Ch. 15.

14. Quoted in Bertram D. Wolf, *The Fabulous Life of Diego Rivera*, New York 1969, p. 162.

15. Harry M. Geduld and Ronald Gottesman, *The Making and Unmaking of Que Viva Mexico*, London 1970.

16. For a clear account of these and other of Rivera's murals, see Desmond Rochfort, *The Murals of Diego Rivera*, London 1987.

17. Rivera's main source was the writings of Cennino Cennini whose *Il Libro dell'Arte* had appeared in *c.*1390.

18. Siqueiros's most forthright attack on the artist appeared in 'Rivera's Counter-revolutionary Road', *New Masses*, May 1934.

19. A Brechtian maxim recounted to Walter Benjamin. See 'Conversations with Brecht', in *Aesthetics and Politics*, London 1977.

20. For a discussion of this influential art teaching establishment, see Hans M. Wingler, *The Bauhaus*, Cambridge, Mass. 1969.

21. Laurence Hurlburt, 'The Siqueiros Experimental Workshop', *Art Journal*, Spring 1976.

22. *Tropical America* was painted on the walls of the Plaza Art Center in Los Angeles. See Shifra Goldman, 'Siqueiros and Three Early Murals in Los Angeles', *Art Journal*, Summer 1974.

23. See *The Fabulous Life of Diego Rivera*, Ch. 26.

24. Richard D McKinzie, *The New Deal for Artists*, Princeton 1973.

25. *Clement Greenberg: The Collected Essays and Criticisms* vols 1 & 2, ed. J. O'Brien, Chicago 1986.

26. *Art and Revolution*.

27. Lucy Lippard, *Get the Message? A Decade of Art for Social Change*, New York 1984.

28. Frequently such a categorization is implicit rather than declared. A good example of this type of exclusive history is Werner Hauftmann, *Painting in the Twentieth Century*, London 1960. In some four hundred pages Latin American artists receive scant notice, the Mexicans being referred to as 'primitive extra-European peoples', p. 320.

29. Octavio Paz, *One Earth, Four or Five Worlds: Reflections on Contemporary History*, Helen R. Lane (trans.), New York/London 1985, p. 147.

Chapter 4

1. Alfred H. Barr, *Der Stijl, 1917–1921*, New York 1961.

2. Torres García's son first introduced the artist to pre-Hispanic art, by way of Nazca pots from Peru in the collection of the Musée de l'Homme in Paris, where he was working.

3. Susan Compton, *Henry Moore* (exhibition catalogue), London 1988.

4. See Franklin Rosemont, *André Breton and First Principles of Surrealism: Selected Writings of André Breton*, London 1978.

5. 'Second Manifesto of Surrealism', 1930, in André Breton, *Manifestos of Surrealism*, Ann Arbor, Michigan 1972.

6. In April 1938 Breton and his wife Jacqueline arrived in Mexico, where they stayed with Kahlo and Rivera, socializing and travelling with them and the Trotskys. In the same year Breton and Rivera co-signed the 'Manifesto for a Free Revolutionary Art' (which appeared in *Partisan Review*), although it was actually written by Trotsky.

7. Lam was both helped and hindered by Picasso's approval, prized as a discovery of the great master yet also condemned to stand in his shadow. See H.H. Arnason, *A History of Modern Art*, London 1977, p. 579.

8. The most complete discussion of Matta's work to date is *Matta*, catalogue of an exhibition at the Centre George Pompidou, Paris 1985.

9. *Manifestos of Surrealism*, p. 125.

10. See Octavio Paz, *Marcel Duchamp, Appearance Stripped Bare*, Rachel Phillips and Donald Gardener (trans.), New York 1978, p. 125.

11. *Minotaure*, no.11, Spring 1938.

12. C-E.J. Le Corbusier-Saugnier, *Vers une architecture*, Paris 1923. See also;

Le Corbusier, Architect of the Century, exhibition catalogue, London 1988.

13. Dawn Ades, *Dada and Surrealism Reviewed* exhibition catalogue, London 1978, p. 315.

14. From an interview with Matta published in *Matta Coïgitum*, exhibition catalogue, London 1977.

15. See Peter Hulme, *Colonial Encounters: Europe and the Native Caribbean 1492–1797*, London/New York 1986.

16. While Matta does not seem to refer to specific examples, his images evoke the presence of the ancient Mexican screenfolds. The Dover reprint of *The Nuttall Codex*, Zelia Nuttall (ed.), London/New York 1975, offers an introduction to the distinctive forms of pre-Hispanic writing.

17. *Rufino Tamayo: Myth and Magic*, exhibition catalogue, Solomon R. Guggenheim Museum, 1979, p. 10.

18. Tamayo's popularity in North America is evidenced by his one-man exhibitions at prestigious locations such as the Guggenheim Museum (1979) and the Phillips Collection (1978).

19. The *nahual* or animal spirit guide is seen to act as the shaman or tribal healer's alter ego during journeys into the spirit world.

20. C.G. Jung *The Archetypes of The Unconscious: Collected Works Vol. 1*, London 1966.

21. These pre-Columbian clay vessels from Colima in the shape of plump dogs have been popular throughout this century. There is a particularly fine collection in the Museum of History and Anthropology in Mexico City.

22. Peter Webb and Robert Short, *Hans Bellmer*, London 1985.

23. On the *inti-huatana* of Machu Picchu, see John Hemming and Edward Ranney, *Monuments of the Incas*, Boston 1982, pp. 147–9; on the role of the *aclla* or chosen women, see Irene Silverblatt, *Moon, Sun and Witches: Gender Ideologies and Class in Inca and Colonial Peru*, Princeton, New Jersey 1987, pp. 81–108.

24. Ralph L. Roys, *The Books of Chilam Balam of Chumayel*, Norman, Oklahoma, 1968.

25. Fray Bernadino de Sahagún, *The Florentine Codex* (trans. J.O. Anderson and C.E. Dibble), Santa Fe, New Mexico, 1978.

26. *Joseph Beuys: In Memoriam*, Inter Naciones, Bonn 1986.

Chapter 5

1. For example, *Arte popular de América*, published under the direction of August Panyella and with photographs by F. Català Roca in Barcelona in 1981, was also published simultaneously in New York, under the title *Folk Arts of the Americas*.

2. *Textos sobre arte popular*, Mexico 1982, is a collection of polemical writings on the subject dating back to the beginning of the century; see also Francisco Stastny, *Las artes populares del Perú*, Madrid 1981.

3. Chapter 1, pp. 14–15.

4. The Chilean *arpilleras* are patchwork pictures made by groups of women as a form of direct opposition to the Pinochet regime. The *arpilleras* are essentially anonymous and although each is executed by a single woman they are produced within an ethos of collectivity, a characteristic of the popular but also the political ideal of many radical artists.

The first *arpillera* workshop grew out of the Association of the Families of the Detained-Disappeared, and the moment of abduction of a son or husband

can be the primary subject matter of the patchwork. Even though the materials are drawn from any available scraps and discarded pieces of fabric they often include personally evocative or precious items such as a passport photo or memento of the 'disappeared', a lock of the maker's own hair or skirt and sometimes little references to the real such as sea-shells in a fish-market scene or matchsticks as police batons. The process of manufacture is clearly visible, making obvious the stitching and the frayed cut edges of the cloth or the rough sacking fabric from which the *arpillera* derives its name. The personal is mixed with the detritus of industrial and daily life to produce an extraordinarily effective visual language. For a more detailed discussion of this exemplary form of Latin American art, see Marjorie Agosín, *Scraps of Life: Chilean Arpilleras, Chilean Women and the Pinochet Dictatorship,* London 1987.

5. Dr Atl, 'Las artes populares en México', in *Textos sobre arte popular,* Mexico 1982, pp. 19–39. Dr Atl (1875–1964), christened Gerardo Murillo, was a theorist and artist and a passionate believer in the need for subject matter with genuinely Mexican roots and for techniques not tainted by the elitism of the European tradition; he invented 'atl-colour'.

6. D.A. Siqueiros, *Art and Revolution,* London 1975, p. 22. Siqueiros is here attempting to work through an interesting dilemma. Early twentieth-century modernism embraced non-European art forms as a way of rejecting the 'civilized' values of their own societies. Latin American artists brought up to denigrate their own popular culture as 'folk art' now found it lauded by European modernists.

7. The Olmecs are one of the earliest civilizations of ancient Mexico. See Ignacio Bernal, *The Olmec World,* Berkeley/Los Angeles 1969.

8. Octavio Paz, *The Labyrinth of Solitude,* Grove Press 1961.

9. The exhibition catalogue *Antonin Artaud: Dessins,* Centre George Pompidou 1987, is a useful introduction to Artaud's overall interests.

10. The conflict between Breton and Artaud is outlined by Dawn Ades in *Dada and Surrealism Reviewed,* London 1978.

11. Fray Bernadino de Sahagún, *The Florentine Codex,* J.O. Anderson and Charles E. Dibble (trans.), Santa Fe, New Mexico, 1978.

12. Held in February 1922, this event was essentially a rebellion by painters, writers and musicians against academicism with the primary aim of embracing modernist trends from Europe.

13. A counterpart to the Venice Biennale, the São Paulo event is now an internationally important date in the art world and one of the main points of contact between Latin American artists and developments elsewhere.

14. Marcel Jean (ed.), *Jean Arp, Collected French Writings,* Joachim Neugroschel (trans.), London 1972.

15. R.H. Fuchs, *Richard Long,* London 1986.

16. This work was part of an exhibition of *Dez Artistas Mineiros* in the Museum of Contemporary Art, São Paulo, in 1984.

17. Siqueiros gives an account of this mural and its production. It was painted in a private house in the village of Don Torcuato near Buenos Aires. See *Art and Revolution,* p. 38.

Afterword

1. Ink on gessoed paper; the technique is a combination of drawing and something akin to Max Ernst's *frottage*.

2. In Holliday T. Day and Hollister Sturges, *Art of the Fantastic: Latin America 1920–1987*, exhibition catalogue, Indianapolis 1987, p. 242.

3. *Art of the Fantastic.* pp. 180–82.

Select Bibliography

Agosín, Marjorie, *Scraps of Life: Chilean Arpilleras, Chilean Women and the Pinochet Dictatorship*, London 1987.

Arciniegas, Germán, *Fernando Botero*, New York 1977.

Arte y tesoros del Perú: Pintura contemporánea (Part 2, 1920–60), Lima 1960.

Bayón, Damian (ed.), *América Latina en sus artes*, Mexico City 1974.

Bayón, Damian, *Artistas contemporáneos de América Latina*, Paris/ Barcelona 1981.

Bayón, Damian, *Aventura plástica de Hispanoamérica: Pintura, cinetismo, artes de la acción, 1940–1972*, Mexico City 1974.

Bayón, Damian (ed.), *Arte Moderna en América Latina*, Madrid 1985.

Bayón, Damian (ed.), *El artista latinoamericano y su identidad*, Caracas 1977.

[Botero], *Fernando Botero* (text Cynthia Jaffee McCabe), Smithsonian Institution, catalogue, Washington, DC 1979.

Charlot, Jean, *The Mexican Mural Renaissance*. Austin, Texas 1962.

Chase, Gilbert, *Contemporary Art in Latin America: Painting, Graphic Art, Sculpture, Architecture*. New York 1970.

Cien años de arte colombiano, 1886–1986, Museo de Arte Moderno, Bogotá 1986.

Cultures: Cultural Identity in Latin America, Unesco, Paris 1986.

Day, Holliday T. and Sturges, Hollister, *Art of the Fantastic: Latin America, 1920–1987*, exhibition catalogue, Indianapolis 1987.

Eder, Rita, *Gironella*, Mexico 1981.

The Emergent Decade, Solomon R. Guggenheim Museum, New York 1966.

Favela, Ramón, *Diego Rivera: The Cubist Years,* Phoenix 1984.

Fernández, Justino, *A Guide to Mexican Art,* Chicago 1969.

Findlay, James, *Modern Latin American Art: A Bibliography,* Westport, Connecticut 1983.

Folgarait, Leonard, *So far from Heaven: David Alfaro Siqueiros' The March of Humanity and Mexican Revolutionary Politics,* Cambridge 1987.

Franco, Jean, *Modern Culture of Latin America: Society and the Artist,* Harmondsworth 1970.

Frida Kahlo and Tina Modotti, Whitechapel Art Gallery, catalogue, London 1982.

Glusberg, Jorge, *Art in Argentina,* Milan 1983.

Goldman, Shifra M., *Contemporary Mexican Painting in a Time of Change,* Austin 1981.

Goldwater, Robert, *Primitivism in Modern Art,* New York 1967.

Gradowczyk, Mario H., *Alejandro Xul Solar,* Buenos Aires 1988.

Gradowczyk, Mario H., *Joaquín Torres García,* Buenos Aires 1985.

Herrera, Hayden, *Frida: A Biography of Frida Kahlo,* New York/London 1983.

Imagen de Mexico: Der Beitrag Mexikos zur Kunst des 20.Jahrhunderts, Shirn Kunsthalle, catalogue, Frankfurt 1987.

Imaginários Singulares, catalogue of an exhibition in the 19th Bienal, São Paulo 1987.

King, John, *El Di Tellà y el desarrollo cultural argentino en la década del sesenta,* Buenos Aires 1985.

Matta, Centre Georges Pompidou, Musée d'art moderne, catalogue, Paris 1985.

Modernidade: art brésilien du 20e siècle, Musée d'art moderne de la ville de Paris, catalogue, Paris 1987.

¡Orozco!, Museum of Modern Art, catalogue, Oxford 1980.

Paz, Octavio, *Los privilegios de la vista: Arte en México,* Mexico 1987.

Pontual, Roberto, *Dicionário das artes plásticas no Brasil,* Rio de Janeiro 1969.

Richard, Nelly, 'Post-modernism and Periphery', *Third Text,* 2, Winter 1987/8.

Rochfort, Desmond, *The Murals of Diego Rivera,* London 1987.

Rodríguez, Antonio, *A History of Mexican Mural Painting,* Marina Corby (trans.), New York 1969.

Rodríguez Prampolini, Ida, *El surrealismo y el arte fantástico de México,* Mexico 1969.

Sarduy, Serero, *Ensayos generales sobre el barroco,* Mexico 1987.

Siqueiros, David Alfaro, *Art and Revolution,* London 1975.

[Tamayo] *Rufino Tamayo: 50 Years of his Painting,* Phillips Collection, catalogue, Washington, DC 1978.

[Tamayo] *Rufino Tamayo: Myth and Magic,* Solomon R. Guggenheim Foundation, catalogue, New York 1979.

[Toledo] *Francisco Toledo: Exposición restrospectiva, 1963–1979,* Museo

de Arte Moderno, catalogue, Mexico City 1980.

Torres García: Grid-Pattern-Sign, Hayward Gallery, catalogue, London 1985.

Traba, Marta, *Dos décadas vulnerables en las artes plásticas latinoamericanas, 1950–1970*, Mexico DF 1973.

Wand Bild Mexico, Nationalgalerie, catalogue, Berlin 1982.

Zanini, Walter, *História geral da arte no Brasil*, 2 vols, São Paulo 1983.

ILLUSTRATIONS

FIGURES

PLATES

16 Jacobo Borges, *Encuentro con un círculo rojo o Rueda de locos/Meeting with Red Circle* or *Circle of Lunatics*, 1973; Museo de Arte Moderno, Mexico DF.

17 Wifredo Lam, *Luz de arcilla/Light of Clay*, 1950; Museo de Bellas Artes, Caracas.

18 Roberto Matta, *A Grave Situation*, 1946; Museum of Contemporary Art, Chicago.

19 María Izquierdo, *Altar de Dolores*, 1943; Galería de Arte Mexicano, Mexico DF.

20 Rocío Maldonado, *La Virgen/The Virgin*, 1985; Centro Cultural de Arte Contemporáneo, Mexico DF.

21 Antonio Berni, *Juanito dormido/Juanito Sleeping*, 1978.

22 Jacobo Borges, *Upwards,* 1988

PHOTOGRAPHIC CREDITS

INDEX

Latin America
Bureau

The Latin America Bureau is a small, independent, non-profit-making research organisation established in 1977. LAB is concerned with human rights and related social, political and economic issues in Central and South America and the Caribbean. We carry out research, publish books, publicise and lobby on these issues, and establish support links with Latin American groups. We also brief the media, organise seminars and have a growing programme of schools publications.

Recent *LAB* books include:

Cuba: The Test of Time
JEAN STUBBS

As Cuba enters the fourth decade of its revolution, this book assesses the island's social and political development in the light of current socialist re-thinking.

'A most informative and fair-minded survey of the achievements and problems of a revolution under blockade.'
Robin Blackburn, *New Left Review*

150 pages, £4.70/US$9.50, ISBN 0 906156 42 4

Guatemala: False Hope, False Freedom
JAMES PAINTER

'An excellent study of Guatemala's Christian Democrat government . . . Brimming with data yet eminently readable. A must for understanding the phenomenon of President Cerezo.'
NACLA, *Report on the Americas*

175 pages, £6.95/US$10.50, ISBN 0 906156 41 6

The Dance of the Millions: Latin America and the Debt Crisis
JACKIE RODDICK et al.

'A crisp and informative introduction to the Latin American debt crisis . . . Price, clarity of presentation, and a robust grasp of the structural characteristics of the world economy will ensure the success of this carefully reasoned polemic.'
Times Higher Education Supplement

258 pages, £6.95/US$12.50, ISBN 0 906156 30 0

Prices are for paperback editions and include post and packing. For a complete list of books, write to Latin America Bureau, 1 Amwell Street, London EC1R 1UL. LAB books are distributed in North America by Monthly Review Press, 122 West 27th Street, New York, NY 10001